INFINITE ISLAND

INFINITE ISLAND

# Contents

# Artists in the Exhibition

Jennifer Allora
and
Guillermo Calzadilla

Alexandre Arrechea

Ewan Atkinson

Nicole Awai

Mario Benjamin

Terry Boddie

Alex Burke

Javier Cambre

Charles Campbell

Keisha Castello

Liset Castillo

Colectivo Shampoo

Christopher Cozier

José (Tony) Cruz

Annalee Davis

Maxence Denis

Jean-Ulrick Désert

Roberto Diago

Polibio Díaz

Dzine (a.k.a. Carlos Rolón)

Joscelyn Gardner

Quisqueya Henríquez

Alex Hernández Dueñas

Satch Hoyt

Deborah Jack

Remy Jungerman

Glenda León

Hew Locke

Miguel Luciano

Tirzo Martha

Ibrahim Miranda

Melvin Moti

Fausto Ortiz

Steve Ouditt

Raquel Paiewonsky

Ebony Grace Patterson

Marta Maria Pérez Bravo

Marcel Pinas

Jorge Pineda

K. Khalfani Ra

Santiago Rodríguez Olazábal

Veronica Ryan

Beatriz Santiago Muñoz

Storm Saulter

Arthur Simms

# Foreword

The nations of the Caribbean share a history of colonialism, slavery, and intense interaction among cultures and races. The travel-poster image of the Caribbean tropical paradise contrasts sharply with the complex realities of the region, which has been shaped by its long history and by more recent sociopolitical changes. Economic pressures and political instability have fostered migration in large numbers among and beyond the islands, but at the same time, strong cultural traditions and ethnic identities have created unbreakable bonds with Caribbean homelands. These forces have forged a dynamic hybrid culture, neither entirely local nor imported, that is constantly transforming itself.

Contemporary Caribbean art reflects this diversity and dynamism, and the Brooklyn Museum is proud to present *Infinite Island: Contemporary Caribbean Art*, introducing our visitors to work by forty-five emerging and established artists. Selected from hundreds around the world, the artists are mostly Caribbean-born and live in the region as well as abroad. Their work explores Caribbean history, identity, and sociopolitical changes in terms of cultural encounters and convergences, which often extend beyond the Caribbean into diasporic communities throughout the world.

Brooklyn's Caribbean American population is notable among these diasporic communities. The borough is home to one of the greatest concentrations of Caribbean people in the country. The sheer scale of the annual West Indian–American Day Carnival and Parade, with two million participants and spectators, is evidence of the Caribbean presence in Brooklyn. The Brooklyn Museum is in the very heart of this event, with four days of concerts taking place on the Museum's grounds and leading up to the exciting and extravagant parade.

The Brooklyn Museum's organization of *Infinite Island* is most appropriate, not only because of the link to our Caribbean community but because the Museum has been at the forefront of showcasing Caribbean art, organizing the landmark exhibition *Haitian Art* in 1978 and exhibiting *Caribbean Festival Arts* in 1990. We are proud to continue this tradition, part of our larger mission of presenting the rich artistic heritage of world cultures.

I extend special thanks to Tumelo Mosaka, Assistant Curator for Contemporary Art and Exhibitions, who conceived and organized the exhibition and who also oversaw the accompanying catalogue and wrote an introductory essay. Annie Paul, Associate Editor of the journal *Small Axe* and Head of Publications at Sir Arthur Lewis Institute of Social and Economic Research at University of the West Indies in Kingston, Jamaica, contributed an essay that offers an insightful overview of art in the Caribbean; and Nicollette Ramirez, a writer and art critic from Trinidad and Tobago who is based in New York, wrote the commentaries about the artists in the exhibition.

We are grateful to the Peter Norton Family Foundation for its early and generous support of the exhibition. We also thank the American Center Foundation and the National Endowment for the Arts for their very generous grants for this project. The publication of the exhibition catalogue was supported in part by an endowment established by the Iris and B. Gerald Cantor Foundation and the Andrew W. Mellon Foundation.

For the ongoing support of the Museum's Trustees, we extend special gratitude to Norman M. Feinberg, Chairman, and every member of our Board. Without the confidence and active engagement of our Trustees, it would not be possible to initiate and maintain such a high level of exhibition and publication programming as is exemplified by *Infinite Island*.

*Arnold L. Lehman, Director*
*Brooklyn Museum*

# Preface and Acknowledgments

Since very few contemporary artists from the Caribbean have had significant exposure in the United States, organizing the exhibition *Infinite Island: Contemporary Caribbean Art* has been a challenging project of considerable magnitude. Many exhibitions in the last decade have focused attention on Caribbean artists who have resettled abroad, most often in the United States. As curator of this exhibition, however, I was interested in presenting the multiple perspectives of Caribbean artists from within the islands as well as abroad.

*Infinite Island* brings together some eighty works by forty-five emerging and established artists who work in the Caribbean, the United States, Canada, and Europe. Most were born in the Caribbean, with ties to fourteen countries and territories—Cuba, Haiti, Jamaica, Trinidad and Tobago, Barbados, Puerto Rico, the Dominican Republic, Martinique, Suriname, Curaçao, St. Maarten, Montserrat, Nevis, and Guyana. All the works on view were made in the last six years, and several were commissioned especially for the exhibition. The artists work in various materials and media, including painting, prints and drawings, installation, photography, video, and sculpture, to reflect the region's culturally dynamic heritage and to present competing ideas about the shifting nature of Caribbean identity.

The organization of this exhibition and publication has involved the collaborative effort and participation of many individuals. First, I would like to thank all the artists I contacted during the research phase for their generous hospitality, stimulating conversations, and good humor.

I am indebted to many people at the Brooklyn Museum for their assistance and enthusiasm. From the beginning, Arnold Lehman, Director of the Brooklyn Museum, has been very passionate in his dedication to the project. Charles Desmarais, Deputy Director for Art, Kevin Stayton, Chief Curator, Judith Frankfurt, Deputy Director for Administration, and Cynthia Mayeda, Deputy Director for Institutional Advancement, offered steadfast support and guidance throughout the exhibition process.

Space does not permit me to thank all those at the Brooklyn Museum who contributed to the success of the exhibition and its accompanying publication. I would like to express my sincere gratitude to Charlotta Kotik, Radiah Harper, and Nicole Caruth for their encouragement, good counsel, and unwavering support. I extend special thanks to Tamara Schechter, Nomaduma Masilela, and former departmental assistant Rebecca Veit for their fine research skills and for facilitating all communication between the Museum and the artists. I am evermore grateful to interns Javier Corro Olmo, Rebeca Noriega Costas, and Maddalena Tibertelli and volunteers Elsa Gardner and Lillie DeBevoise for their boundless enthusiasm and dedication. Among the many others

at the Museum who have made major contributions to the project are Kenneth Moser, Rachel Danzing, Antoinette Owen, and Lisa Bruno; Elizabeth Reynolds and Deana Dentz; Megan Doyle Carmody; and Walter Andersons, Travis Molkenbur, and the entire staff of art handlers, who accomplished a daunting amount of work. Also deserving particular mention is Matthew Yokobosky, whose sensitivity to each artist's vision informed the exhibition design. Judith Paska, Rob Krulak, and Leslie Brauman of Development and their former colleague Breta Petraccia worked tirelessly to secure funds for the project. Deirdre Lawrence and Sandy Wallace from the Museum Library and Archives provided great support during the research phase. Deborah Wythe, Sarah Gentile, and Jessica Pepper from Digital Collections and Services expertly managed the collection and preparation of digital images for the catalogue. Sallie Stutz, Sally Williams, Schawannah Wright, Shelley Bernstein, and the Education Division played key roles in bringing the exhibition and its publication to a wider audience.

Beyond the Museum walls, many friends and colleagues have lent support and encouragement. I wish to acknowledge Hazra Joanna Ali, Camilo Alvarez, Catherine Amidon, Wilfredo Benitez, Isolde Brielmaier, Paul Bucknor, Deborah Cullen, Charlotta Elias, Gloria Gordon, Rosie Gordon-Wallace, Jonathan Greenland, Therese Hadchity, Sara Hermann, Reynald Lally, Marc Latamie, Jennifer Leamy, Mario Lewis, Kynaston McShine, Marysol Nieves, Yasmin Ramirez, Juan Pablo Rodriguez, Carole Rosenberg, Antoine Schweitzer, Danny Simmons, Tina Spiro, Claire Tancons, Allison Thompson, and Octavio Zaya.

I extend my gratitude to my fellow authors Annie Paul and Nicollette Ramirez, whose contributions to this volume offer thought-provoking insights into artistic practice in the Caribbean. I am grateful to James Leggio for his editorial advice and guidance during the publication process, and to Joanna Ekman for her meticulous editing and management of the catalogue. At Philip Wilson Publishers, I thank Anne Jackson for her dedication to the project. Caroline and Roger Hillier of The Old Chapel Graphic Design created a striking design for the volume.

It has been a rewarding experience learning about the work of the artists participating in the exhibition and forming new and lasting relationships. I wish to extend my sincere appreciation to them all. Finally, I thank Irene Small for her support, humor, and patience throughout the entire course of the project.

*Tumelo Mosaka*

UNITED
STATES

Miami •

BAHAMAS

• Nassau

*Gulf of*

*Mexico*

*G* *r* *e* *a* *t* *e* *r*

Havana •

CUBA

CAYMAN
ISLANDS (U.K.)

Kingston
•

JAMAICA

MEXICO

BELIZE

*C a r i b b e a n*

GUATEMALA

HONDURAS

EL SALVADOR

NICARAGUA

*Pacific*

COSTA
RICA

*Ocean*

PANAMA

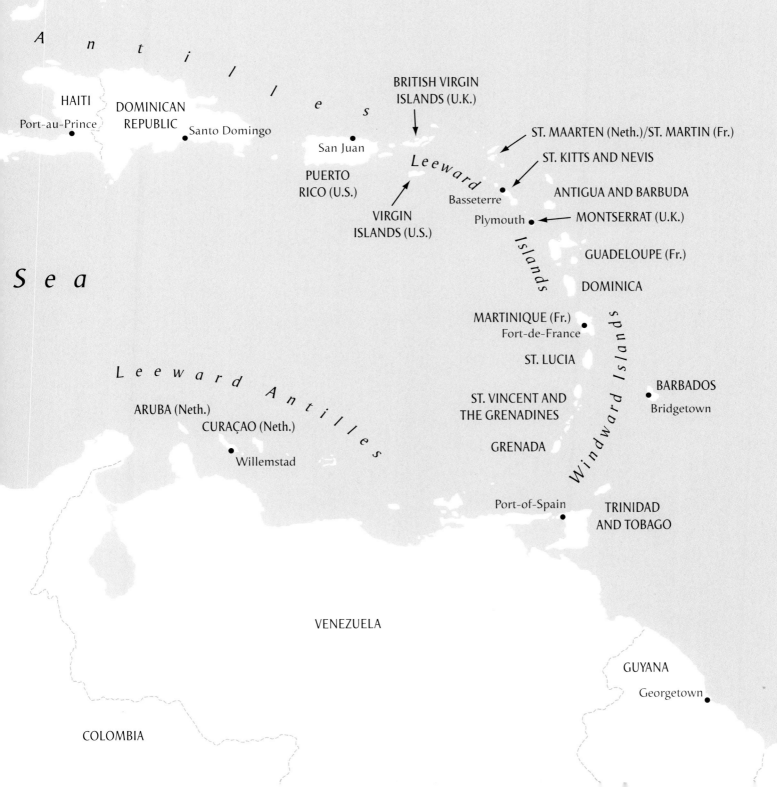

Atlantic Ocean

A n t i l l e s

HAITI
Port-au-Prince •

DOMINICAN
REPUBLIC
• Santo Domingo

BRITISH VIRGIN
ISLANDS (U.K.)

• San Juan

PUERTO
RICO (U.S.)

Leeward

VIRGIN
ISLANDS (U.S.)

ST. MAARTEN (Neth.)/ST. MARTIN (Fr.)

ST. KITTS AND NEVIS

• Basseterre

ANTIGUA AND BARBUDA

Plymouth • ← MONTSERRAT (U.K.)

GUADELOUPE (Fr.)

Islands

DOMINICA

MARTINIQUE (Fr.)
• Fort-de-France

ST. LUCIA

Sea

Leeward Antilles

ARUBA (Neth.)

CURAÇAO (Neth.)

• Willemstad

ST. VINCENT AND
THE GRENADINES

GRENADA

Windward Islands

BARBADOS
• Bridgetown

Port-of-Spain •

TRINIDAD
AND TOBAGO

VENEZUELA

GUYANA

• Georgetown

COLOMBIA

SURINAME

# Infinite Island
## Contemporary Caribbean Art

Tumelo Mosaka

Break a vase and the love that reassembles the fragments is stronger than that love which took its symmetry for granted when it was whole. . . . Antillean art is this restoration of our shattered histories, our shards of vocabulary, our archipelago becoming a synonym for pieces broken off from the original continent.

—Derek Walcott, Nobel Lecture, 1992

When Christopher Columbus arrived in the Caribbean in 1492, he believed that he had reached the shores of the Indies, the alleged Asian land of riches described by Marco Polo in the late thirteenth century. According to one account, Columbus asked the Indians in Cuba if the land was an island or a continent, to which they replied that it was an infinite land of which no one had seen the end.[1] To Columbus, this response appeared to confirm his dream of discovering a vast territory of abundant material possibilities. He believed he had reached a continent, not a series of fragmented islands separated by miles of sea. The indigenous Indians, however, had a very different conception of geography. They did not live in permanent settlements but moved between islands according to their needs and desires. They envisioned the open seas as corridors and bridges that connected and extended the geographical borders of each physical place. For them, an "island" was not a place defined by its boundaries but a constantly changing space defined by its possibilities. This tension between what

Christopher Cozier
**The Castaway** (detail), from *Tropical Night*, 2006–present
(see page 84)

might be termed *place* (connoting boundaries, insularity, containment) and *space* (suggestive of interconnection, flux, and transformation) is one that continues to define the Caribbean and its geopolitical relations with the West. But it is also an animating force within its culture and within its art.

### THE CARIBBEAN AS PLACE

The Caribbean is typically defined as the series of fragmented sea islands that stretch between North and South America. As a result of varying colonial histories, the composition of the contemporary Caribbean includes sixteen independent states and twelve dependent territories. Although the majority are islands, mainland states that share a similar historical legacy (such as Suriname and Guyana) are also included within the designation "Caribbean." Although the Caribbean is marked by certain elements of shared history, it varies widely with respect to political system, ethnicity, and language, and the cultures that have developed within it are extremely diverse.

Throughout the region's history, those in power have attempted to delimit the Caribbean as a fixed entity for particular strategic ends. This endeavor can be traced to the very designation of the region. The name *Caribbean* derives from *Los Caribes*, the term the Spanish invaders used to describe the local inhabitants and which means "man-eater" or "uncivilized."[2] The act of naming embodies a world of meaning that is tied to the history and mythology of place. It is a means of locating and defining oneself—an act of empowerment—but it is also a function of privilege and authority. Those who name are usually in power; those who are named are usually subject to that power. Naming, as Kimberly Benston has written, is "the means by which the mind takes possession of the named, at once fixing the named as irreversibly other and representing

it in crystallized isolation from all conditions of externality."[3] The idea of cannibalism contributed to the mythology of the Caribbean as a savage territory to be tamed and saved. The Europeans could therefore justify their presence and expropriation of natural resources in the name of religion and moral uplift.

Other names for the Caribbean such as the Antilles and the West Indies also underscore the function of myth in the act of naming. The former derives from *Antilia*, a term used by medieval geographers to refer to the "Island of the Seven Cities" believed to exist somewhere in the Atlantic Ocean.[4] This mythical Island of the Seven Cities was imagined to be the home of the Portuguese Christians who fled the Moorish invasion in the eighth century. But since this island could not be located, the name was given to those islands chanced upon by Columbus, conveniently appropriating unknown territories within a known tradition of European history. The term *West Indies*, in turn, exposes the extent to which the legacy of Columbus's material ambitions and misguided geographical designation remains a part of Caribbean identity, even today.

Having found very little gold and material wealth, Columbus and his men transformed the islands into industrial production sites for raw materials in the service of the West. This new industrial economy required a large dependable labor force to work the plantations, since the arrival of the Europeans had caused a massive depopulation of the indigenous Indians, who resisted colonialism and were exterminated as a result of massacres, famine, and foreign diseases such as smallpox. The colonizers therefore imported a workforce of slaves from Africa and, later, indentured servants from India. The plantations became central to the Western economy, generating raw products such as sugar, coffee, leather, indigo, cocoa, and cotton for European consumption. Because of the immense wealth generated in the Caribbean, the islands became a battleground for competing European economic and political interests. The fixing of names and territories as possessions with defined borders was absolutely central to the workings of colonialism. Mapping—the drawing and redrawing of boundaries—became the necessary correlate to naming.

The postcolonial Caribbean has transformed its image from plantation economy to tourist haven, promoting the idea of insularity and exclusivity as an attraction for Westerners seeking tranquil, sun-filled getaways. The image of beautiful mountains, dense tropical forests, golden beaches, and rocky deserts is seductive, but this marketing strategy of packaging the Caribbean as "Paradise" conceals social conditions burdened by poverty, crime, and lack of education and health care. These conditions engender fragile governments that are vulnerable to outside manipulation. In addition, the region is afflicted by natural disasters such as hurricanes and volcanoes—phenomena inconsistent with the paradisiacal image that draws tourists to the region.

In the years since many territories gained independence between the 1960s and 1980s, the notion of Caribbean "hybridity" has gained currency as a nationalist ideal as well as a self-defining theme for the region. Based in the Caribbean's history of slavery and interaction between cultures and ethnicities, this notion suggests that the exchanges between distinct cultures resulted in a new hybrid culture that is not only cohesive but entirely unique to the region. It is often articulated in the composition of national anthems, such as "Out of Many, One People" (Jamaica) and "One People, One Nation, One Destiny" (Guyana). Such expressions of nationalism emphasize the act of seeking common ground as a way to bridge diverse communities. Approaching nationalism through the lens of hybridity, however, can also reduce the cultural complexity of the Caribbean to a homogeneous entity in the service of political interests. Such nationalisms presuppose that cultural hybridity produces equality among its component parts, when in fact the historical particularities of the region have resulted in the privileging of certain groups within the various cultures that make up the Caribbean. In the case of Trinidad and Tobago, for example, Indo- and Afro-Trinidadians, two groups with overlapping histories of exploitation and brutality, compete for power and culturally define the location while racial and economic divisions also determine power relations. It is the cultural mixture and tension of differences that give the Caribbean its dynamism.

## THE CARIBBEAN AS INFINITE ISLAND

Even the notion of a homogeneous "hybrid" Caribbean culture, then, fails to recognize the complex way in which elements drawn from cultures of origin are reconfigured and transformed in new contexts. Caribbean culture is perhaps better described as both hybrid and composite: African, Indian, and European cultures have mixed to create a distinct Caribbean culture, but within this culture there are also distinct cultural practices that maintain their own particularity and independence. In Haiti, for example, the slaves brought

over from different parts of Africa, who practiced various cultural traditions and spoke different languages, were forced to coexist on the plantations; they developed a unique language and culture influenced by multiple African and French traditions. After the Haitian Revolution in 1804, the island became the first black republic. The resulting culture and language became known as Creole, a cultural and linguistic blend that has retained certain distinct African characteristics fused with French culture. Elements from the culture of origin are always reconfigured in some fashion and are transformed in complex ways that respond to the new environment.

In addition to this mix of traditions, the movement of people to, from, and within the Caribbean has cultivated a dynamic culture that is still evolving today. The region has always been a crucible of migration and diasporic experience beginning with slavery and colonialism. Continuing migration between and beyond the islands is now motivated by a different set of issues that include not only crime, political unrest, famine, and unemployment but the quest for better opportunities and new experiences. Recently, migration of Caribbean populations to metropolitan centers around the world has created yet another diaspora, one that now looks back to the Caribbean as its origin.

In the context of globalization, the region has become a "space" defined by complex relations that interconnect power, class, race, and gender. Defying the strictures of limiting categories associated with physical boundaries, national desires, and market-driven images, the contemporary artists in *Infinite Island: Contemporary Caribbean Art* reimagine the Caribbean as a place where both infinite and delimited conditions apply. They examine aspirations, nostalgia, history, and memory with great ambivalence and interpret the sociopolitical realities of the islands and their diasporas as constantly changing the Caribbean's identity. The exhibition is organized around four overlapping themes—History and Memory; Politics and Identity; Myth, Ritual, and Belief; and Popular Culture—which provide entry points into the complexity of the works on view and present the Caribbean as a site of debate. The artists apply various strategies to seek out ways to transform and alter existing notions about the region while presenting competing ideas about what constitutes Caribbean sensibility.

## History and Memory

Works grouped within the theme of History and Memory explore colonialism's impact on the present. A range of signs, symbols, and sounds connect modern-day poverty and servitude with the trauma of slavery, suggesting the continued violence against those who are victims of discrimination because of race and gender. Roberto Diago's installations and Alexandre Arrechea's photographs explore discrimination and inequality under Cuban socialism. The photographs of Fausto Ortiz, which examine the predicament of illegal immigrants in the Dominican Republic, address the tension between Haiti and the Dominican Republic, two nations that share an island and a history of distrust, physically close and culturally distant because of the linguistic and political traditions born of different histories of occupation.

Works by Terry Boddie and Charles Campbell explore the sociopolitical histories and cultural environments affecting black people in the diasporas caused by slavery and recent emigration from the Caribbean. Both artists use iconic images of human slave cargo as a reminder of the horrific and traumatic experience of the Middle Passage, the voyage that transported Africans across the Atlantic to the plantations of the Caribbean and the Americas. Merging historical documentation with contemporary imagery, Boddie likens the disempowerment of blacks today with the experience of slavery. In Campbell's paintings, the slave-ship motif is abstracted, allowing viewers to arrive at their own interpretations.

Hew Locke takes a different approach to the legacy of colonialism in his exploration of public images of British royalty and the way in which symbols of power such as monuments, emblems, and images speak to the continuing power of the British monarchy within the Caribbean and Africa. His use of readily available "low"-culture objects in his oversize image of Queen Elizabeth not only subverts the power usually associated with the monarchy but also suggests that while the colonizer's culture was imposed on the Caribbean, the colonizer is also susceptible to local influences.

The ramifications of the colonial encounter are also present in the socially engaged work of Jennifer Allora and Guillermo Calzadilla, whose collaborative projects examine the manifestation of power in public spaces as well as strategies of struggle and resistance. Their 2001–2 *Land Mark (Foot Prints)* project focuses on issues about land ownership and the rights of private citizens and the state in Vieques, Puerto Rico, where

residents protested the continuing occupation of their land by the U.S. Navy for military testing and exercises.

## POLITICS AND IDENTITY

The politics of identity always concern power and control. Who speaks for whom? How is national representation achieved? What defines community? Who speaks for that community? While governments may embrace national identities that articulate a unified official ideal, the reality of individual experience is much more complex and diverse. Similarly, the importance of national versus regional identity may shift according to one's geographical location or ethnicity. In this exhibition the theme of identity surfaces as a strategy of distancing the self from prescribed definitions and of imagining new ones. In the work of some artists, fiction is used to amplify the selectivity and omissions of memory. For others, representational, spatial, or temporal fragmentation is a way of complicating given or imagined narratives.

Jean-Ulrick Désert examines how various signifiers such as skin color, clothing, and language determine social hierarchy and categorize individuals. His performance and installation works explore how identity is brought into focus or rendered invisible in a global context. Christopher Cozier by contrast, is interested in revisualizing the Caribbean as a product of colonialism now in search of its modern roots. His work, using the personal-diary format of the artist notebook, is rooted in the historical dynamics that shape a new postcolonial vision. In his *Tropical Night*, 2006–present, for example, visual references to colonialism, tourism, and nationalism are filtered through a personal system of mark making, color, and iconic repetition of signs and symbols.

Gender is the central issue for artists such as Ebony Grace Patterson, whose works comment on the exploitation and fetishization of the black female body in the mass media. The objectification of the body of the "Hottentot Venus" as the subject of desire and curiosity is revisited in her work as a literal and conceptual abstraction. For Patterson, and many other artists in this exhibition, the work of art is a site where transformation is made possible.

## MYTH, RITUAL, AND BELIEF

While the dominant religions of the Caribbean islands are variants of Christianity, several of them are the direct product of African influences. The confluence of ancient African cultural practices and the European Christianity that was forced on slaves resulted in new syncretic religions such as Vodun, Santeria, Candomble, Ifa, Palo Monte, and others. Believers in many of these religions worship *orishas* (gods of West African Yoruban culture) that possess divine powers and mediate between human and spiritual realms. Such traditions survived because early slave practitioners of these religions disguised the African roots of the *orishas* by appropriating Christian iconography. In Cuban Santeria, for example, Saint Anthony the gatekeeper became Elegba, guardian of the crossroads. The political aspect of Caribbean religion is manifest not only in the appropriations of syncretic religions passed down through generations (in Haiti, Vodun was a vehicle of political mobilization that was outlawed under colonialism and later by the ruling class until 1946) but also in recent religions such as Jamaican Rastafarianism, which looks to independent nation states of Africa, specifically Ethiopia, as symbols of liberation and freedom.

The practice and politics of Caribbean religion have provided fertile ground for contemporary artists. Marta Maria Pérez Bravo, for example, documents her own performance of rituals that embody sacred mysteries linked to the Afro-Cuban religions of Santeria and Palo Monte. She then manipulates these photographs in the darkroom to suggest the transformation of the self within religious ritual. The work of Santiago Rodríguez Olazábal is closely related to his experience as a priest of the cult of the *orisha* Ifa. The particular philosophical approach of Ifa religion, with its emphasis on achieving balance between forces of man and nature, appears in his serigraphs through the interaction between figuration, abstraction, and various systems of signs.

While artists such as Pérez Bravo and Rodríguez Olazábal use their active religious practice to inform their work, others such as Alex Burke approach the intersection of history and religion in a more ambiguous way. Burke's fabric sculptures made of fragments of recycled rags resemble effigies used for ritual purposes associated with Vodun. Yet the artist's reference to the mythologies of "voodoo dolls" is not limited to the mysticism that surrounds the religion but also suggests the survival and continuation of culture in the Caribbean. His use of colorful recycled material suggests the way in which elements are transformed within varying cultural practices in order to create new aesthetic meanings layered with old histories. Paradoxically, the disparate sources of the fabric remnants that Burke uses mean that the individuality of each piece is a result of the fragmentation of the urban experience.

This sense of urban fragmentation is reinforced by other artists such as Arthur Simms and Liset Castillo, with their sculptures and photographs about the built environment.

POPULAR CULTURE

Although the Caribbean has been influenced by global mass culture, the region is also a key producer and exporter of popular culture to the world. In fact, it is the continual process of exchange and reinterpretation within the Caribbean and its diaspora that gives its popular cultures their particular dynamism. The work of Miguel Luciano examines the effect of American consumerism on Puerto Rican culture. He transforms common objects such as plantains and other goods associated with Puerto Rico into fetishized commodity objects in order to evoke the process by which ordinary objects become cultural icons. Dzine is similarly interested in the urban culture that is created between Puerto Rico and the United States. His abstract paintings and installations translate rhythms of hip-hop music and graffiti into fine art, suggesting the sensory fusion of sound and image.

Music is a key vehicle of cultural interaction, appropriation, and self-definition in the Caribbean. Throughout the history of the region, the reinterpretation of external influences by Caribbean musicians has given rise to innovative musical forms such as calypso and reggae. Calypso, originating in Trinidad and Tobago, has a long association with the carnival, where it has served as a wide lens through which social ills are examined by means of parody and exaggeration. Reggae, the musical form born in Jamaica and made popular by Bob Marley, attempts to raise political consciousness of social injustice. Both musical forms, though expressive of national identity, have been largely critical of the status quo. These musical genres have also been appropriated in turn, subverted and transformed into new cultural forms. Reggae, for example, has given rise to populist genres such as dancehall and reggaeton. These new forms appeal to younger, more rebellious audiences, while their lyrics of consumerism and sexuality are often antithetical to the ideas of nationhood and liberation initially associated with reggae.

The music rhythms and dance styles from the Caribbean serve as inspiration for several visual artists in the exhibition. Storm Saulter documents and manipulates footage of dancehall parties in order to highlight the way in which the exhibitionism and sexualized display that occur at these events are opportunities for various enactments and definitions of

self. Melvin Moti, exploring how music is a marker of history, portrays Miss Daisy, old-time queen of ska. Stripped of musical accompaniment, Miss Daisy's songs are out-of-tune and fractured, intensifying the disconnect between the present and the golden days of the past.

At the beginning of this essay, the metaphor of the "infinite island" was invoked to suggest a Caribbean space defined by its possibilities rather than its boundaries. In the same manner, the works of art in this exhibition can be understood to move beyond the limits imposed by geographical or national boundaries. Just as the Indians used the open seas as corridors and bridges rather than barriers, the exhibition pieces can be seen as bridges that connect not only physical spaces but also ideas and imaginations. The artwork is a mobile entity; it moves physically between places, and temporally through history. Its meanings change depending on its social context, location, and audience. As such, the works do not present a singular coherent identity but rather exist in manifold realities distributed through diverse spaces. These works of art function as spaces in which ideas and subjectivities are examined and reimagined. In them, the Caribbean is a site of constant change and infinite possibility.

NOTES

1  The title of this essay was inspired by Gerardo Mosquera's seminal essay on Cuban art, "'The Infinite Island," in *Caribe Insular: Exclusión, Fragmentación y Paraíso*, exh. cat. (Badajoz, Spain: Museo Extremeño e Iberoamericano de Arte Contemporáneo, 1988). For the account of Columbus and the Indians, see 324–26.

2  Norman Girvan, "Reinterpreting the Caribbean," in *New Caribbean Thought: A Reader*, ed. Brian Meeks and Folke Lindahl (Kingston, Jamaica: University of the West Indies Press, 2001).

3  Kimberly W. Benston, "'I Yam What I Am': Naming and Unnaming in Afro-American Literature," *Black American Literature Forum* 16 (1982): 3–11.

4  James Ferguson, preface to *The Story of the Caribbean People* (Kingston, Jamaica: Ian Randle Publishers, 1999). The term *Antilles* is largely used in the French-speaking islands of Martinique, Guadeloupe, and St. Lucia and in the Dutch-speaking Caribbean (Suriname, St. Maarten, Aruba).

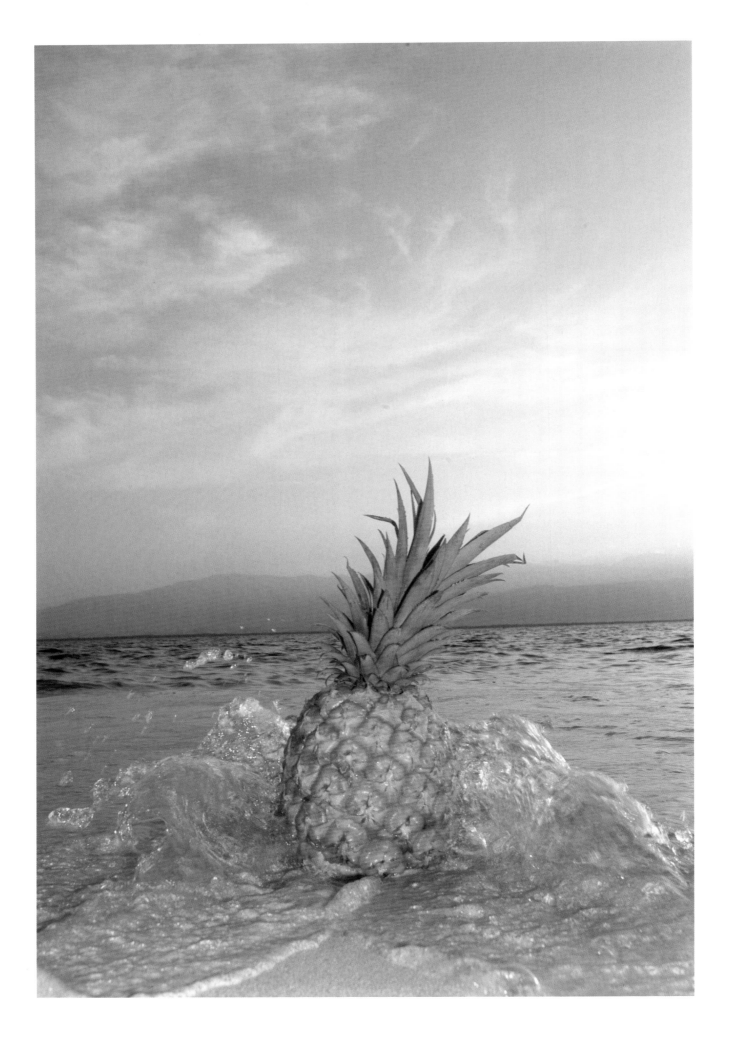

# Visualizing Art in the Caribbean

Annie Paul

Native to southern Brazil and Paraguay . . . , the pineapple was apparently domesticated by the Indians and carried by them up through South and Central America to Mexico and the West Indies long before the arrival of Europeans. Christopher Columbus and his shipmates saw the pineapple for the first time on the island of Guadeloupe in 1493. . . . Caribbean Indians placed pineapples or pineapple crowns outside the entrances to their dwellings as symbols of friendship and hospitality. Europeans adopted the motif and the fruit was represented in carvings over doorways in Spain, England, and later in New England for many years.[1]

Even though the Caribbean, hyped as "Paradise," is one of the most visited sites on earth, for many of its inhabitants it is the kind of place from which even its indigenous symbol of welcome, the pineapple, is trying to escape—to migrate from these supposedly hospitable, gracious shores (fig. 1). What kind of paradise could this be, you wonder, where the natives are fleeing while happy foreigners arrive daily to be pampered and feted on vacations from *their* real lives?

"Christopher Columbus landed first in the New World at the island of San Salvador, and after praising God enquired urgently for gold," wrote C. L. R. James of the first fateful penetration of the Caribbean by Europe.[2] Five hundred years later, visitors seeking gold continue to arrive in search of golden holidays in the golden sunshine (fig. 2). Though the

Caribbean is one of the most heavily trafficked tourist areas in the world, the truth is that the resorts tourists visit there are like elaborate site-specific installations, highly controlled environments scooped out of these tiny troubled postcolonial and semicolonial desti(nations) (figs. 3, 4). Here tourists remain quarantined for the duration of their visits, insulated from the itinerant violence that casts persistent shadows across these costly playgrounds. Perhaps our migrating pineapple was worried about being fed to tourists as a piña colada, perhaps it feared police brutality. Who knows? I am intrigued by the possibilities raised by this image of the friendly, welcoming pineapple as a warning symbol—a hint of the dark side of these islands.[3]

The image of the Caribbean as a collection of pleasure islands is a carefully cultivated one. As far back as the beginning of the twentieth century, countries such as Jamaica were being advertised as the "Riviera of the New World" while the Caribbean itself was touted as the "Mediterranean of the Americas." A booklet titled *Jamaica: The New Riviera*, published in 1903, claimed that only a few years before, the name Jamaica had evoked "practically nothing" in the mind of what it called the average reader,

> but now the mere mention of the island's name conjures up the vision of a blue sky over a blue sea, in which is set a beautiful island of luxurious vegetation and lovely scenery, fragrant with the odour of spices and flowers, with an atmosphere refreshed by invigorating sea breezes, and where, if you wish, you may dwell on the heights and enjoy all the beauty of the tropics.[4]

Fig. 1.
Peter Dean Rickards
*Escaping Pineapple*, 2005
Courtesy of the photographer

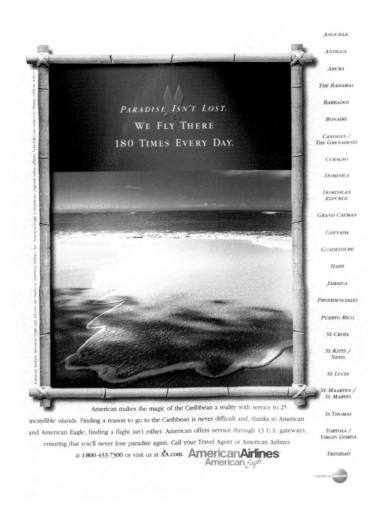

ANGUILLA

ANTIGUA

ARUBA

THE BAHAMAS

BARBADOS

BONAIRE

CANOUAN /
THE GRENADINES

CURAÇAO

DOMINICA

DOMINICAN
REPUBLIC

GRAND CAYMAN

GRENADA

GUADELOUPE

HAITI

JAMAICA

PROVIDENCIALES

PUERTO RICO

ST. CROIX

ST. KITTS /
NEVIS

ST. LUCIA

ST. MAARTEN /
ST. MARTIN

ST. THOMAS

TORTOLA /
VIRGIN GORDA

TRINIDAD

FIG. 2.
American Airlines advertisement in *Island Scene* magazine
(Winter/Spring 2002)

How was this transformation achieved, considering that there were no television, video, or Technicolor movies in those days? In fact, photography itself could only represent "reality" in black and white. The art historian Krista Thompson notes that early promoters of tourism in Jamaica "hired local and foreign photographers to create a substantial new repertoire of images of the island. Through photographs, lantern lectures, and colonial exhibition displays they aimed to reinvent the image of Jamaica."[5]

Textual description was also pressed into use. The campaign to attract tourists to Jamaica continued well into the twentieth century, with vivid imagery and word pictures attempting to convey the island's magic:

The abiding impression of Jamaica, gained by the visitor from the less colourful lands of the north, may be compared to the effect produced on the mind by the lifting of a stage curtain and the revelation of a beautiful, golden, sunlit scene—a dream picture of exotic-looking vegetation, of bright flowers and charming waters, complete with a magnificent background of mountains. . . . In Jamaica all the ingredients of the pretty stage-scene are there and it is not merely a warm and sunny vision enjoyed for a brief hour—the Jamaica counterpart is real, live and throbbing—a thing to be revelled in day after day, in a land of eternal summer.[6]

While the Caribbean was being pictured in glowing colors for consumption by those outside the region, artists within countries such as Jamaica struggled to find suitable local subjects for their art. Thompson records the fact that in the early twentieth century the Jamaica Portrait and Picture Gallery, "the first permanent display of art on the island," consisted almost entirely of "a pantheon of white countenances . . . more specifically . . . white male faces."[7] Apparently only colonial officials, many of them not even physically present on the island, were considered worthy of being painted.

What gets repressed in these glossy portrayals of the Caribbean is the history of slavery submerged one layer below. These were ex-slave societies, and ex-slaves were not considered suitable subjects for artists to portray. They were, however, considered fitting models for representations of the island as a paradise populated by hardworking, industrious people, as seen in two photographs reproduced in the book promoting Jamaica as the new Riviera. One is titled "Mending Our Ways" with a kind of mordant humor, while the other is called, rather baldly, "Hard Labour" (figs. 5, 6).

If it was inconceivable to early artists in Jamaica that the average inhabitant of the island might be an art-worthy subject, there was a similar hesitance about painting local flora and fauna, with one artist even importing English flowers to use as the subjects of her paintings. According to Thompson, "England became the island's representational mirror."[8] Since English paintings featured white subjects and northern landscapes, artists in the Anglophone Caribbean would faithfully follow suit. During the course of the twentieth century, the first proponents of modernism would change all this; they considered it their mission to unapologetically

Figs. 3, 4.
Peter Dean Rickards
**Braidhead 1** and **Braidhead 2**, 2004
Courtesy of the photographer

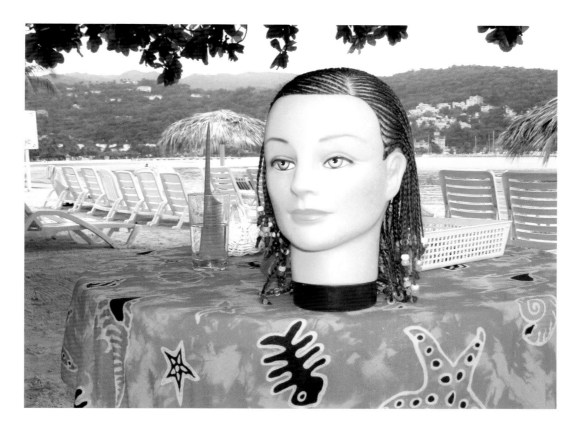

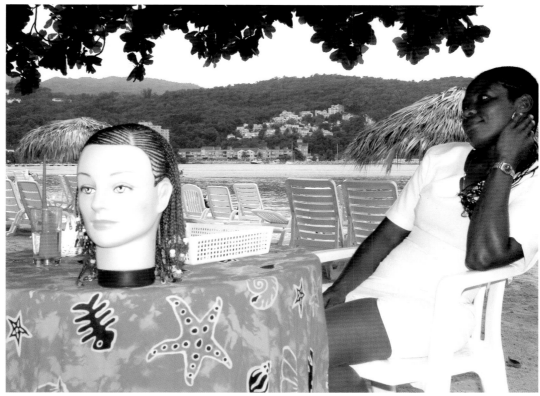

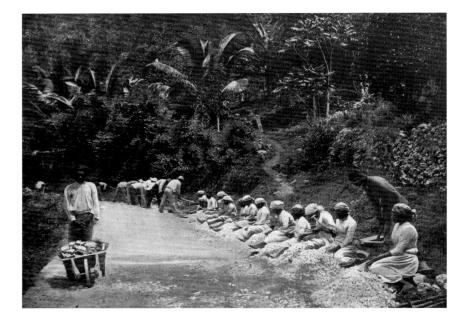

FIG. 5.
Unknown photographer
***"Mending Our Ways"***
From James Johnston, *Jamaica, The New Riviera: A
Pictorial Description of the Island and Its Attractions*
(London: Cassell, 1903)

portray the black subject to compensate for centuries of
representational neglect. The nude or seminude black male
became the subject of many a painting and sculpture.

In contrast to the English "representational mirror" in the
Anglophone islands, the model for art in the Hispanophone
and Francophone Caribbean was Paris, which by the 1920s
and 1930s was the epicenter of modern art. It was common for
artists from Cuba and the Dominican Republic to visit Paris
and spend time there, returning filled with inspiration by
the latest developments in modern art. Post-Impressionism,
Cubism, Fauvism, and Surrealism had a direct influence on
artists in Havana during the first four decades of the twentieth
century. Such movements reached the Anglophone Caribbean
much later, and it would be well into the second half of the
century before artists there seriously started applying modern
European genres to local subjects. As the St. Lucian Nobel
laureate in poetry, Derek Walcott, declared in 1971, "If Mr.
Cezanne painted the first square apple, Mr. St. Omer [the St.
Lucian artist Dunstan St. Omer] has painted the first square
coconut tree."[9]

Another major influence on art in the Caribbean in
the early twentieth century was Mexican muralism. Most
often associated with the renowned artist Diego Rivera
(1889–1957), muralism had an impact at this time not only
in Hispanophone countries but all over the world, including
the United States. As Edward Lucie-Smith noted, once the

movement was removed from its Mexican context, it "rapidly
became an official style" that "checked rather than aided the
development of Modernism."[10] Artists in Caribbean locations
looked toward Mexico for alternatives to the Euro-American
canon of art. It was felt that Mexican artists had succeeded
in marrying art and political commitment, thus providing a
model for socially engaged artists in other places.

By the end of the twentieth century, the Caribbean
provided an interesting case study in the development of
visual art for it contained two paradigmatic, if fundamentally
opposed, poles of art making—those represented by Haiti and
Cuba. Haitian art, virtually a branded entity, immediately
evokes brilliantly colored paintings of lush flora and fauna,
folkloric exotica, and tropical scenery. It has more in common
with so-called naïve art produced by peasants and proletarian
subjects elsewhere in the world—people traditionally deprived
of the technical know-how of painting and art. In Haiti
the Centre d'Art, founded in 1944 by two Americans, was
responsible for making art and a rudimentary art education
available to members of the peasantry and the newly created
urban proletariat, segments of the population normally
excluded from art discourse because of their low level of
education. The paintings they produced shared certain
characteristics such as gigantism (landscapes dominated
by giant fruits and vegetables) and repetition (hundreds of
market vendors crouched in exactly the same position or

Fig. 6.
Unknown photographer
***"Hard Labour"***
From James Johnston, *Jamaica, The New Riviera: A Pictorial Description of the Island and Its Attractions* (London: Cassell, 1903)

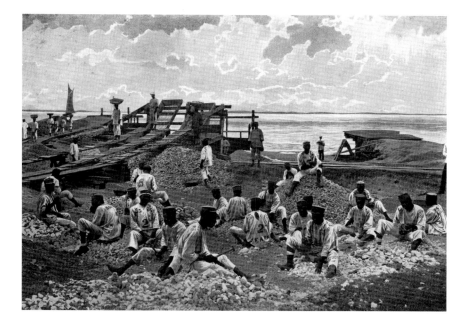

multiple birds and animals). Verging on the lurid, this kind of art can communicate a deep spiritual charge at its best and at its worst reduce the richness of Haitian life to repetitive patterns, the most popular of which is the much-reproduced market scene.

Art made in Cuba, on the other hand, is the product of a society that rejected the market completely, one of a handful globally, whose experiment with socialism still continues. The socialist worldview could have led to a highly controlled, centralized art scene stifled by five-year plans and state directives; instead, it has proved very successful in creating an art milieu with a significant presence in the Euro-American–dominated international art world. Cuban artists have led the way in participating in this exclusive art club on their own terms, setting trends in contemporary art (no market scenes here) and, through the well-known Havana biennial, the Bienal de La Habana, creating visibility for artists from other Third World countries and regions as well as themselves.

Interestingly, both Haiti and Cuba are "revolutionary" societies. The Haitian Revolution of 1804 was the second such rebellion in this hemisphere (after the American Revolution), whereas the Cuban Revolution of 1959 was one of the most recent. Haiti became the first black republic in the world after its French slaves fought a prolonged but successful battle against Napoleonic armies, vanquishing them and sending aftershocks and tremors throughout the region. The Cuban

Revolution involved not only the overthrow of the local dictator Fulgencio Batista, seen by many as an American puppet, but the liberation of the island from the loving, almost possessive, embrace of the Americans.

Haiti (like Cuba) would pay dearly for its independence. Obliged to pay exorbitant reparations to its former colonizers, it was left virtually bankrupt. Some estimate the current value of the figure paid at U.S.$21 billion, a crippling handicap by any standards. Subjected to embargoes and repeated invasions over the next century and a half, Haiti today is a tragic travesty of itself, a "failed state," a symbol of desolation regularly ravished by cycles of violence. Between invaders and marauding rulers, the country has been plucked clean like a chicken, according to Maximilien Laroche: "To make a country lose its political, financial, and economic independence is to effectively reduce it to the condition of the living dead. In Haitian, we would say it was a zombi."[11]

The Martinique-born philosopher and psychoanalyst Frantz Fanon vividly detailed the worldview of the colonized, of people confronted with such desolation:

> Meanwhile, however, life goes on, and the native will strengthen the inhibitions which contain his aggressiveness by drawing on the terrifying myths which are so frequently found in under-developed communities. There are maleficent spirits which

intervene every time a step is taken in the wrong direction, leopardmen, serpent-men, six-legged dogs, zombies—a whole series of tiny animals or giants which create around the native a world of prohibitions, of barriers and of inhibitions far more terrifying than the world of the settler.[12]

Fanon's description of the mythological spirits employed as avoidance mechanisms by natives confronted with oppressive colonial violence could just as well be a description of the iconographic content of much Haitian art. Edouard Glissant, another Martinican thinker, states that "Haitian painting is derived from the spoken," commenting on the ability of oppressed people to create fantasy and invoke the marvelous from their wretched reality in both modes of expression.[13]

Describing Haitian art as the "painted symbol" acting as "refuge" for the oral expression of the people—Haitian Creole—Glissant goes on to emphasize the common thread of repetition that links Haitian art and Creole oral tradition, which both present a symbolic, "schematic version of reality":[14]

There is an art of repetition that is characteristic of the oral text and of the painted sign described as naïve.

Such a discourse therefore gains from being repeated at leisure, like the tale recounted evening after evening. Each of the "masters" of this pictorial art has "apprentices" who reproduce his style perfectly. Tourism has increased the production that has become more schematic without becoming an industry. The discourse is reproduced on its own but its vulgarization (the countless canvases exploiting the naiveté of tourists) does not differentiate between "valid" paintings and an undistinguished pile of tourist art. We think we recognize from a distance the suspended cities of Prefette-Duffaut, when these images of levitation could be the work of an apprentice. Haitian painting challenges the magical notion of "authenticity" in art. It is a community endeavor. An entire people's discourse.[15]

If Haitian art is linked with Creole and the naïve, one might then ask, What of Haitian artists coming out of other traditions, the (learned) scribal as opposed to the oral, or those trained in art, its history and theory? The stereotyped identification of Haitian art with exotic and exaggerated

visual descriptions of a particular kind leaves very little room for artists whose approach to art departs from this norm. A paradigmatic exception has been the celebrated artist Edouard Duval-Carrié, who describes himself as having "taken the whole baggage of popular art and worked it into a contemporary language."[16] Actually, although one popular narrative attributes the origin of this kind of art to the founding of the Centre d'Art in the 1940s, the painting tradition in Haiti actually goes back to the nineteenth century, when a corps of artists was busy creating portraits of the blacks and mulattoes who constituted the country's new elite (fig. 7).[17] Contrast this with Jamaica, where at the beginning of the twentieth century there were no such images.

In contrast to overdetermined Haitian art, there is no such distinct entity as Cuban art. That is to say, art in Cuba encompasses a wide range of art-making practices from the usual packaging of the picturesque for tourist consumption to the most sophisticated forms of contemporary art imaginable using the latest media and languages. This is remarkable, considering that Cuba is as embargoed, blockaded, and isolated a country as it is. Its disconnection from the world capitalist system, its unique social system, and its investment in education and culture have produced an art scene that is quite the opposite of that of Haiti and unlike any other in the region.

In fact, the Cuban Revolution rearranged the social and economic landscape in that country in such a way that the traditional cornerstones of a functioning art world were all eroded or erased. In the absence of a functioning market mechanism, there were no longer private companies, galleries, collectors, or patrons to sustain art production. On the other hand, the revolution's commitment to free education for all provided anyone with artistic talent with access to high-quality training in art. Thus, in contrast to the situation in Haiti, art in Cuba was able to develop well beyond the folkloric and the picturesque. Although art production is completely state-funded, Cuban artists enjoy an unparalleled freedom in choice of styles and themes, and unlike their counterparts in many other socialist states, they are not corralled into versions of Soviet social realism.

Despite the U.S. embargo against Cuba, artists there have managed to keep abreast of international developments in art. Mere imitation of international art styles was never the objective, as Luis Camnitzer has observed: "The intention of

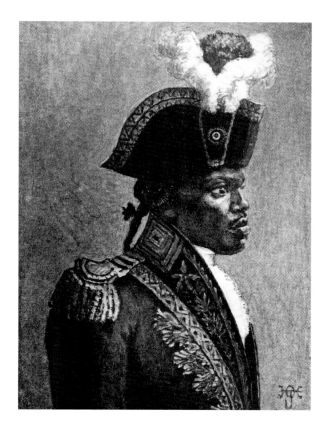

Fig. 7.
Unknown artist
**Toussaint Louverture**, about 1795
From Sir Harry H. Johnston, *The Negro in the New World* (London:
Methuen, 1910)

the artists was to find a Cuban answer to those movements, not to follow them. They expressed the wish to create an informed nationalistic art rather than one stemming from isolationism."[18]

*Volumen I* (*Volume I*) is the name of the landmark show that inaugurated "new art" in Cuba in 1981. According to Camnitzer, it "began a process of increasingly radical ruptures with Cuban art traditions. It also fueled the break with an epic past, opened the way for self-referential issues about art that were absent during the 1970s, and dealt with the international art scene without a guilt complex."[19] In such respects Cuban artists were well ahead of artists in the rest of the region. It was not surprising that the Bienal de La Habana, the trendsetting event that provided a venue for art from the Third World and brought Cuban art to international attention, originated in this newly reconstituted society. It is worth emphasizing that the Havana biennial is an international, rather than a regional or local, art event.

★

And what shaped the artistic environments in other parts of the Caribbean? Unlike Haiti and Cuba, whose people fought fiercely for their independence, other Caribbean countries either were granted independence (several of them in the 1960s) or remain colonial possessions and protectorates. Whereas Jamaica, like Haiti, is predominantly black, some countries have racially and ethnically diverse populations—including Trinidad and Tobago, and Guyana, where half the population is descended from indentured laborers brought from India in the later nineteenth and early twentieth centuries after slavery was abolished. In many Caribbean countries there are not only local whites but pockets of Chinese, generic "Syrians" (a reference to the Middle Eastern origins of the individuals concerned), and other minorities. In the countries with sizable Indian populations, a distinction is made between them and "Creoles," or Afro-Caribbeans. In those societies there was much ambivalence about becoming independent.

The pre-independence period saw a brief federal union of the ten English-speaking islands, all colonies of England. The Federation of the West Indies was short-lived. Created by the United Kingdom in 1958 with the intention that it would become an independent state, the federation disinte-grated in 1962, after Jamaicans voted to depart the union in 1961. Today the University of the West Indies, with campuses in Jamaica, Trinidad and Tobago, and Barbados, and the West Indian cricket team are the only surviving reminders of that federal impulse.

The question of whether Caribbean islands were to go it alone as sovereign, independent states or present themselves as a united front had implications for the development of art in the region. Before the federal movement collapsed, the dilemma for government patronage of art was this: "Should the frame of reference . . . be the development of a West Indian collection, located in one central place to create a West Indian image, or should it be a dispersed collection located on the various islands and therefore, more oriented toward the individual islands."[20] There was even talk of a National Gallery of the West Indies, but before the question of whether the art collection should express a federal or national identity and/or a regional or local identity could be resolved, the nascent Federation of the West Indies was defeated by Jamaica's decisive rejection of a federal union.

Jamaica, followed by Trinidad and Tobago, became independent in 1962. Nearly all of the other members of the

federation attained independence over the following two decades, bringing a new environment for artists and writers:

> Independence came as a shock to the intellectual and artistic community of Trinidad. The Creole community, by and large, stressed its symbolic significance and viewed it in terms of liberation, freedom, and analogues to the emancipation from slavery. East Indians, Chinese and whites, the latter now called "expatriates," were less euphoric and feared a deterioration of their position as minority group members. For whites, the clause in the new constitution that demanded that they give up double citizenship caused much distress. Even for writers and artists of negro descent, there were many questions unanswered. The narrower confines of an island nation rather than the expanded horizon of West Indian federalism now confronted them.[21]

With the advent of nationhood, artists in Caribbean countries had to contend with various demands. The ubiquitous tourist gaze was fixed on images of "tropical fruits" and "native huts." Internally, there was a demand for nationalist or "indigenous" imagery (in Trinidad the creation of a "national art" coincided with the creation of a national bird, a national flower, and a national history).[22] Populists and Marxists exerted pressure to "represent" the masses, while the middle class insisted that art depict its "moral aspirations." Resident foreigners often mediated these art worlds as arbiters of aesthetic virtue but brought their own prejudices with them. Hans Guggenheim noted that many foreigners in Trinidad were "inclined to see Haiti, rather than Paris, as the center for the appropriate style Trinidadian artists should imitate. If Trinidadians did not paint like the Haitians, then at least it was thought desirable that they should be emotional and expressionistic, and stick to local subject matter."[23]

In general, this opinion was not shared by the educated elites who nurtured and managed the fledgling art scenes in these Caribbean islands. As artists with academic training, they tended to explicitly reject the Haitian model, preferring to assert their right to experiment with a wide range of genres without feeling boxed into the narrow confines of the "primitive" or "naïve" category. Equally disdained was any suggestion that an artist's job in these tropicalized islands was to produce "tourist kitsch" or other propagandistic representations designed to "sell" them as fantasy islands.

In Jamaica, for instance, where a national gallery was established in 1974, a hard and fast line was drawn by art historians between artists referred to as mainstream and those euphemistically called intuitive (meaning self-taught). The latter are the Jamaican counterpart of Haitian artists, in many cases spiritually motivated individuals who tend to express themselves in frenzied paintings and carvings. Oddly enough, if the work appears too deliberate and studied rather than free-spirited or expressive, it is not deemed "intuitive" regardless of whether the artist is self-taught or not.

Jamaica equipped itself in short order with all the prerequisites it considered necessary for a superior art scene: a National Gallery, an art history, an art school, a so-called avant-garde, and a canon anchored by a great white ancestor and worthy black subjects. In keeping with Euro-American art narratives that invariably start with the myth of the white founding father, the carefully constructed canon rests squarely on the shoulders of the English-born and -bred Edna Manley (1900–1987). Claiming "artistic primacy" in the Anglophone Caribbean in the sixties, seventies, and early eighties, Jamaica's art scene fairly sizzled with excitement. Yet at the beginning of the twenty-first century, it finds itself with little or no artistic milieu to speak of, even less of a critical milieu, and only one functioning commercial gallery. How to explain this? We will return to this question, and its ramifications for the future of Caribbean art, at the end of this essay.

In contrast to Jamaican visual art, that of Trinidad and Tobago lacks a written history, a canon, or even institutional structures such as those provided by the government in Jamaica. It nevertheless has a vibrant contemporary art scene, the hub of which seems to be CCA (Caribbean Contemporary Arts). Founded in 1997, CCA describes itself as "an international arts organisation that works with contemporary visual artists, curators, writers, historians and art educators from the Caribbean and the Caribbean Diaspora to exhibit, publish and document our region's art practice, influences and ideas."[24] The Ford Foundation–funded organization was the natural outcome of conversations among a group of Trinidadian artists who had studied abroad and returned home to an insular and conservative art scene that was hostile to them and their new ways of thinking about art. With no local institutions to fall back on, Trinidadian artists had little recourse but to create their own organization by recruiting local and foreign sponsors willing to bankroll their vision. What is noteworthy about CCA

is that its ambit is regional rather than national and that it includes the diaspora.

Another measure of Trinidad and Tobago's active art scene was the 2006 six-week-long season of art events, public forums on art, and musical concerts that was titled *Visibly Absent* to describe the dilemma of artists in Trinidad working outside conventional genres. Initiated and run by artists themselves, *Visibly Absent* promises to become an exciting annual event in the Caribbean.

The Hispanophone islands such as Cuba, the Dominican Republic, and Puerto Rico had the advantage of being seen as part of a "Latin American" grouping (including Central and South American countries), even though the histories of these Caribbean islands are very different from each other. The Dominican Republic occupies the same landmass as Haiti but remained under Spanish control until 1865. Puerto Rico became a territory of the United States in 1898 and remains so today. Nevertheless, despite their hugely varying circumstances, the art worlds of the Hispanophone islands, former colonies of Spain, were shaped by the constant cultural exchanges among them and, in the case of Puerto Rico, with the United States. Unlike Britain, Spain has taken an active interest in the cultural development of its former colonies. The city of Valencia, for instance, regularly hosts a biennial symposium known as Dialogos Ibero-Americanos, to which it invites curators, critics, and other art personnel from South America (including Brazil) and Latin America (including the Caribbean).

In Puerto Rico, development in art accelerated after the American government instituted Operation Bootstrap in the 1950s in an effort to transform the island from an agrarian economy into an industrialized one. Under this program a number of murals were commissioned for government buildings. Puerto Rico developed a strong graphic-arts tradition specializing in poster art, for which it became internationally recognized. In 1970 the Bienal del Grabado de San Juan (now Trienal Poli/Gráfica de San Juan) was initiated. Because of the island's conflicted relationship with the United States, Puerto Rican artists have tended to look toward Spain and other Hispanophone countries for cultural relationships.

Aside from Cuba, the Dominican Republic probably has the most active art scene in the Caribbean in terms of number of art galleries, curators, art collections, critics, and artists. Though it suffered from insularity during the dictatorship of Rafael Trujillo (1930–61), a period when traveling abroad

became very difficult, the Dominican art scene was also very European in orientation. In the late 1930s many Spanish Republican artists arrived and were protected by Trujillo although he was a close friend of the Spanish dictator Francisco Franco. These artists were the first directors and teachers of the Escuela Nacional de Bellas Artes, the first school of its kind in the Caribbean (today there is a second, private art school affiliated with the Parsons School of Design). The first national biennial in the Caribbean took place in the Dominican Republic in 1942, and the Museo de Bellas Artes was established the same year. In 1970 the Museo de Arte Moderno was opened with the collection of the Museo de Bellas Artes as its foundation. This collection essentially consisted of all the artworks that had won prizes in the national biennials.[25]

An important event on the Caribbean art scene has been the Santo Domingo Bienal del Caribe, which developed out of the national biennials held in the Dominican Republic. Early biennials were dominated by painting, but in 2001 the art event was transformed by the Museo de Arte Moderno's extremely youthful, Cuba-trained director, Sara Hermann, who pushed to have new media foregrounded. The jury included art personalities such as Nelson Herrera Ysla, one of the curators of the Havana biennial, and Alanna Heiss of P.S.1 Contemporary Art Center in New York. The Dominican Republic has several internationally connected galleries, and during the Santo Domingo international biennials, as in Havana, numerous parallel exhibitions have presented works by artists from the Hispanophone diaspora.

Private patronage of art in the Dominican Republic is robust compared to patronage in the Anglophone islands. Grupo León Jimenes instituted the León Jimenes Art Competition in 1961. Its art collection is housed in an elaborate, custom-built facility, Centro León, which is open to the public and includes a wide range of art, from objects made by the original inhabitants of the island, the Taino, to contemporary works in the latest media.

Throughout the Caribbean there has been a sustained tension between traditionalist artists, who felt that their mandate was to give visual form to the local, the indigenous, and the native, and modernists, who considered themselves internationalist in orientation and favored a more cosmopolitan, less parochial outlook. The former tended toward national themes, and toward realism and illusionism as preferred techniques of

image making; the latter preferred international styles such as Surrealism, Abstract Expressionism, and Minimalism, and in more recent times have been experimenting with the new media of installation, site-specific work, performance, and video.

The traditionalist-modernist dichotomy has resulted in interesting situations. For instance, in 1962 just after Trinidad's independence, an invitation to participate in the São Paulo Bienal in Brazil forced the Trinidadian art world to reconcile the "image for domestic consumption" and the "image for export."[26] Whereas the work of modernists was considered suitable for export, the traditionalists were favored for internal consumption. Prominence was given to the work of a traditionalist artist named Codallo, whose painting *Trinidad Folklore* depicted mythical figures and fantastical characters such as the Soucouyant and Papa Bois. Codallo's paintings, which expressed Trinidadian Creole traditions of the nineteenth century, were dismissed by the modernists, whose cosmopolitan taste was offended by these romanticized, bucolic images.[27]

Visual art in Jamaica, dominated by a high modernist outlook, is an interesting case study. Although politically an "open" society, Jamaica has produced one of the most insular and isolationist art scenes in the region. This is even more remarkable considering that official Jamaican art had always been modernist in orientation, with a curatorial elite in place since the seventies that had managed to contain and curb traditionalist tendencies. Yet even though there has been considerable investment by the state in institutionalizing art— including the creation of a national gallery and a state-funded school of visual art—the population at large has remained ignorant of and untouched by the artistic sphere. In part this is because visual art is, by its very nature, an elite activity in most societies. Cuba and Haiti are exceptional cases, where, for all the reasons discussed earlier, art is no longer the exclusive preserve of the middle and upper classes.

Because the curating elites in societies such as Jamaica's are usually so different in cultural, color, and class terms from the citizenry they supposedly represent, there is little or no common basis for dialogue or interaction between the two. In Jamaica, for example, there is quite a sharp and virtually unbridgeable divide between the formal public sphere, in which so-called Standard English is the official language, and the informal popular culture, in which Jamaican Patwa prevails. The visual-art scene in Jamaica has located itself exclusively in the formal sphere, with one concession—its strategic embrace of the popular (even if a rural, folkloric, and therefore limited conception of the popular) in the form of so-called intuitive art.

Consequently, visual art is constructed in Jamaica as a signifier of good taste, connoisseurship, civility, and refinement—a veritable bulwark against the incursions of the supposedly loud and cultureless mob perceived as threatening the hard-won gains of high art with its "vulgar" music and dance. In Jamaica the figure of the *buttoo* (Patwa for vulgar, tasteless, lower-class barbarian) is often mobilized to defend the art establishment's zealous patrolling of gallery walls and its rigid control over what gets designated art with a capital *A*.

It doesn't help that the spirit and language invoked are those of high modernism, an early twentieth-century paradigm developed in Europe and the United States, and superimposed on Caribbean reality regardless of fit. Thus, art discourse in Jamaica has a quaint and old-fashioned ring, with its heavy investment in notions of the artist as Romantic hero and heroic individualism; its insistence on the autonomy of art and art's ability to "speak for itself"; and its unquestioning belief in the aura of art objects and the avant-garde. This narrow interpretation of art and visual culture not only ignores the lay of the land locally; it also overlooks the vast changes occurring even in the art meccas held up as distant metropolitan ideals.

For in important art centers such as London, things have more than changed. In a keynote address to the "Museums of Modern Art and the End of History" conference given at the Tate Gallery in 1999, Stuart Hall noted that postmodernism built on and broke from modernism and "transformed it by taking it out into the world." As examples of the impulse of modernity within postmodernism, he cited the growing importance of the symbolic in contemporary life and "the proliferation of sites and places in which the modern artistic impulse is taking place, in which it is encountered and seen."[28] Modernism has escaped from the museum into the streets, according to Hall, exploding the symbolic, physical, and material limits within which practices of art and aesthetics used to be organized.[29]

One such site in Jamaica is its hyperfertile music scene, whose latest product, going by the generic name dancehall, represents a vernacular modern or vernacular cosmopolitanism in fundamental opposition to the delicately constructed high modernism of its art world (figs. 8, 9).

Fig. 8.
Peter Dean Rickards
*Macka Diamond*, 2005
Courtesy of the photographer

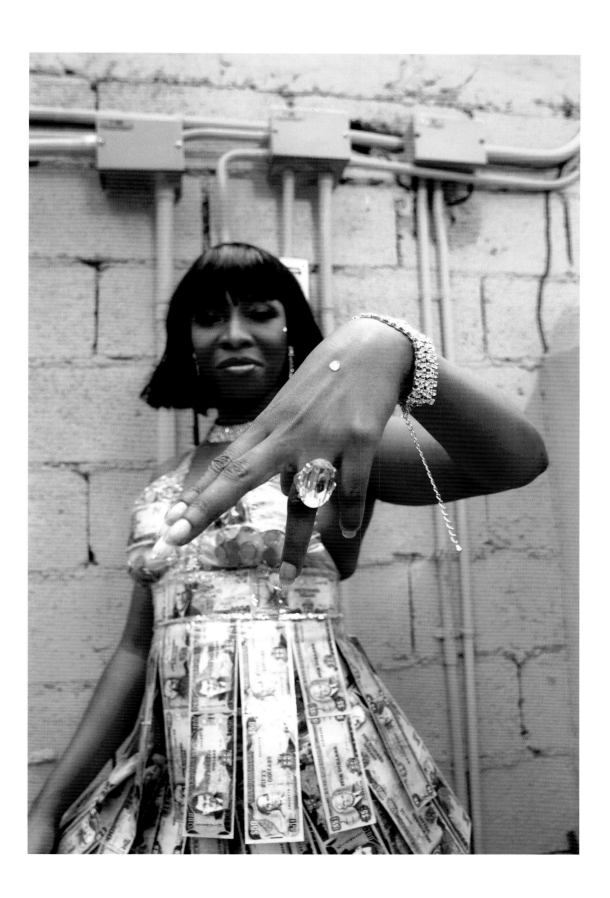

Modernism in the streets has produced vernacular moderns or popular moderns that cannot be discussed or understood in the critical language of high modernism. To put it another way, Jamaica's official art scene, with its formal English affect, will have to learn to communicate in Patwa, the vernacular language of the Jamaican street, if it wants to reach a wider public. It will have to become at least bilingual.

Caribbean popular culture, Jamaican music in particular, presents a transnational model that could fruitfully inform any cultural enterprise in the twenty-first century. For if the attempt at a federal union in the Caribbean was a failure, the impulse of the region's popular culture has been profoundly

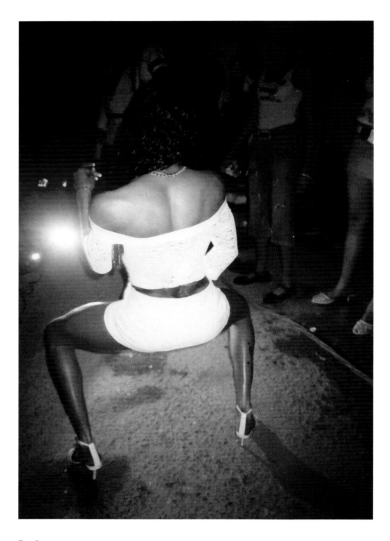

Fig. 9.
**Dancehall Queen**, 2004
(Photo: Annie Paul)

counternational, freely crossing national or even international borders. As Charles Carnegie notes in an insightful essay on Bob Marley, this popular culture has produced an "agile multivocality" and fluid "transnational cultural circuitry" that unite the region with its diasporas and far-flung audiences; along the way it has generated new publics as well. Terms such as "Jamaican music" are inadequate, Carnegie points out, for "[w]hile the music is rooted in the proverbial wit of the Jamaican peasantry, it links and articulates the rural directly with the urban and the transnational."[30]

How relevant, then, are constructs such as Puerto Rican or Cuban art, Trinidadian or even Caribbean art, in the twenty-first century? The region needs more than anything a post-national gallery—or a series of them—entities that mediate art in regional and transnational terms, providing artists in the Caribbean with wider publics as well as more immediate ones. The diaspora offers a wealth of resources that ought to be tapped. The many musical genres of the region—salsa, reggae, soca, dancehall, reggaeton, and others—have shown the way, creating alternative universal registers unforeseen by traditional modernism.

The Caribbean is striking in having produced subalterns, or members of the underclass, with distinctive and powerful voices of their own, whether expressed in painting and religion as in Haiti or music and dance as in Jamaica. Caribbean visual art cannot model itself on narrow modernist concepts and tropes without risking extinction. The region's vernacular moderns are self-representing subjects who demand engagement on their own terms, cultural citizens combining oral tradition with technological dexterity who spurn the meager opportunities offered by the Caribbean tourist industry and its postcolonial desti(nations) (figs. 10, 11). Visual art has much to learn from this vibrant region where sound sculpts new, unimagined communities from people once treated as property:

Marley's music echoed (and still does) across the borderlands. It cleared new paths and crossings, and still gives warning, vision, voice and hope. That the border zone is still an open frontier, unregulated, without overarching systems of meaning or democratic governance, and teeming with liminal confusions, does not imply that it always will be, nor that when the time comes the old hegemonies will necessarily set the grid for the new order.[31]

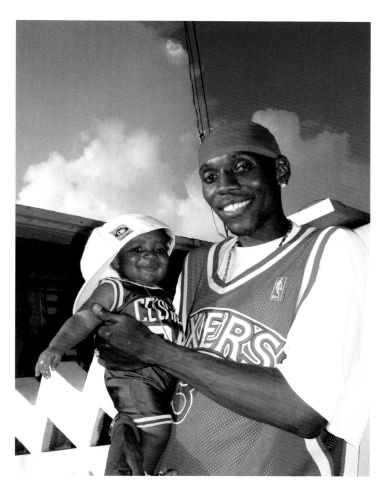 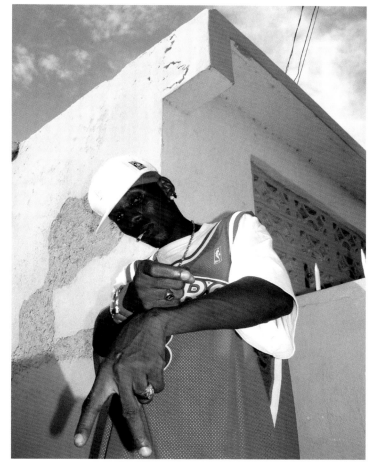

Figs. 10, 11.
Peter Dean Rickards
*DJ Vybz Kartel*, 2003
Courtesy of the photographer

NOTES

1  Center for New Crops & Plant Products, Purdue University, http://www
.hort.perdue.edu/newcrop/morton/pineapple.html.

2  C. L. R. James, *The Black Jacobins: Toussaint L'Ouverture and the San Domingo
Revolution*, 2nd rev. ed. (1938; repr., New York: Vintage Books, 1963), 3.

3  One might call it a signifying pineapple.

4  James Johnston, *Jamaica, the New Riviera: A Pictorial Description of the Island
and Its Attractions* (London: Cassell, 1903), 8.

5  Krista A. Thompson, "'Black Skin, Blue Eyes': Visualizing Blackness in
Jamaican Art, 1922–1944," *Small Axe* 16 (September 2004): 4.

6  Philip Olley, ed., "A Description of Jamaica and Its Dependencies," *Guide
to Jamaica, British West Indies, compiled and edited for the Tourist Trade
Development Board, Kingston, Jamaica, B.W.I.*, 3rd ed. ([Glasgow: Printed by
R. MacLehose, University Press], 1952), 15.

7  Thompson, "'Black Skin, Blue Eyes,'" 9.

8  Ibid., 10.

9  Quoted in Bruce Alvin King, *Derek Walcott: A Caribbean Life* (New York:
Oxford University Press, 2000), 75. Walcott was reviewing a show of St.
Omer, a close friend.

10  Edward Lucie-Smith, *Latin American Art of the 20th Century* (London:
Thames and Hudson, 1993), 69.

11  Maximilien Laroche, "The Founding Myths of the Haitian Nation," *Small
Axe* 18 (September 2005): 4.

12  Frantz Fanon, *The Wretched of the Earth*, preface by Jean-Paul Sartre, trans.
Constance Farrington (London: Penguin Classics, 1965; repr., 2001), 42–43.
Page citations are to the reprint edition.

13  Edouard Glissant, "Cross-Cultural Poetics," in *Caribbean Discourse: Selected
Essays*, trans. J. Michael Dash (Charlottesville: University Press of Virginia,
1989), 156.

14  Ibid., 155. Glissant's claim that this kind of painting is a visual
representation of Haitian Creole, that it speaks in Haitian as it were,
reminds me of a catalogue essay I once came across accompanying an
exhibition of Jamaican art that had a memorable typo in its text. A section
of the essay was intriguingly titled "From the Oral to the Scribble" (the
word processor's spellchecker having changed the word *scribal* to *scribble*).
Ironically, the altered phrase captured a prevalent and popular belief in the
inferiority of oral culture by suggesting that the written manifestation of the
oral was tantamount to a scribble.

15  Ibid., 157.

16  Quoted in Donald Cosentino, *Divine Revolution: The Art of Edouard Duval-
Carrié*, exh. cat. (Los Angeles: UCLA Fowler Museum of Cultural History,
2004), 22.

17  Anne Walmsley, *Art of the Caribbean* (Didcot, United Kingdom: Goodwill Art
Service, 2003), 4.

18  Luis Camnitzer, *New Art of Cuba* (Austin: University of Texas Press, 1994), 14.

19  Ibid., 5.

20  Hans Guggenheim, "Social and Political Change in the Art World of
Trinidad during the Period of Transition from Colony to New Nation,"
Ph.D. dissertation, New York University, 1968, 67.

21  Ibid., 74.

22  Ibid., 109.

23  Ibid., 52.

24  Caribbean Contemporary Arts, old site archives, "CCA," http://www.cca7
.org/cca.html (new site in preparation).

25  Writer and curator Alanna Lockward, personal communication.

26  Guggenheim, "Social and Political Change," 100.

27  Ibid., 78. Interestingly, Guggenheim noted that the figures Codallo painted
represented an oral tradition rather than a visual one. This would suggest
that he gave visual form to the characters populating the folk or popular
imaginary in much the same way as the painters of Haiti attempted in their
paintings to visualize their *loa* and other Vodun deities.

28  Stuart Hall and Sarat Maharaj, *Modernity and Difference*, ed. Sarah Campbell
and Gilane Tawadros, Annotations 6 (London: Institute of International
Visual Arts, 2001), 13.

29  According to Hall, "The break which modernism makes with representation
is so fundamental that I view postmodernism as the next turn in the cycle
of modernism. It's what happens in the aftermath of modernism, the
afterwash of modernism. It still has a lot of modernism secreted in it but it's
come out of the museum, it's come out of fine arts, it's come out. . . ." Annie
Paul, "The Ironies of History: An Interview with Stuart Hall," *IDEAZ* 3, nos.
1–2 (2004): 74.

30  Charles Carnegie, "Marley," in *The Future of Knowledge and Culture: A
Dictionary for the 21st Century*, ed. Vinay Lal and Ashis Nandy (New Delhi;
New York: Penguin, Viking, 2005), 173.

31  Ibid., 174.

# The Plates

Quotations from artists in the texts are from artist statements and correspondence with the curator.

A ☆ in the caption indicates that the work is included in the exhibition.

Measurements are in inches followed by centimeters; height precedes width precedes depth.

# Jennifer Allora and Guillermo Calzadilla

Based in Puerto Rico, the collaborative artists Jennifer Allora and Guillermo Calzadilla examine political and social issues of independence and control in an age of globalization. In their poetic and playful conceptual work, which includes video, film, performance, sculpture, and installation, they have treated subjects as diverse as the U.S. military's occupation of Vieques, Puerto Rico, and ecological damage in China. The artists occasionally collaborate with activist groups in their politically conscious work.

The duo's *Land Mark (Foot Prints)* project of 2001–2 was one such collaboration, undertaken with activists involved in the civil disobedience movement that ultimately forced the removal of the U.S. military from Vieques in 2003. Allora and Calzadilla designed rubber soles that were worn by protesters who trespassed at the military base in order to disrupt the testing of bombs and other weapons. The photographs in the series show the footprints left in the sand, juxtaposed with tire tracks, ripples formed by the tide, and sprigs of vegetation, compelling us to ponder our impact on the planet.

The video *Under Discussion*, 2005, returns to the situation in Vieques, where civic groups are demanding decontamination of the former military site and the return of the land to its original inhabitants. The video's protagonist, the son of a local fisherman who was involved with the civil disobedience movement in the 1970s, has converted an overturned conference table into a fishing boat that he navigates around the island, mobilizing discussion and turning the debate upside down, literally and figuratively.

ABOVE AND FOLLOWING PAGES
Jennifer Allora
(b. United States 1974; works in Puerto Rico)
and
Guillermo Calzadilla
(b. Cuba 1971; works in Puerto Rico)
☆ *Land Mark (Foot Prints)*, 2001–2
Chromogenic prints, each 20 × 24 in. (50.8 × 61 cm)
Courtesy of the artists and Galerie Chantal
Crousel, Paris

OPPOSITE
Jennifer Allora
(b. United States 1974; works in Puerto Rico)
and
Guillermo Calzadilla
(b. Cuba 1971; works in Puerto Rico)
☆ *Under Discussion*, 2005
Single-channel DVD, sound, 6 min. 14 sec.
Courtesy of the artists and Galerie Chantal
Crousel, Paris

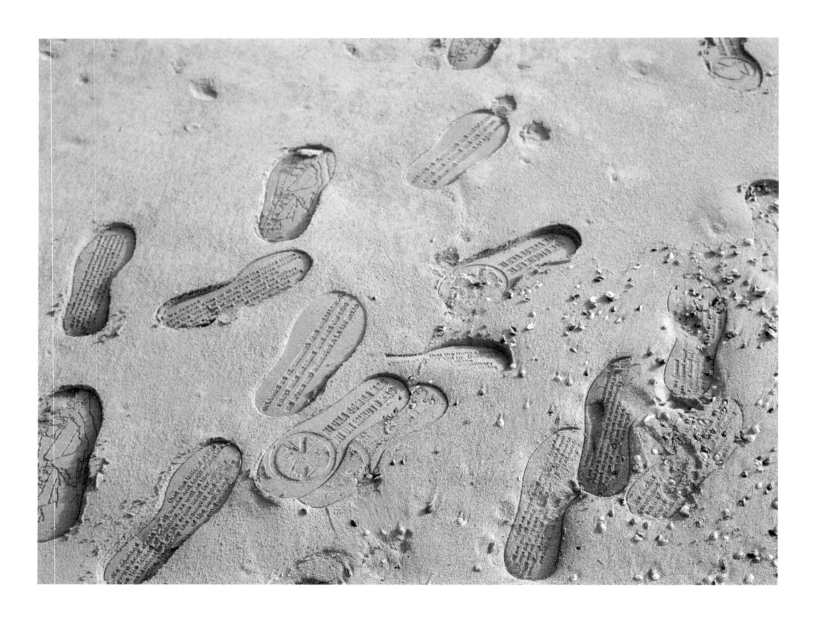

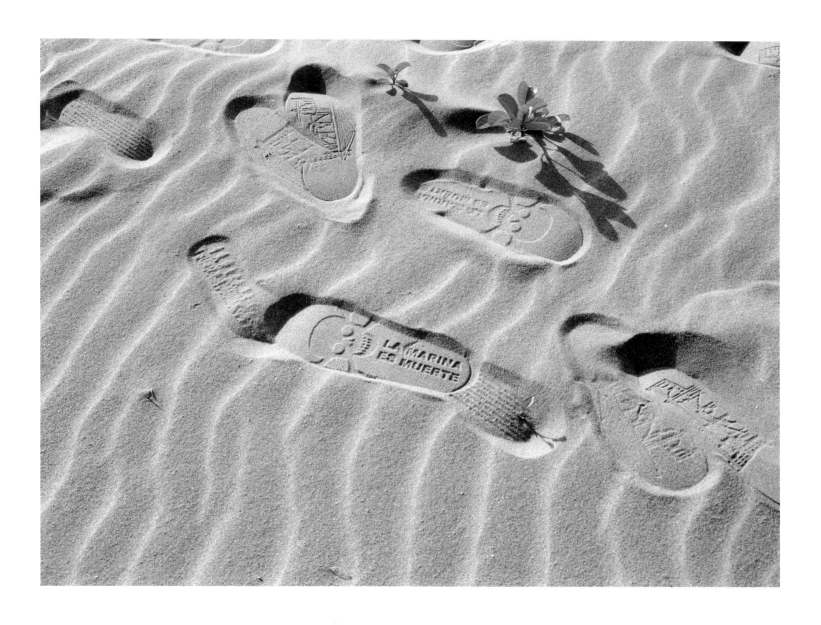

# Alexandre Arrechea

Alexandre Arrechea divides his time between his native Cuba and Madrid. His photographic series *Elementos arquitectónicos (Architectural Elements)*, 2004–5, plays with socialist propaganda's refrain of the "construction of a new society." The towering column of white brick in each image calls to mind the critical living conditions in Havana, a city of ruins and beautiful old buildings in states of decay whose signs of long neglect and damage are associated with the collapsing infrastructure. At the same time, the white column obstructs the body of the black figure, rendering it almost invisible— alluding to the racial inequality that persists in Cuba, as well as a sense of anonymity under a socialist regime. The figure lifts the seemingly monumental columns to suggest the fragile and heavy burden of the transformation of Cuban society. Like the shifting of tectonic plates in the earth's crust (alluded to in the title), this transformation is a constant process.

*Making Room*, 2004 (included in exhibition; not illustrated), again contrasts socialist ideals and realities. The video combines archival scenes of workers dismantling a police station during the early years of the Cuban Revolution with footage of the artist's recent travel to Havana dressed in six pairs of pants, to be given to friends coping with the scarcity of goods on the island.

In other work that includes painting and installations such as *The Garden of Mistrust*, 2005, Arrechea has tackled broader themes of surveillance and a controlled society.

Alexandre Arrechea
(b. Cuba 1970)
**The Garden of Mistrust**, 2005
Metal tree with white enamel paint,
surveillance cameras,
59 × 59 × 157 in. (150 × 150 × 400 cm)
Ellipse Foundation, Lisbon
(Photo: Gory)

Alexandre Arrechea
(b. Cuba 1970)
☆ *Elementos arquitectónicos I*
*(Architectural Elements I)*, 2004
Chromogenic print,
43¼ × 31½ in. (110 × 80 cm)
Courtesy of the artist and Magnan
Projects, New York

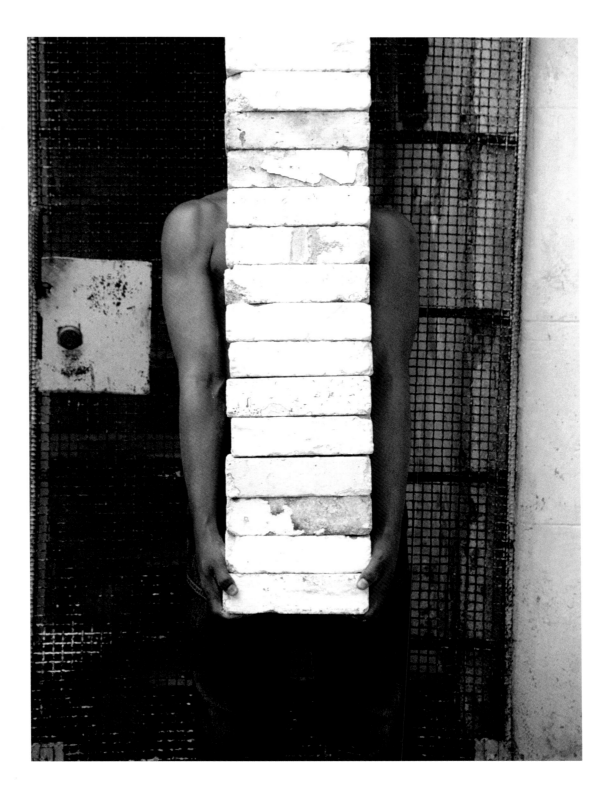

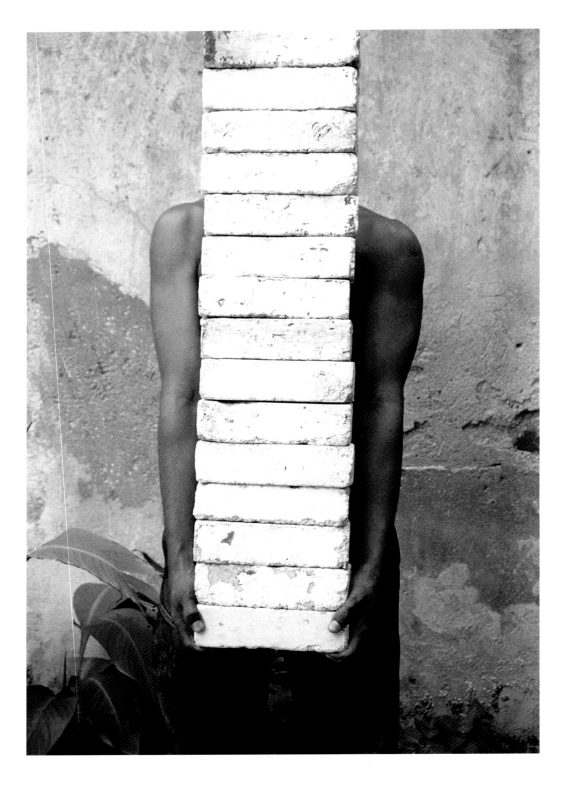

Alexandre Arrechea
(b. Cuba 1970)
☆ *Elementos arquitectónicos II
(Architectural Elements II)*, 2004
Chromogenic print,
43$^{1}/_{4}$ × 31$^{1}/_{2}$ in. (110 × 80 cm)
Courtesy of the artist and Magnan
Projects, New York

Alexandre Arrechea
(b. Cuba 1970)
☆ **_Elementos arquitectónicos III_**
**_(Architectural Elements III)_**, 2004
Chromogenic print,
43¹/₄ × 31¹/₂ in. (110 × 80 cm)
Courtesy of the artist and Magnan
Projects, New York

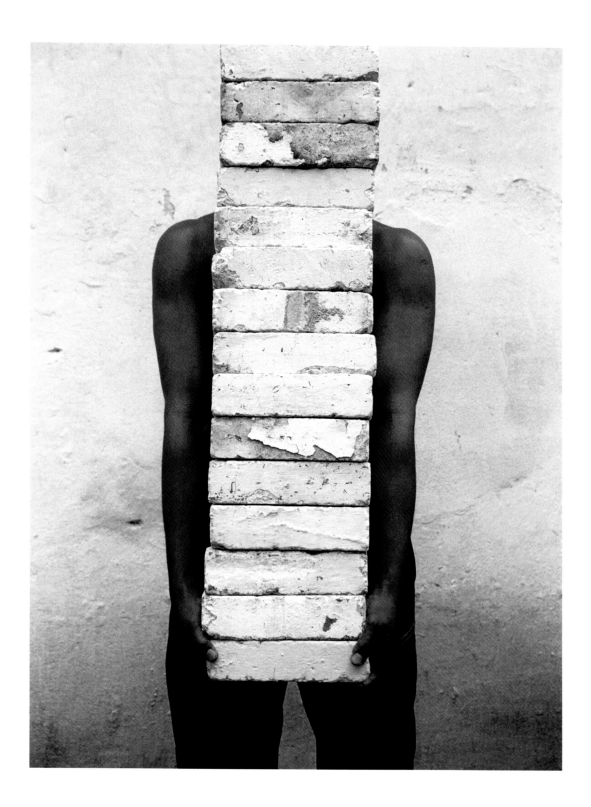

# Ewan Atkinson

A 2005 series in mixed media displays the inventiveness of Ewan Atkinson's installation, performance, and collage work. Like Alice in Wonderland, Atkinson places himself in the context of a smaller-than-normal world in which the English indoctrination of "high" morals, respectability, and reputation is questioned. The effort the artist makes to squeeze into spaces that re-create scenes from old school primers reflects the effort that Caribbean people make to fit into a society based on colonial values.

By including the textbook pages in the works, the artist underscores the effectiveness of colonial indoctrination. Like a model student, Atkinson acts out the role he sees in the textbook. The re-creation of the bathroom scene down to the reflection of the flower imagery on the wallpaper in the background shows the absurdity of following tradition blindly. As if searching the heavens for inspiration on how to deal with present-day dilemmas of identity, Atkinson looks up to a light that shines down on him like the spotlight on a stage. The stage metaphor is apt, for the artist is in fact acting out the role of the colonial subject. In other works in the series, he wears a schoolgirl's dress or uniform, suggesting the traditionally submissive female role. In these dramatizations, Atkinson pushes the limits of what is deemed acceptable behavior as well as demarcates new boundaries for interaction among the people of the Caribbean.

Ewan Atkinson
(b. Barbados 1975)
☆ *You Will Have to Use Soap*, 2005
Digital print and mixed media on printed textbook pages,
24½ × 16 in. (62.2 × 40.6 cm)
Collection of Judilee Reed,
Brooklyn, New York
(Photo: Courtesy of the artist)

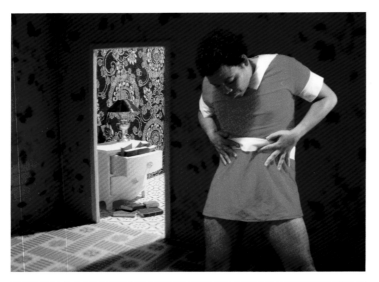

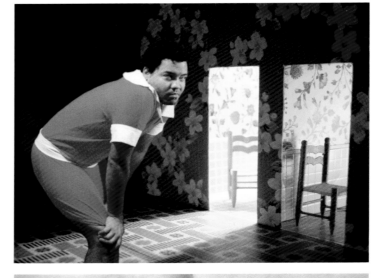

Ewan Atkinson
(b. Barbados 1975)
☆ *I Cannot Wear This Dress*, 2005
Digital print and mixed media on
printed textbook pages,
24½ × 16 in. (62.2 × 40.6 cm)
Collection of Judilee Reed,
Brooklyn, New York
(Photo: Courtesy of the artist)

Ewan Atkinson
(b. Barbados 1975)
☆ *Many Boys and Girls Live in Flats*,
2005
Digital print and mixed media on
printed textbook pages,
24½ × 16 in. (62.2 × 40.6 cm)
National Art Collection of Barbados
(Photo: Courtesy of the artist)

Ewan Atkinson
(b. Barbados 1975)
☆ *This Belongs to Me*, 2005
Digital print and mixed media on
printed textbook pages,
24½ × 16 in. (62.2 × 40.6 cm)
National Art Collection of Barbados
(Photo: Courtesy of the artist)

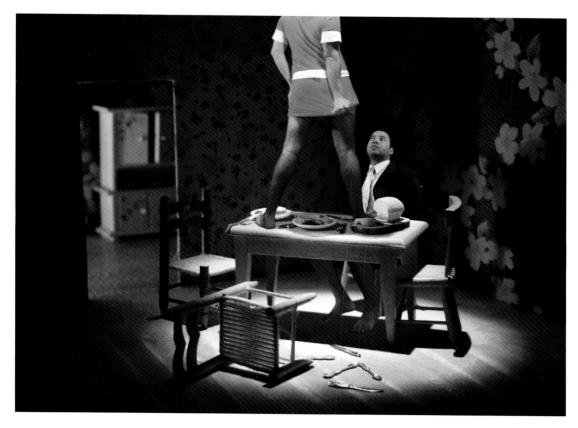

# Nicole Awai

Nicole Awai's drawings, paintings, photographs, and sculptures explore the struggle to transform and define a postcolonial society that combines multiple histories and perspectives. Using cultural artifacts including bottles, dolls, Tarzan action figures, religious ornaments, and birthday tiaras and infusing them with the language of blueprints and technical drawing, she creates metaphors and allegories of the constant flux, expansion, and contradictions of culture in a global society.

Her *Local Ephemera* series, featuring the adventures of a female character, began as sculpture but later moved into two-dimensional works. *Resistance with Black Ooze*, 2005, shows that character as half of a plantation mammy/mistress "topsy-turvy doll" whose two parts are engaged in struggle. Awai has said that the blob of black ooze between the two figures "represents a corrupting and healing force in history" and compares it to a pus that forms in the body to identify damage and begin the process of healing.

This primordial substance appears as white ooze in *Tension Springs*, 2004. Here the artist incorporates the mechanical device of the tension spring to evoke human interaction and history in a constant state of expansion and contraction, flux, and re-formation. The shapes in the ooze intersect and seem to blend many human elements, while the outstretched arms grasp the tension springs as if life depended on them.

*Bikini Beach: Balandra*, 2006, belongs to a photographic series in which Awai explores personal history and memory. The bikini in the foreground is lined with images of the artist at age five wearing a similar bathing suit on the same beach in Trinidad.

Nicole Awai
(b. Trinidad 1966;
works in United States)
☆ ***Specimen from L.E. (Local Ephemera): Resistance with Black Ooze***, 2005
Graphite, acrylic paint, nail polish, and glitter on paper,
52 × 58 in. (132.1 × 147.3 cm)
Courtesy of the artist
(Photo: Jason Mandella)

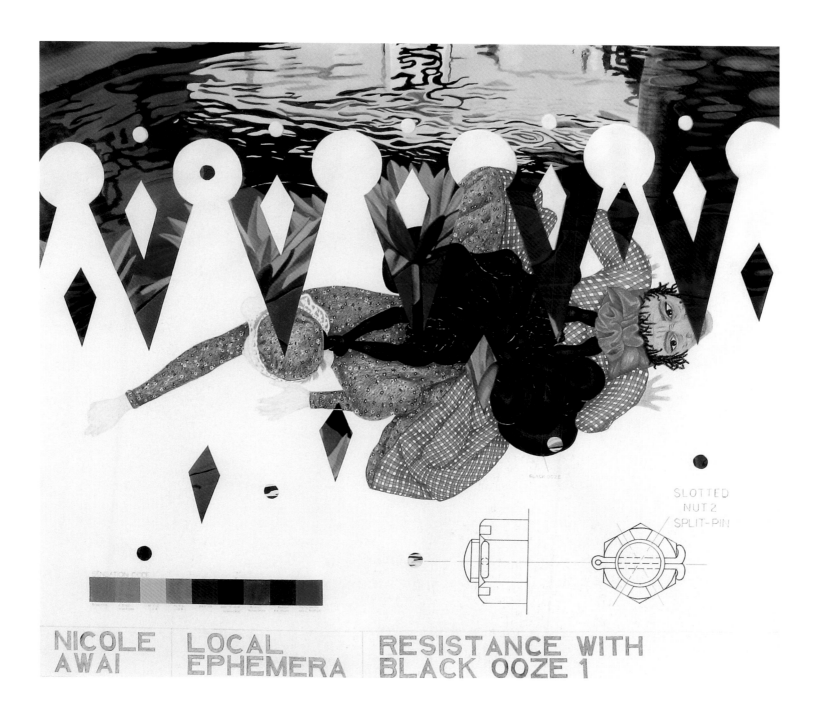

NICOLE AWAI | LOCAL EPHEMERA | RESISTANCE WITH BLACK OOZE 1

Nicole Awai
(b. Trinidad 1966;
works in United States)
**Bikini Beach: Balandra**, 2006
Chromogenic print,
16 × 20 in. (40.6 × 50.8 cm)
Courtesy of the artist

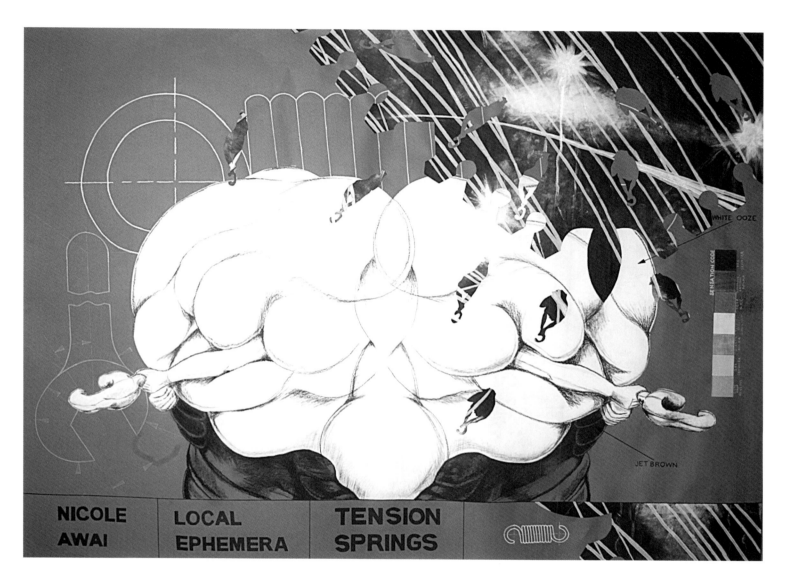

Nicole Awai
(b. Trinidad 1966;
works in United States)
☆ *Specimen from L.E. (Local Ephemera):*
*Tension Springs*, 2004
Graphite, acrylic paint, nail polish,
and glitter on paper,
53 × 72 in. (134.6 × 182.9 cm)
Courtesy of the artist
(Photo: Jason Mandella)

# Mario Benjamin

Mario Benjamin began his career as a successful portraitist and photo-realist painter. He subsequently rejected this mimetic work, which he had come to view both as an endorsement of the bourgeois power base of Haitian politics and finance and as a reflection of the traditionalism that had relegated folkloric Haitian art to a position of creative stasis. Since his rejection of hyperrealism, Benjamin has begun drafting an alternative visual language for Haitian art through painting, sculpture, and installation work that consistently subverts imposed stereotypes of Haitian visual expression. To undermine the Western "anthropological gaze" that dismisses Haitian art and culture as naïve and unchanging, he says that he examines the creolization of Haitian culture as it absorbs influences from outside its borders. Benjamin's installations are constructions illuminated within dark space in which a combination of recognizable fragments, unidentified objects, and photographic and video images projected on a variety of surfaces create an ambivalence of perception that visualizes the artist's own "cosmic understanding of reality" and challenges the viewer's perception of reality in Haiti and elsewhere.

*The Oratory Chamber*, 2001, questions preconceived notions of Vodun as it is practiced in Haiti, addressing the tension between modernity and tradition. The installation consists of two massive neon light boxes covered in a grid of transparent and layered images of a doll. The boxes suggest the Vodun chapel, and the hazy, undefined image of the doll calls to mind the spiritual powers of transcendence harnessed within Vodun. This doll is not a religious object, however, and the replication of its image as wallpaper on the two boxes reduces and undermines the potency associated with the singular iconic image in Vodun. The religious practice of Vodun is presented here as existing within contemporary time, negotiating with modernity and dealing with the results of this interaction, both positive and negative.

In *Untitled*, 2003, images from present-day North American television shows are projected through the plastic material of a seashell-printed tablecloth of the sort commonly sold in Haiti, while a combination of sound from the television images and a recording of urban sounds from Port-au-Prince serve as the soundtrack. In this installation, Benjamin again creates an environment that illustrates the creolization of Haitian culture in its combination of global influences, "naïve" images of Haitian artistic expression, and active and turbulent sounds of Haitian life. It thereby subverts ideas of Haitian developmental stasis and defies simplistic and fixed conceptions of Haitian culture and its artistic production.

The artist will create a new work for *Infinite Island: Contemporary Caribbean Art*.

Mario Benjamin
(b. Haiti 1964)
*Untitled*, 2003
Printed plastic canvas, televised projected images, mirrors, and sound track,
29 ft. 6 in. × 29 ft. 6 in. × 9 ft. 10 in. (9 × 9 × 3 m)
Installation at Museum of Contemporary Art, Miami
(Photo: Tim McCaffee)

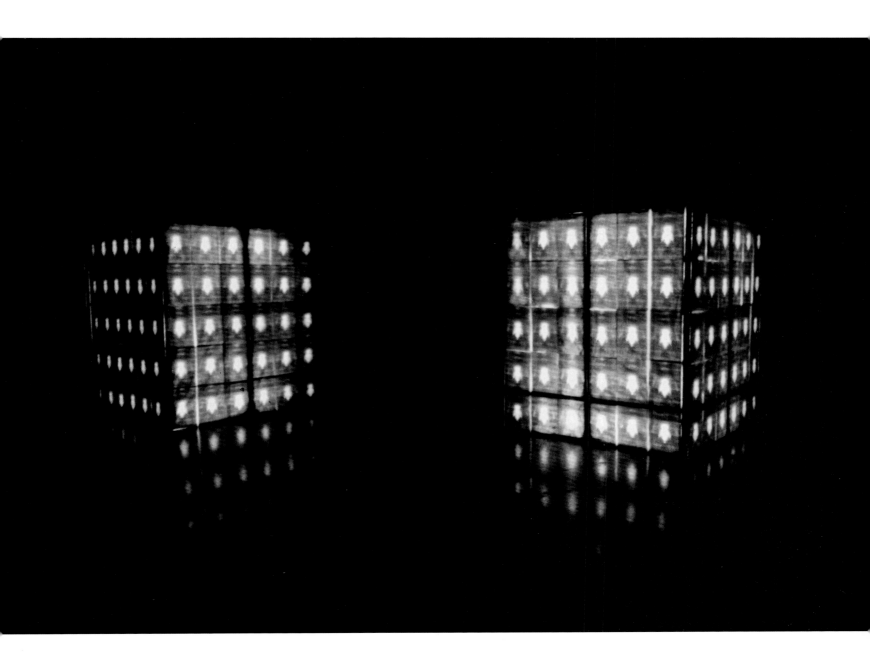

OPPOSITE AND ABOVE
Mario Benjamin
(b. Haiti 1964)
*The Oratory Chamber*, 2001
Two cubes with photocopies on tracing
paper, muslin, and neon,
each cube 78 ¹/₄ in. × 78 ¹/₄ × 78 ³/₄ in.
(200 × 200 × 200 cm)
Installation at Bienal del Caribe, Santo
Domingo
Museo de Arte Moderno, Santo Domingo
(Photo: Miguel Gomez)

# Terry Boddie

Terry Boddie works in the photographic medium, yet at times he blurs the lines separating it from other media by manipulating his photographs with ink, charcoal, oil stick, graphite, and other materials. He is particularly intrigued by the way personal and collective memory participates in the construction of history, a theme that he suggests by combining historical photographs with new photographic images and mixed media.

In two works of 2002, Boddie explores the established historical record of the African diaspora through voluntary and forced migration and the way these issues are recalled individually and en masse in textbooks and popular media. *Blue Print* shows a plan of a cargo slave ship as if the tin cover of a can of sardines had been pulled back to reveal the neat lineup of fish inside. Boddie juxtaposes this mass of bodies evoking the trauma and violence of the Middle Passage with a modern image of a row of buildings suggesting the overcrowded, grim living conditions of many minority communities. Boddie says this layering of imagery "implies the accretion of history and memory, as well as the competition between 'subjective' and 'objective' voices for narrative space"— referring to the contrast between the "subjective" views of those affected by the legacy of slavery and the "objective" views of established stories sometimes printed as truth in books.

These two voices are again represented in the layering of photographic images in *Stars and Stripes*. The stars of the flaglike image are made from historical photographs of slaves; the stripes, in the form of whips, are composed of grains of salt and pepper, substances that were rubbed into slaves' wounds after whippings to inflict greater pain. The work points to the fact that America continues to be built on the backs of immigrants, regardless of their ethnicities, although many minorities remain powerless or voiceless in their new country.

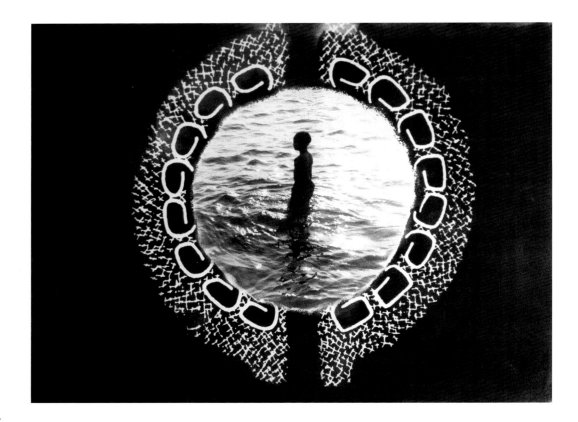

Terry Boddie
(b. Nevis 1965;
works in United States)
***Latent 2***, 2003
Gelatin silver emulsion and
pastel on paper,
22 × 30 in. (55.9 × 76.2 cm)
Courtesy of the artist

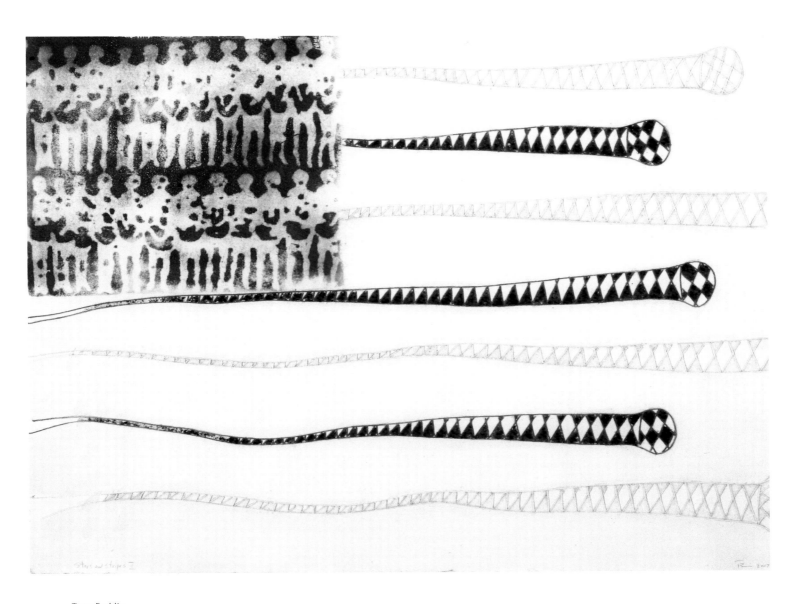

Terry Boddie
(b. Nevis 1965;
works in United States)
☆ **Stars and Stripes**, 2002
Gelatin silver emulsion, string, ink,
salt, and pepper on paper,
22 × 30 in. (55.9 × 76.2 cm)
Courtesy of the artist

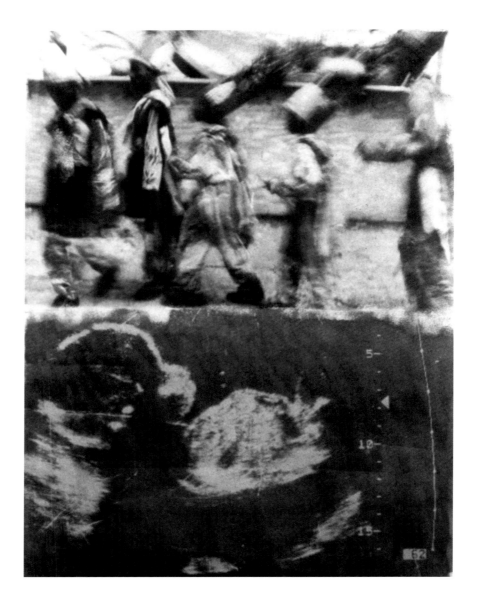

Terry Boddie
(b. Nevis 1965;
works in United States)
*Stasis (Alpha)*, 2003
Gelatin silver emulsion on paper,
30 × 22 in. (76.2 × 55.9 cm)
Courtesy of the artist

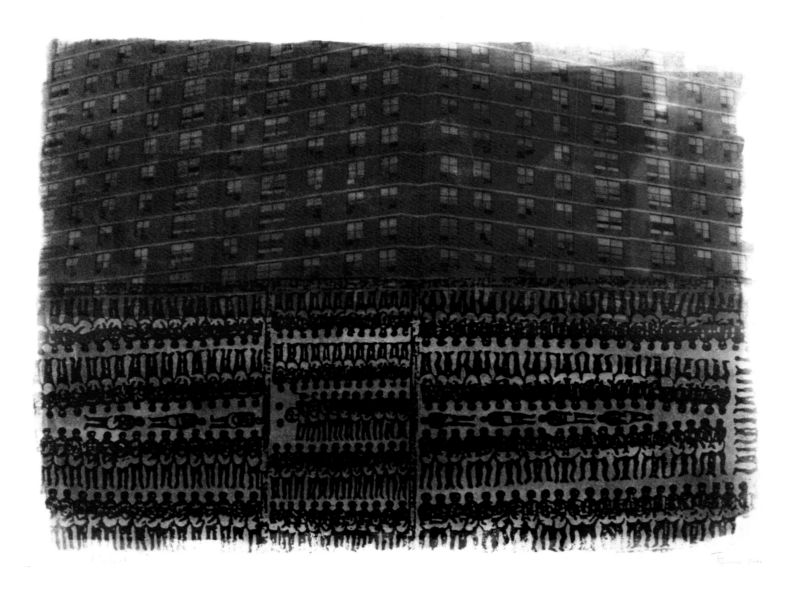

Terry Boddie
(b. Nevis 1965;
works in United States)
☆ **Blue Print**, 2002
Gelatin silver emulsion on paper,
22 × 30 in. (55.9 × 76.2 cm)
Courtesy of the artist

# Alex Burke

Before making *Les otages (The Hostages)*, 1999–present, Alex Burke sent one thousand envelopes throughout the Americas with drawings of Gorée Island, Senegal, one of the main slaveholding sites in West Africa. He used these envelopes for his drawings of featureless black figures that seem oppressed by poverty and hunger, their individuality sucked from them. Burke says that the envelope "is charged, it is the vehicle of a human story, it is displacement, migration, a change of geographic space, . . . it is exile."

Les otages, with *Vue de l'atelier (View from the Studio)*, is part of a larger installation in which the black forms drawn crudely on brown envelopes are combined with human-size forms mummified in colorful scraps of used cloth from different parts of the world. Appropriating the mythology of the "voodoo doll," the artist evokes ways that oppression and hardship take the living hostage in the globalized world, transforming them into zombies, the living dead.

In *The Spirit of Caribbean*, 2006, the numerous dolls are also wrapped up in cloth, but price tags hang from them and some are bound with rope and string. Here the evocation of slavery is strong, and the symbols of slavery are starkly portrayed throughout the installation, in which the figures stand as if on an auction block. The imagery of Vodun, where dolls become the embodiment of the invisible spirit, is also present in this and other work by Burke. This religion, repressed by the ruling class, has acted as a vehicle of resistance, offering many consolation by providing a way to preserve cultural practice and transcend physical oppression. Vodun is also a symbol of what has survived the violence of slavery.

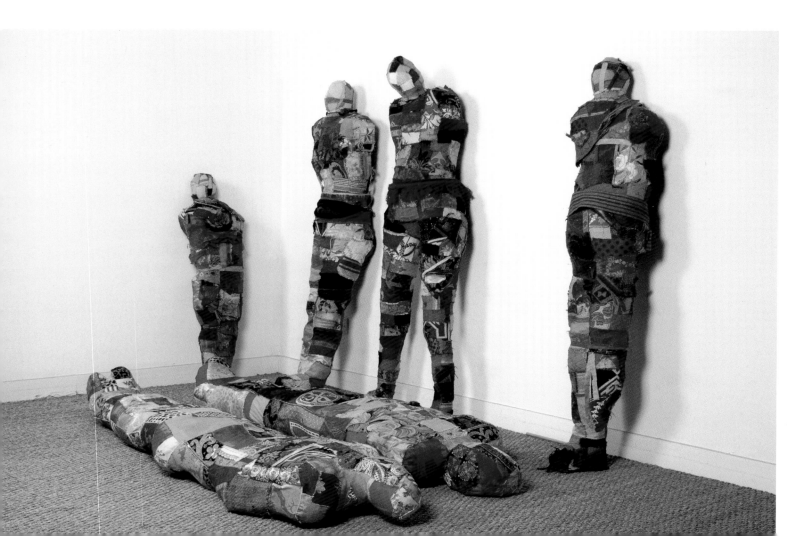

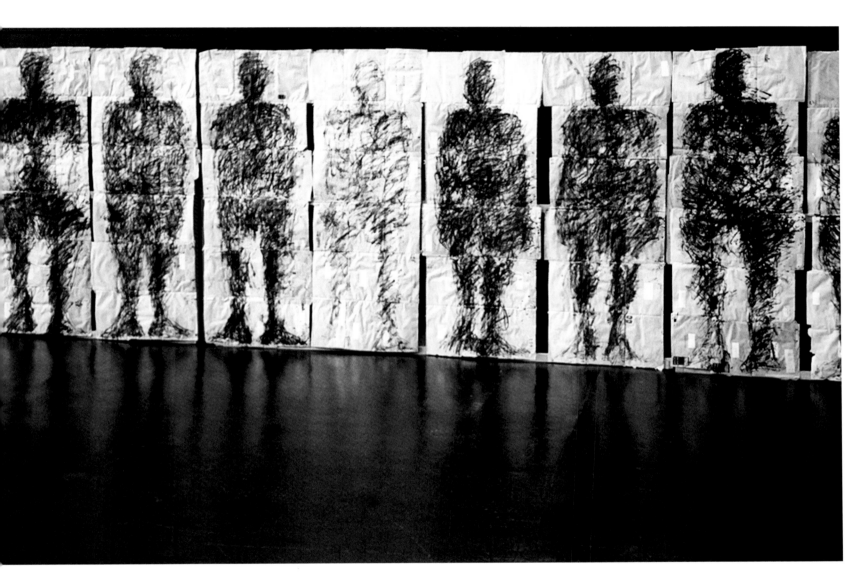

Alex Burke
(b. Martinique 1944;
works in France)
*Les otages (The Hostages)* (detail),
1999–present
Black stone on paper, each drawing
$73^5/8 \times 29^1/2$ in. (187 × 75 cm)
Courtesy of the artist
(Photo: Franck Girier Du Fournier)

OPPOSITE
Alex Burke
(b. Martinique 1944;
works in France)
*Vue de l'atelier (View from the
Studio)*, 2005–6
Mixed media, dimensions variable
Installation in the artist's studio
Courtesy of the artist
(Photo: Jean François Bocie)

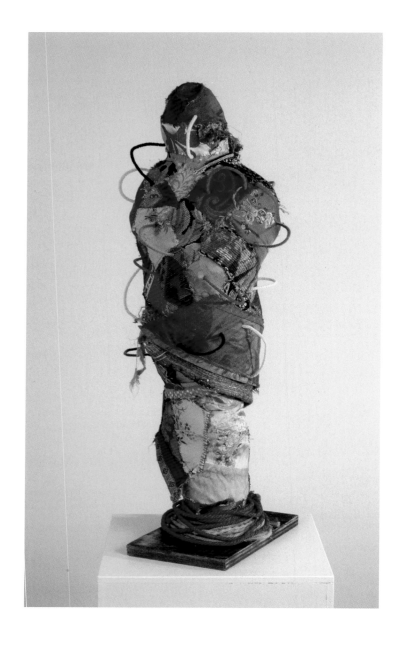

Alex Burke
(b. Martinique 1944;
works in France)
*Untitled*, 2006
Fabrics and other materials,
24³/₄ × 7⁷/₈ × 9⁷/₈ in. (63 × 20 × 25 cm)
Courtesy of the artist

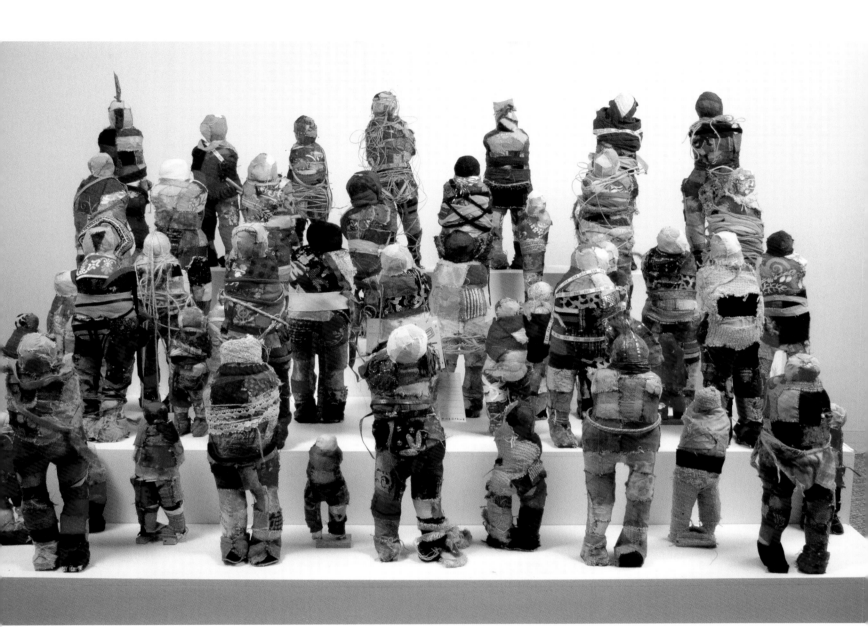

Alex Burke
(b. Martinique 1944;
works in France)
☆ *The Spirit of Caribbean*, 2006
Forty-seven dolls made of various
fabrics and other materials,
dimensions variable
Courtesy of the artist
(Photo: Franck Girier Du Fournier)

# Javier Cambre

Javier Cambre's work is informed by a sensibility that is at once Puerto Rican, American, and European. He says that his sculptural collages, photography, and film, sometimes made in collaboration with a musician, "deal with the passage of time, memory, reality, and desire, hinting at an irresolute yet ironic perception of the human condition after modernism and its reevaluations."

The video *Cerca a la Puerta del Sol (Near the Puerta del Sol)*, 2005, captures the marginalized life of Madrid's prostitutes, homeless, and Roma (Gypsies)—people who are considered undesirable and invisible to society. Cambre's camera puts his subjects, often female, into the center of our focus, while shoppers and workers pass by, oblivious to them. Employing a mixture of music, sound disruptions, and pregnant silences, Cambre presents an almost Goyaesque view of Madrid in the twenty-first century that is by turns detached, curious,

or ironic. He intermittently highlights the angels from the monument in the square—including the fallen angel, Lucifer—ambiguously juxtaposing them with the human scene below.

In the video *Glass House Cinema*, 2004, the seemingly aimless wanderings of a female architecture student in a Universidad de Puerto Rico building designed in the 1960s by Heinrich Klumb are reflected onto a transparent Plexiglas box. Cambre originally trained as an architect, and his modernist glass box alludes to the utopian ideals of the tropical modern architectural style of the fifties and sixties. The female student's wanderings in the university building, intercut with archival images of protests and other violence at the university in 1971, inject a mood of melancholy and nostalgia at what the artist sees as the ruins of the original utopian ideals of modernist architecture.

Javier Cambre
(b. Puerto Rico 1966; works in United States))
**Glass House Cinema**, 2004
Plexiglas, video projection,
32 × 38 × 72 in.
(81.3 × 96.5 × 182.9 cm)
Courtesy of the artist

Javier Cambre
(b. Puerto Rico 1966; works in
United States)
☆ *Cerca a la Puerta del Sol
(Near the Puerta del Sol)*, 2005
Single-channel DVD,
color, sound, 6 min. 50 sec.
Courtesy of the artist and Galeria
Comercial, San Juan

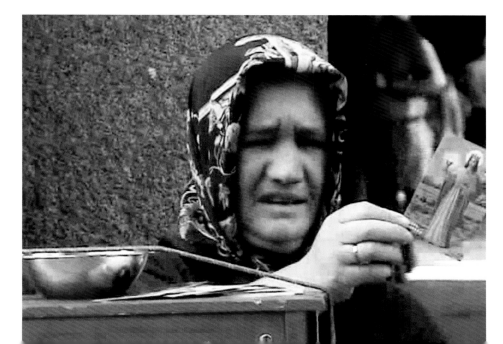

# Charles Campbell

Charles Campbell's repertoire of skills includes painting, installation, performance art, sound, and video. He employs the language of geometric pattern, symmetry, and abstract repetition of form, not only in subjects drawn from nature such as the ocean and birds in flight, but in his seemingly contradictory "mandala" images that refer to the trauma of the Middle Passage.

In *Untitled (Hexagon)*, 2005, he repeats and rotates the image of a slave ship to create a hexagonal pattern in the tradition of the Hindu and Buddhist symmetrical cosmic diagrams called mandalas. *Middle Passage Mandala*, 2005, creates a pattern from figures that suggest the human cargo of the slave ships, while *Maroon Mandala*, 2005, contains fragments of shackle-like forms. Campbell deliberately charges these works with a tension between the violence and suffering associated with slavery, on the one hand, and the harmony, enlightenment, and healing represented by the mandala, on the other, in order to (in his words) "produce enigmas out of mere paint and canvas." At the same time, the way to reconciling the two opposing forces perhaps lies in confronting the past in an effort to transcend it, and Campbell's own mandalas can be said to do just this.

The artist will create a new work for *Infinite Island: Contemporary Caribbean Art.*

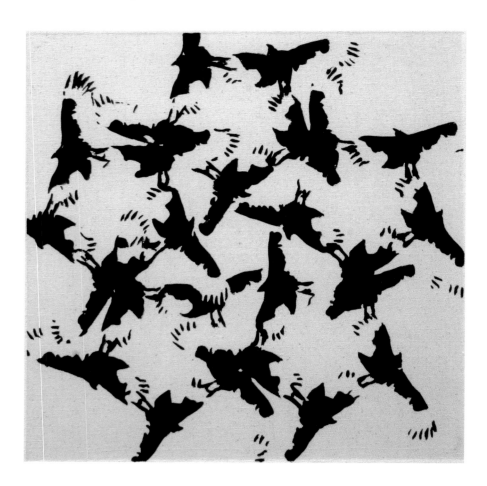

Charles Campbell
(b. Jamaica 1970; works in Canada)
***John Crow Circles***, 2005
Oil and vellum on canvas,
18 × 18 in. (45.7 × 45.7 cm)
Courtesy of the artist and Mutual
Gallery, Kingston, Jamaica

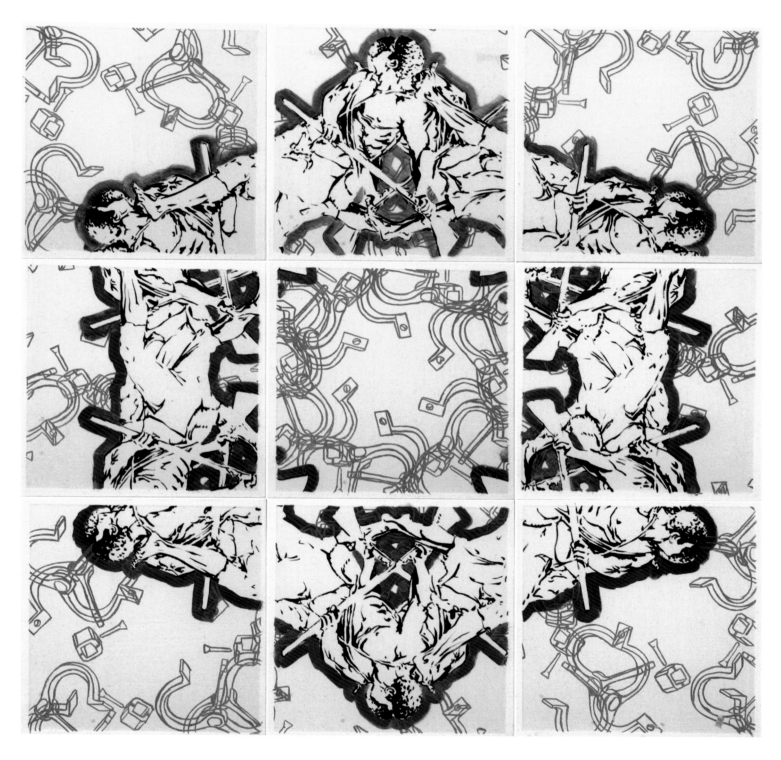

Charles Campbell
(b. Jamaica 1970; works in Canada)
*Maroon Mandala*, 2005
Oil and vellum on canvas,
48 × 48 in. (121.9 × 121.9 cm)
Courtesy of the artist and Mutual
Gallery, Kingston, Jamaica

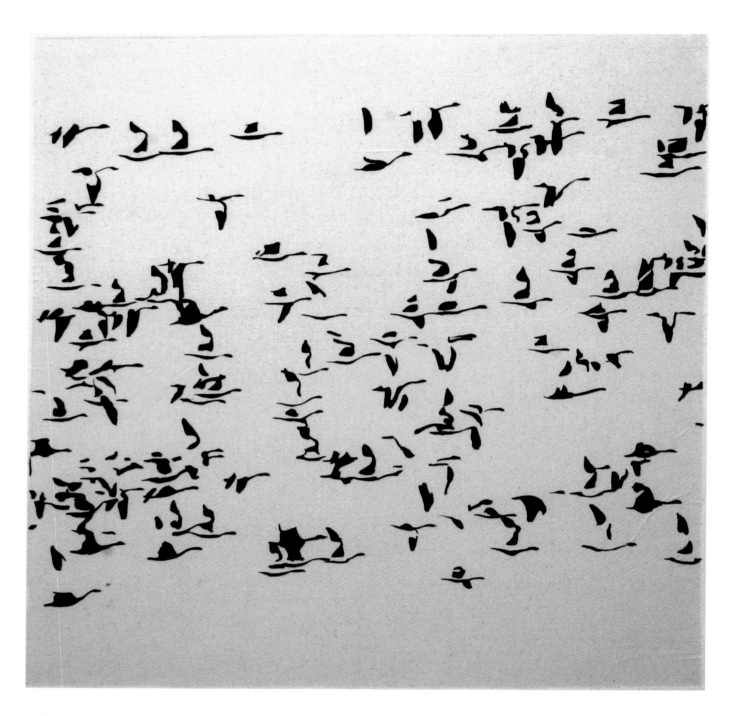

Charles Campbell
(b. Jamaica 1970; works in Canada)
*Flock-Flight*, 2005
Oil and vellum on canvas,
36 × 36 in. (91.4 × 91.4 cm)
Courtesy of the artist and Mutual
Gallery, Kingston, Jamaica

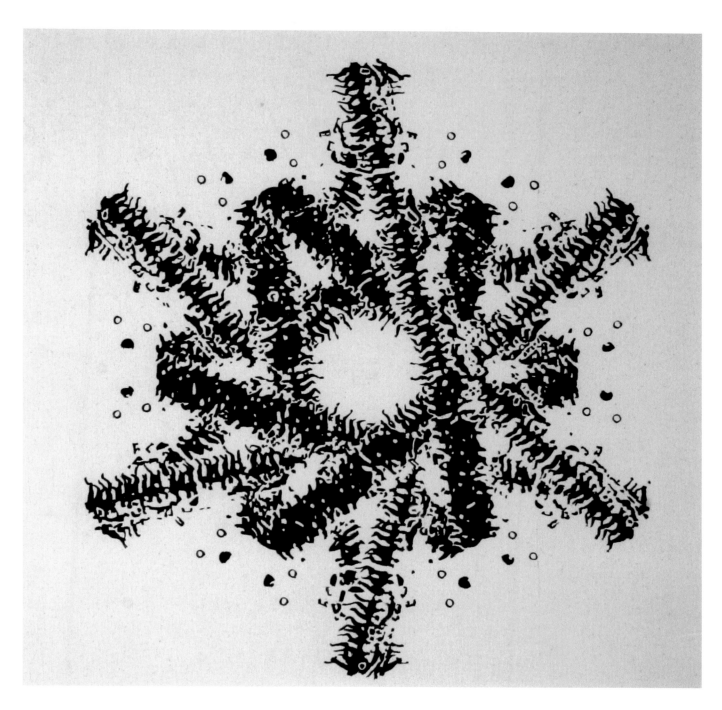

Charles Campbell
(b. Jamaica 1970; works in Canada)
*Middle Passage Mandala*, 2005
Oil and vellum on canvas,
36 × 36 in. (91.4 × 91.4 cm)
Courtesy of the artist and Mutual
Gallery, Kingston, Jamaica

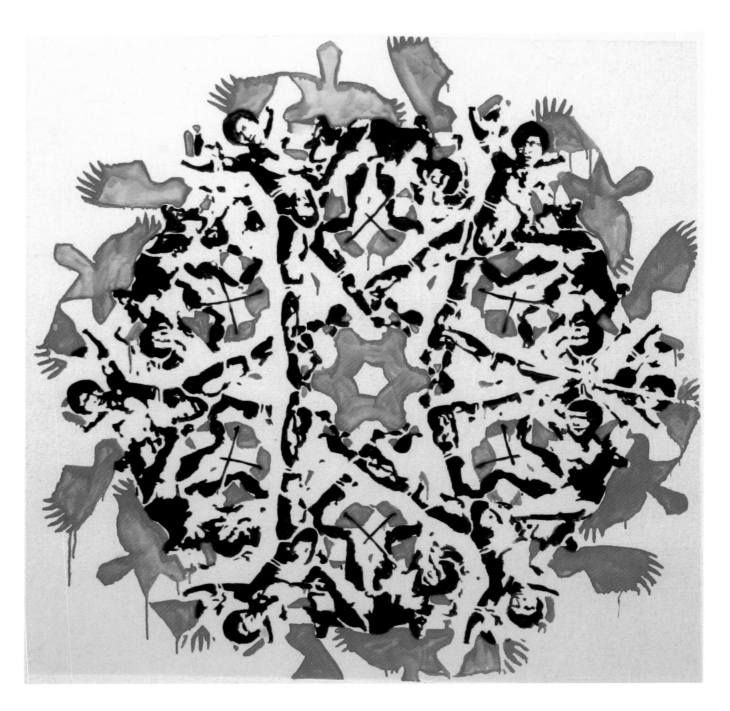

Charles Campbell
(b. Jamaica 1970; works in Canada)
*Jamaican Icarus*, 2005
Oil and vellum on canvas,
36 × 36 in. (91.4 × 91.4 cm)
Courtesy of the artist and Mutual
Gallery, Kingston, Jamaica

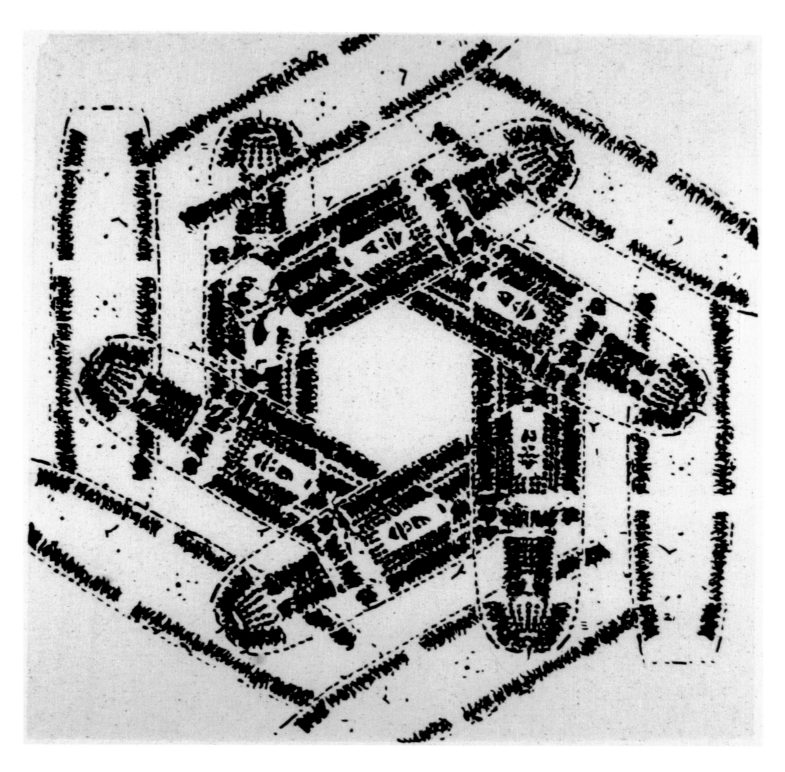

Charles Campbell
(b. Jamaica 1970; works in Canada)
*Untitled (**Hexagon**)*, 2005
Oil and vellum on canvas,
18 × 18 in. (45.7 × 45.7 cm)
Courtesy of the artist and Mutual
Gallery, Kingston, Jamaica

# Keisha Castello

Inspired by nature, Keisha Castello creates compelling assemblages of new and beautiful hybrid forms from found objects such as fish bones, crab shells, feathers, insects, leaves, and dried lizards. Boxed like natural-history specimens, the creatures of *Hybrid Realities*, 2005, give new life to dead and decaying organic matter while expressing the impermanence of life and its natural cycle from birth to death. Drawing the shadow of each hybrid creature in chalk on blackboard or brown wood and employing muted brown and ocher tones that convey a subdued emotional content, Castello drives home the theme of impermanence.

The artist's hybrid "realities," which she says are very personal, play with notions of identity and self-definition. The concept of hybridity has particular resonance in the changing and mixed cultural environment of the Caribbean, where it extends to race, geographical origin, language, and the ongoing process of cultural convergence and transformation. Castello's boxed specimens can be seen to defy classification while establishing their own new reality.

OPPOSITE AND FOLLOWING PAGES
Keisha Castello
(b. Jamaica 1978)
☆ *Hybrid Realities* (details), 2005
Thirteen wooden boxes with
assembled found objects,
each 10 × 10 in. (25.4 × 25.4 cm)
The National Gallery of Jamaica,
Kingston

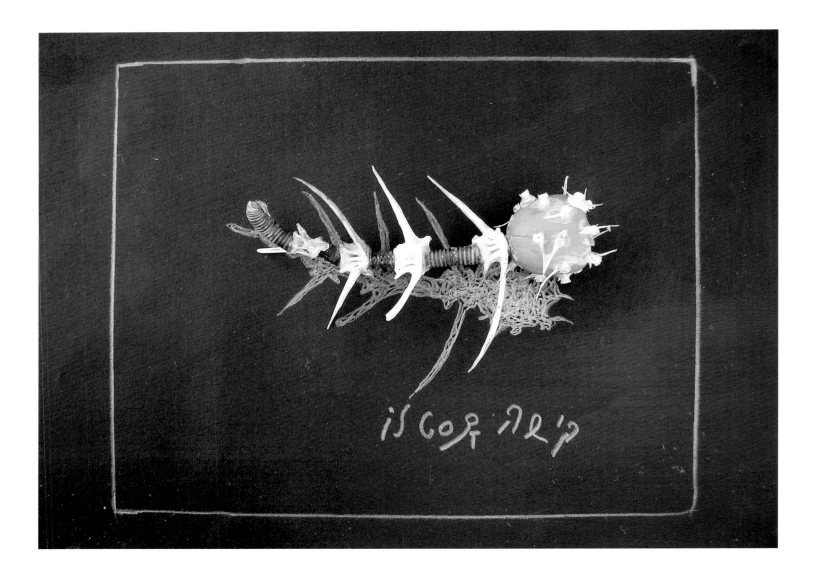

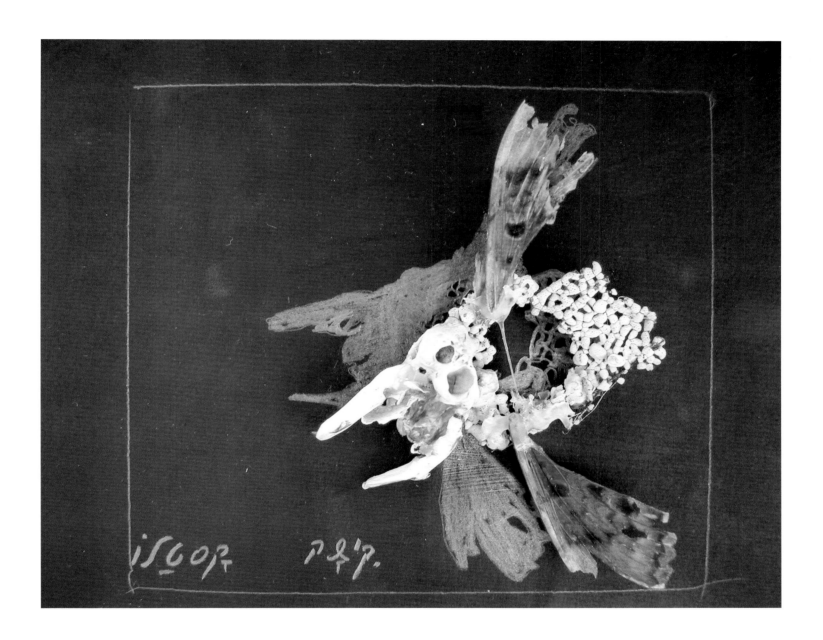

# Liset Castillo

The works in Liset Castillo's *Departure Point* series, 2003, are chromogenic prints of constructs that she creates from sand, water, pigment, and other materials. The photographs are documentations of impermanent structures—the artist's commentary on the transience of life and humankind's constructions on earth.

Beginning with images and plans of highways, suburbs, and other human settlements that she researches on the internet, Castillo interprets and adapts the images in three dimensions, producing large-scale sand sculptures, which she then photographs. The "departure point" of the title alludes to a journey through which humans travel, both physically (on highways like ones we see reflected in Castillo's constructions)

and metaphorically (in terms of evolution). The artist suggests that the effects of time and nature work to destroy the constructs of civilization.

In other work Castillo has created mazes out of sand, painted the sand green to suggest the greenery of suburbs, and drawn white lines on the sand to create a housing plan. The orderly nature of the lines of the drawing and constructs contrasts with the essential chaos that underpins the universe. In addition, the cold lines of Castillo's structures reflect the lifelessness of these environments and describe the alienation of the human beings who inhabit these spaces. This mood is reinforced by the often-bare landscape of the scenes as well as each print's fragmentary view of the whole construction.

Liset Castillo
(b. Cuba 1974; works in United States)
☆ *Departure Point*, 2003
Chromogenic prints,
each 49½ × 65 in. (125 × 165 cm)
Courtesy of the artist and Black &
White Gallery, Brooklyn, New York

# Colectivo Shampoo

The group Colectivo Shampoo is made up of illustrators, architects, graphic designers, photographers, writers, and artists in the Dominican Republic. Constantly looking for new talent to add to its already powerful collective, the multidisciplinary group advocates for public art. The lack of public access to art and artists has prompted the members of the collective to seek alternative ways of showing their work, using the everyday language of advertising to reach a larger audience for its art projects and building community around issues that affect all the inhabitants of the island.

The project *D' La Mona Plaza (The Mona Mall)*, 2004, which examines the plight of the hundreds of people who make the perilous illegal crossing at Mona Passage from the Dominican Republic to Puerto Rico each year, uses irony to show the danger and tragedy of this desperate attempt to find a better life. The artists developed plans for an imaginary rest stop between the two islands that might offer a respite during this journey. Modeled on the *paradores* for travelers along the Dominican highways, the imaginary plaza on the sea contains shopping malls, eateries, bathrooms, and even a lookout.

More recently, the collective has embarked on a project called *Guagua Tap-Tap*, 2006, taking its title from the Dominican *guagua* and the Haitian *tap-tap*, vehicles used (especially by Haitians) for travel between the two countries. Artists from different disciplines traveled between Santo Domingo and Port-au-Prince, visiting urban and rural locales along the way to explore differences and commonalities between the two countries and their people.

Colectivo Shampoo
(Dominican Republic)
☆ *D´ La Mona Plaza*
*(The Mona Mall)* (details of
architectural renderings), 2004
Inkjet prints,
each 40 × 40 in. (101.6 × 101.6 cm)
Courtesy of the artists

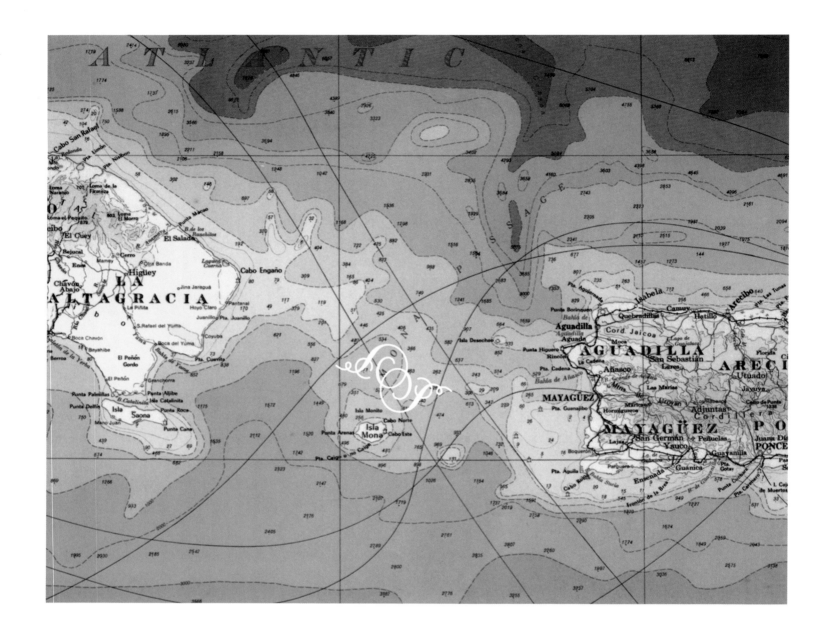

ABOVE, RIGHT, AND OPPOSITE

Colectivo Shampoo

(Dominican Republic)

☆ *D´ La Mona Plaza*

*(The Mona Mall)* (details of map,

logo, and architectural rendering),

2004

Inkjet prints, each 40 × 40 in.

(101.6 × 101.6 cm)

Courtesy of the artists

*D´ La Mona Plaza*

*Donde se paran las aguas*

# Christopher Cozier

Christopher Cozier is a multitalented artist and writer who works in installation, video, performance, drawing, painting, and sound. On his return to his native Trinidad in 1988 after travel and study in the United States, he openly rejected the tourist-brochure subject matter then being touted as "appropriate" for a West Indian artist. In so doing, he helped create a new artistic dialogue, not only in his place of birth, but throughout the Caribbean. Freeing themselves from such formulaic representations, artists were able to explore the truth of their own socially and politically conscious contemporary visions.

Cozier's work examines contemporary social issues but also resonates across the world with its powerful imagery. The artist cites the postcolonial writings of C. L. R. James (1901–1989), the Trinidadian socialist writer who campaigned for the independence of the Caribbean, as one of his inspirations, as well as the music of the region, including calypso, dancehall, dub, and soca. This musical influence can be seen in *Sound System, Voice*, 2000, in which big speakers mark the corners of a four-grid composition. The silhouettes of men and women (in movement and at rest) are layered on top of each other amid the repeated imagery of guitars, a palm tree, and a series of signs derived from historical and contemporary social events.

In his ongoing work *Tropical Night*, 2006–present, Cozier has expanded the composition to many grids, each with a key element of imagery. Cozier says this series of drawings is made up of narrative images that deal with a "sense of the night or of the recessed/repressed" and the question "How do we define living in a site that was designed for others to play in?" Often ambiguous, these images tell a story nonetheless and sometimes include the artist's handwritten personal reflections. The many figures inside colonial fences speak of restrictions to freedom. The figure springing from a stack of books suggests jumping from one historical narrative to another. Other figures are submerged in water, referring to the ideas of self and island. The complexity of this work is camouflaged by the simplicity of Cozier's imagery.

OPPOSITE
Christopher Cozier
(b. Trinidad 1959)
☆ *Tropical Night* (selections),
2006–present
Mixed media on paper, each
drawing 9 × 7 in. (22.9 × 17.8 cm)
Courtesy of the artist

Christopher Cozier
☆ *The Castaway*, from *Tropical Night*

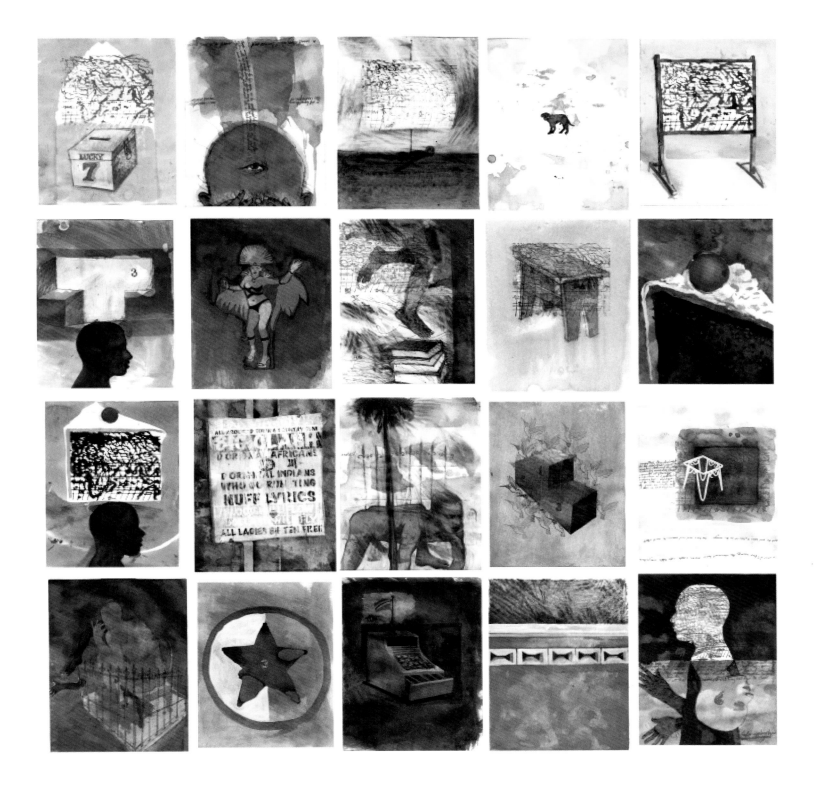

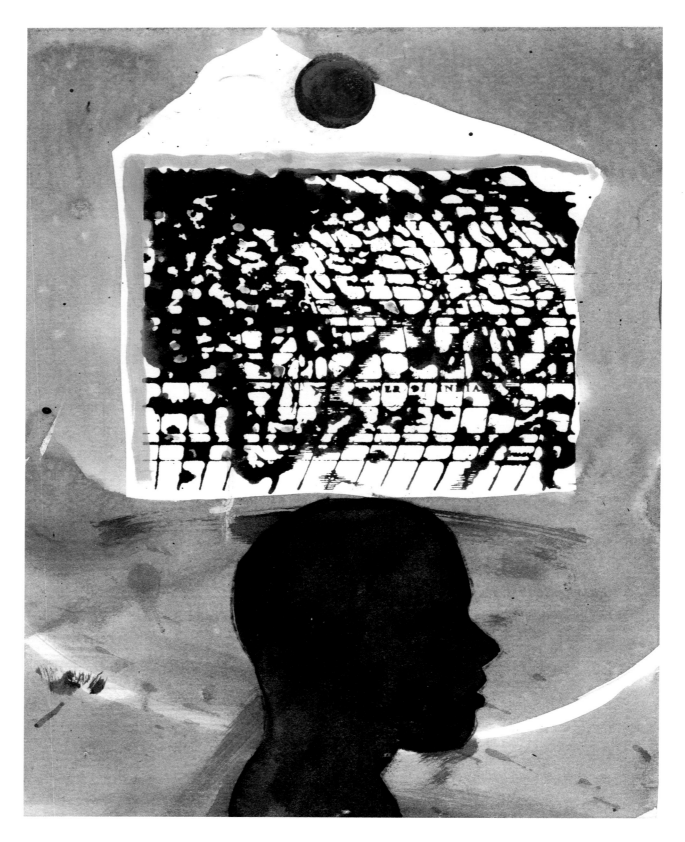

Christopher Cozier
☆ *Carrying a Slice*, from *Tropical Night*

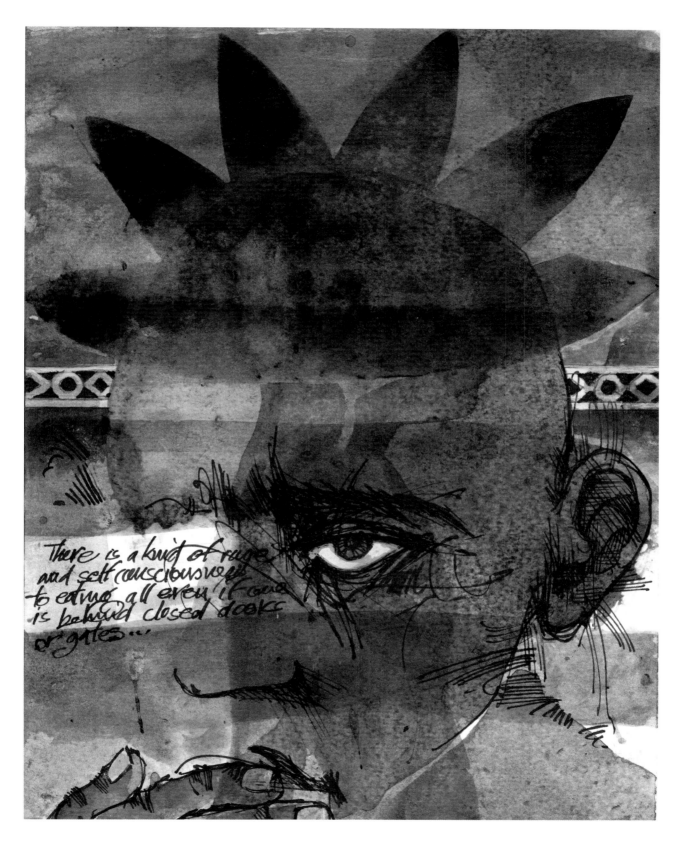

Christopher Cozier
☆ *Hiding to Eat*, from *Tropical Night*

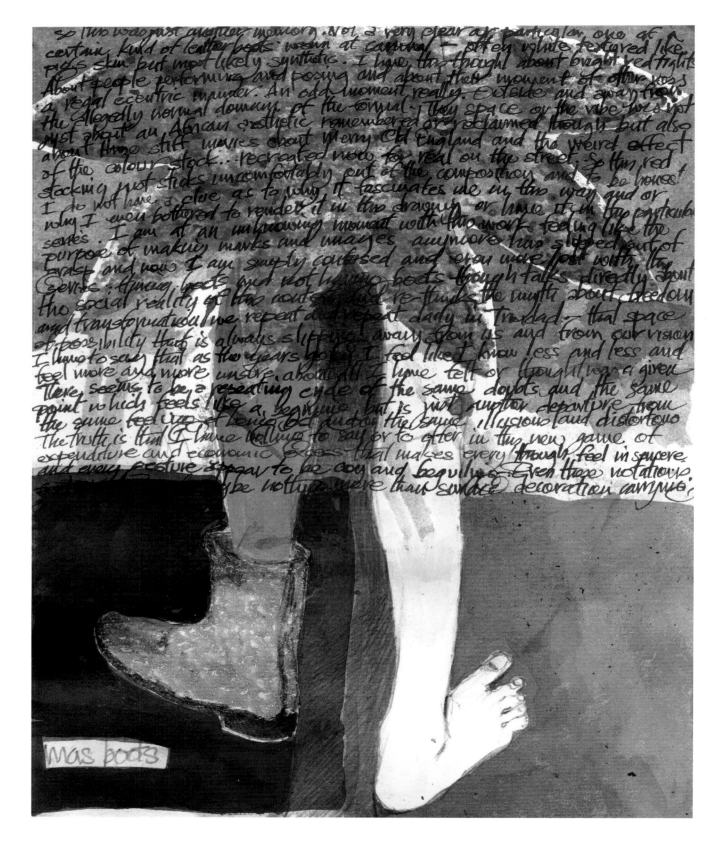

Christopher Cozier
☆ **Gold Boots**, from *Tropical Night*

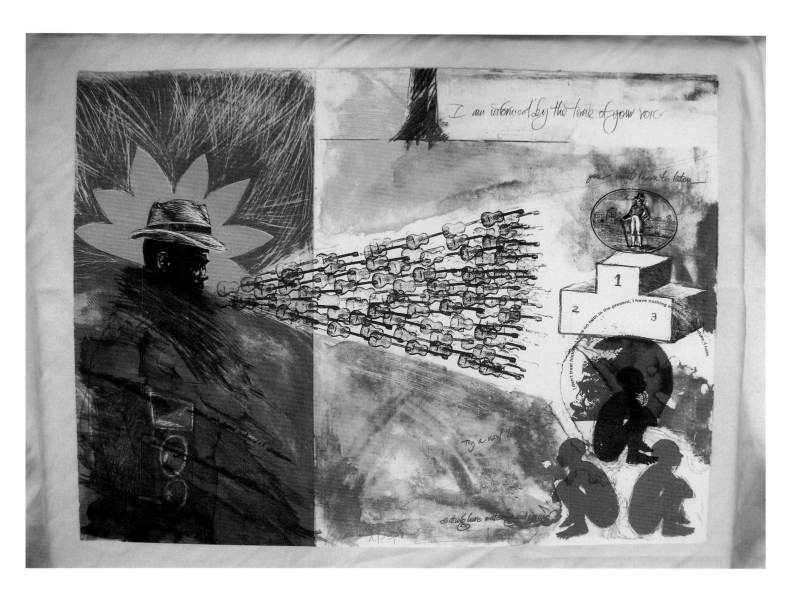

Christopher Cozier
(b. Trinidad 1959)
**Sound System, Voice** (detail), 2000
Serigraph,
39 × 51 in. (99.1 × 129.5 cm.)
Courtesy of the artist

# José (Tony) Cruz

The work of the conceptual artist José (Tony) Cruz comprises site-specific sculpture and drawings that explore drawing as a process of giving form to, or marking, the experience of moving from one point to another. As he explains, the point in movement is the definition of a line. In his recent drawings he records a distance traveled, whether an unimaginably vast expanse (San Juan to Vilnius) or a familiar route with personal significance (his parents' home to his own).

Cruz's two *Drawing on Ball Park* works, 2003–4, recorded the movements of the baseball during a children's game. The work involved the participation of players who, after individual plays, drew their memory of the ball's trajectory in powdered pigment on the field. The children at play are caught in long-range photographs that show the ballpark's drawn lines and the participants interacting, as well as close-up shots of the players in motion. The pigment drawings and the plays themselves, both ephemeral in nature, are captured on film.

Other work by the artist has also invited interactive participation. In the playful *Para 2 (For 2)*, 2000, the artist invites pairs of viewers to use the swing. Again line is a formal and spatial element, creating a drawing in the space in which the work is installed. The artist's spare lines are reflective of an overall economy in his works. Cruz cites the important influence of his father's tool and die drawings in his own mark making and recording of memory through the drawing of lines.

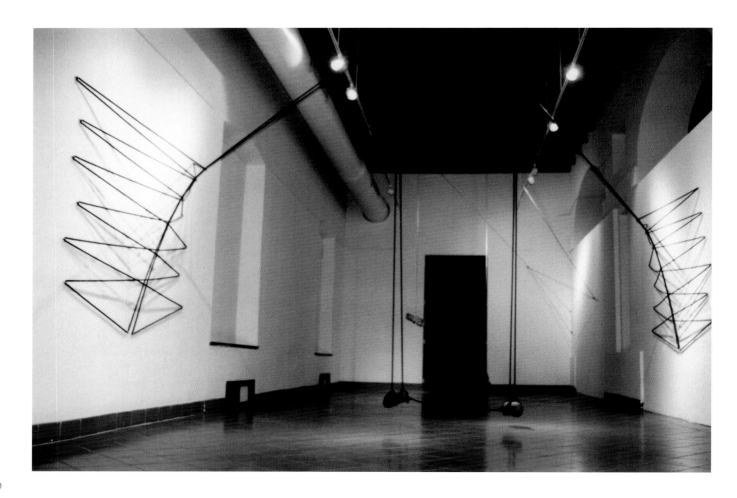

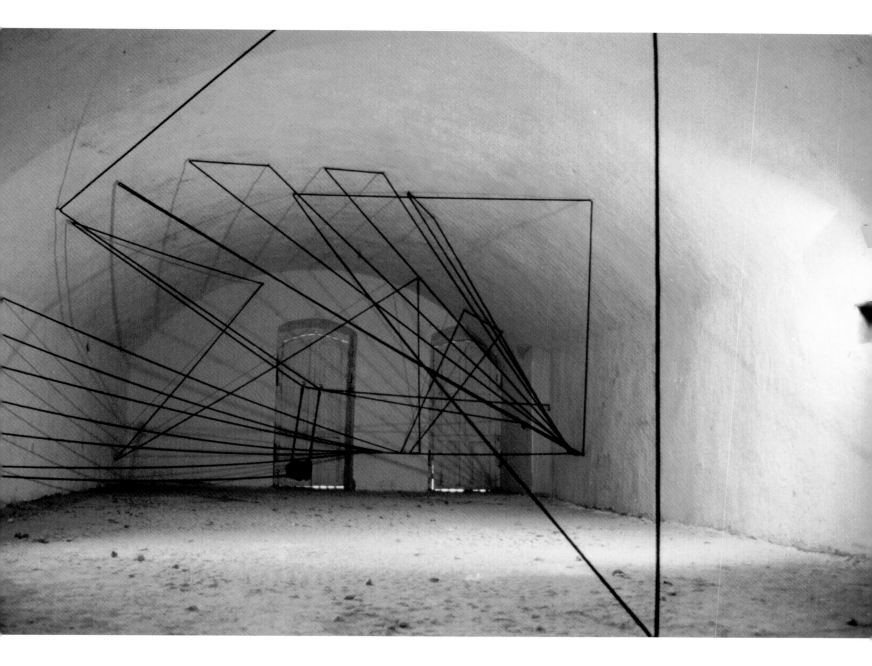

OPPOSITE
José (Tony) Cruz
(b. Puerto Rico 1977)
*Para 2 (For 2)*, 2000
Rope and stone, dimensions
variable
Installation at Museo de las
Americas, San Juan
Courtesy of the artist

José (Tony) Cruz
(b. Puerto Rico 1977)
*Machina (Machine)*, 2000
Rope and stone, dimensions
variable
Installation at Bienal de La Habana,
Havana
Courtesy of the artist

José (Tony) Cruz
(b. Puerto Rico 1977)
☆ **Drawing on Ball Park (Santo Domingo,
Dominican Republic)** (detail), 2003
Chromogenic print,
17 × 22 in. (43.2 × 55.9 cm) overall
Courtesy of the artist

José (Tony) Cruz
(b. Puerto Rico 1977)
☆ **Drawing on Ball Park (Rincón,**
**Puerto Rico)** (detail), 2004
Chromogenic print,
17 × 13 in. (43.2 × 33 cm) overall
Courtesy of the artist

# Annalee Davis

Film, painting, drawing, and installation work provide the vehicle for Annalee Davis's ruminations on Caribbean identity. Davis herself divides her time between Barbados, where she was born and lives, and Trinidad and Tobago. This mobility informs her sense of the divisions separating people and places in the Caribbean. The Caribbean, she says, "for years has romanticized the struggle to be . . . one Caribbean people. Yet today we remain as fragmented as ever, locked into old nationalist crevices, linguistic divides, and exclusivist cultural identities." Davis challenges the notion of social, economic, and political integration touted by politicians and travel magazines in her film *On the Map*, 2007. Focusing on Barbados, Trinidad, and Guyana, the film examines the intraregional migration that has been part of the Caribbean landscape since before the conquistadors. Through interviews with immigrants, immigration officers, and artists such as the Trinidadian Carnival costume designer Peter Minshall, *On the Map* seems to suggest that integration may be more of a dream than a reality.

Davis's mixed-media piece *Barbados in a Nutshell*, 2002, satirically presents a picture of this island state in transition from agricultural to tourist economy. The artist notes that her work "suggests that we cannot become a 'real' country unless we map ourselves for ourselves, without external agency." The audio component contains the sound of the final sugarcane-factory horn heard in 2002 and the artist's singing of the national anthem, with the altered line "These fields and hills beyond recall are *not* our very own."

The artist will create a new work for *Infinite Island: Contemporary Caribbean Art.*

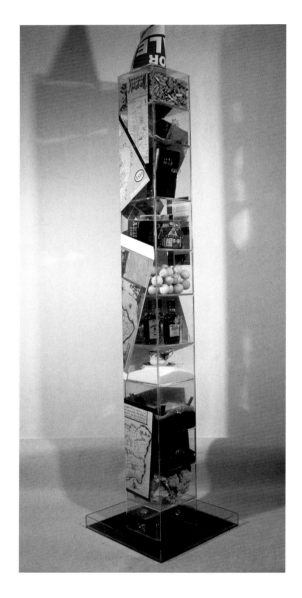

Annalee Davis
(b. Barbados 1963)
***Barbados in a Nutshell***, 2002
Mixed-media installation with sound,
80 × 8 × 8 in. (203.2 × 20.3 × 20.3 cm)
National Art Gallery, St. Michael, Barbados
(Photo: Ronnie Carrington)

Annalee Davis
(b. Barbados 1963)
☆ **On the Map** (production
photographs), 2007
Single-channel DVD,
color, sound, 40 min.
Courtesy of the artist
(Photos: Omar Estrada)

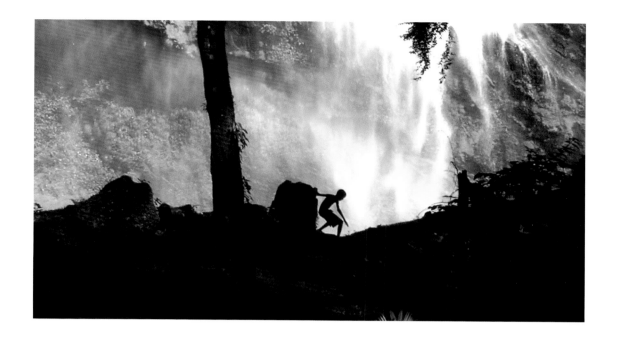

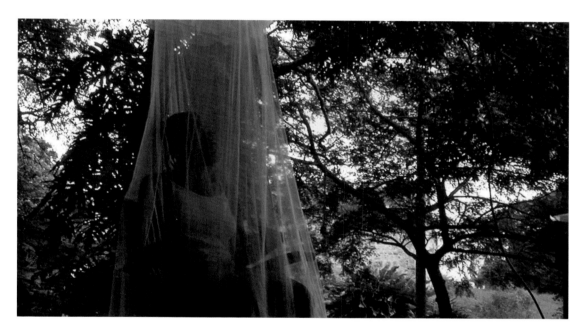

# Maxence Denis

A Haitian who spent time in France before returning to live and work in his native country, Maxence Denis has created a body of video work that attempts to provoke questions concerning the traumatic violence that has become commonplace in Haiti. Documenting and re-creating everyday scenes, Denis portrays a city trapped in turmoil. He describes his work as a way "to externalize my fears, anguish, and revolt and especially to keep in touch with reality."

In Denis's video installation *Kawtchou* (*Tires*), 2006, the pile of tires, which are often burned in protests and used as barricades during social unrest, symbolize revolt. Footage on television monitors inserted into the tires follows two individuals, who reflect the psychological damage and trauma that have been inflicted on the people by Haiti's instability, poverty, and violence.

Vodun, which originated as a form of resistance, is central to *Kwa Bawon (Baron Samedi Cross)*, 2003. Seven monitors in the shape of a cross evoke a real and imaginary space, combining things of the everyday life of Haitians with Vodun ceremonies. In other work the artist has employed disparate found objects such as a computer keyboard, wine bottles, a toilet bowl, and ceremonial masks in sculptural installations that portray the harsh reality of Haiti as a society in conflict with itself.

u moins 600 morts ont
é dénombrés dans cette
lle de 200.000 habitant
à 450 maisons ont été
étruites selon la
otection civile haïtienne

LEFT AND OPPOSITE
Maxence Denis
(b. Haiti 1968)
**Kwa Bawon (Baron Samedi Cross)**, 2003
Video installation with sound, dimensions variable
Courtesy of the artist

blessés recensés, la
part en tombant des
s où ils s'étaient
giés.

autorités ont décidé

blessés recensés, la
part en tombant des
s où ils s'étaient
giés.

autorités ont décidé

blessés recensés, la
part en tombant des
s où ils s'étaient
giés.

autorités ont décidé

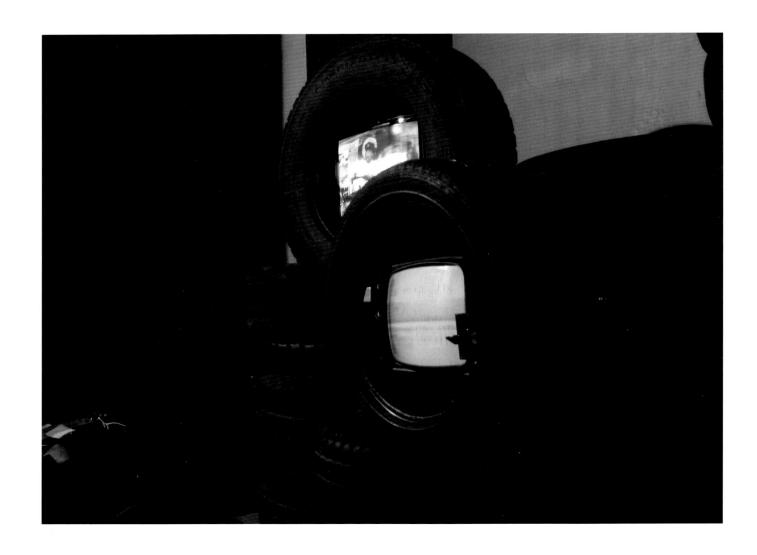

ABOVE AND OPPOSITE
Maxence Denis
(b. Haiti 1968)
☆ *Kawtchou (Tires)*, 2006
Installation with tires, video, and
sound, dimensions variable
Courtesy of the artist

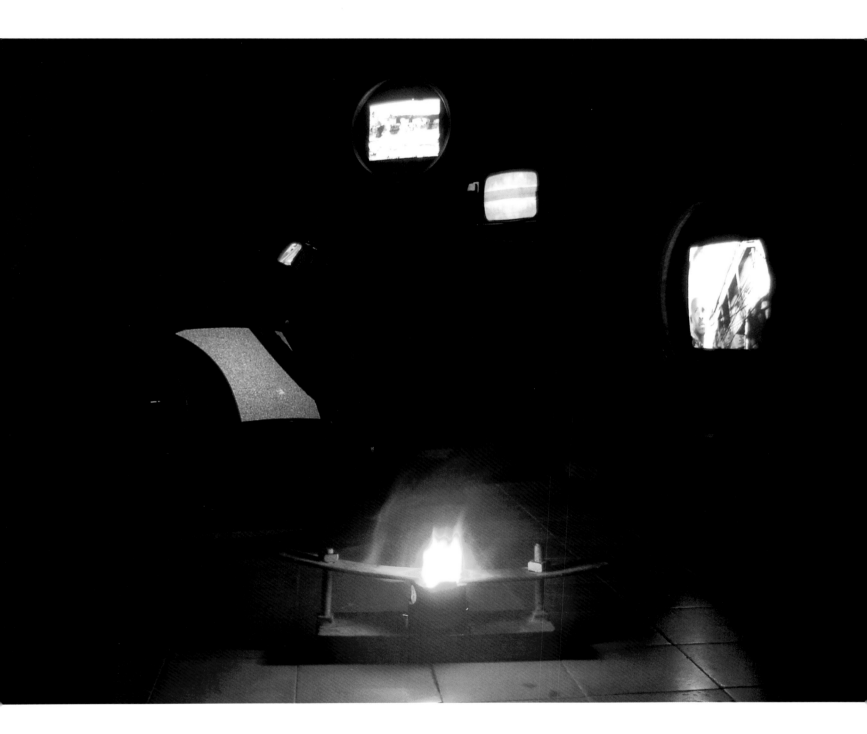

# Jean-Ulrick Désert

Jean-Ulrick Désert's conceptual sculpture, prints, photography, and performance works explore the social construction of identity as defined through race, gender, and sexuality. A Haitian artist working in Berlin and New York, he examines the subtle conflicts of living between cultures.

In his ongoing performance titled *Negerhosen 2000*, 2000–present, Désert addresses the social phenomenon of the invisibility of ethnic minorities in American and European cultures. Inspired by a disturbing incident in which he was accosted in the heart of Berlin because of his race, Désert dons the traditional German outfit including lederhosen, or leather shorts, to challenge racial perceptions and stereotypes as he walks around in public spaces and encounters the German public. By involving other participants in his performance, inviting them to pose with him and evoking mixed reactions, Désert implicates them as witnesses and documenters. The

participants become complicit in the exploration of fetishes, fantasies, and imaginings evoked by Désert's appearance in what is traditionally German dress. The adoption of German national dress may also be the artist's way of questioning what constitutes nationalism.

Iconoclastic juxtapositions are also a part of Désert's *The Burqa Project: On the Borders of My Dreams I Encountered My Double's Ghost*, 2001. In this installation four figures wear the traditional garment for Muslim women; each burka is made out of the flag of a Western superpower, suggesting how France, Germany, America, and the United Kingdom are joined in their complex relationships with the Arab world. Here the viewer is forced to question the Western world's role in the spread of Muslim extremism and the impact of such extremism on Western civilizations.

Jean-Ulrick Désert
(b. Haiti; works in Germany and
United States)
☆ **The Burqa Project: On the Borders of My Dreams I Encountered My Double's Ghost**, 2001
Textile, mannequins, glass vitrine,
63 × 118 in. (160 × 300 cm)
Installation in Berlin-Kreutzberg
Courtesy of the artist

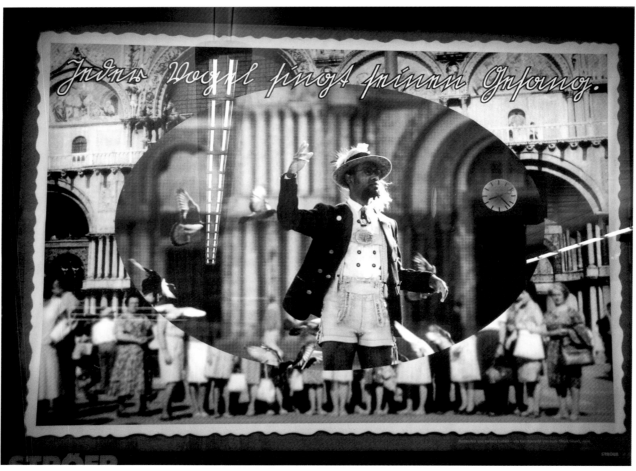

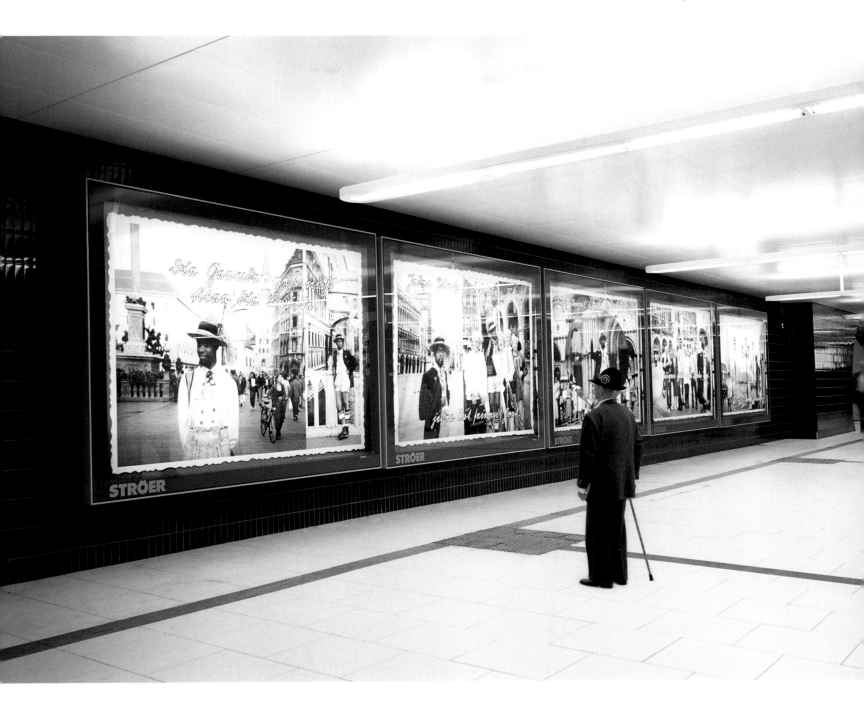

OPPOSITE AND ABOVE

Jean-Ulrick Désert

(b. Haiti; works in Germany and United States)

***Postkarten von meinen Lieben (Postcard of My Love)***,

from ***Negerhosen 2000***, 2000–present

Pigmented inks on textile, illuminated billboard support,

93 × 127½ in. (236 × 324 cm)

Installation at Arti et Amicitiae, Amsterdam, 2004

Courtesy of the artist, Underwritten by Quivid the public art council

of the Landeshaupstadt München Baureferat

(Photos above and opposite, bottom: Andrea Naica Loebell)

(Photo opposite, top: Christoph Mukherjee)

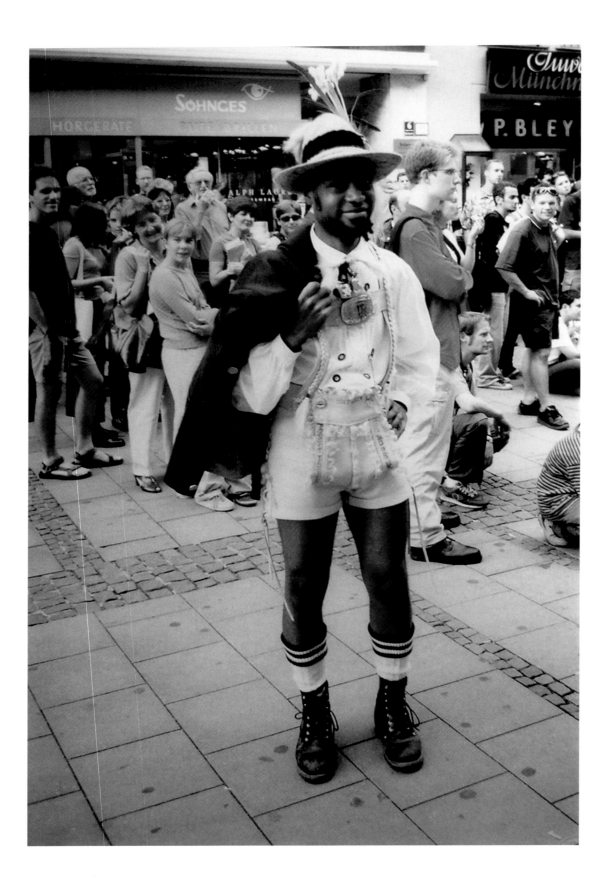

Jean-Ulrick Désert
(b. Haiti; works in Germany and
United States)
*Spectacle (Munich)*, from
*Negerhosen 2000*, 2000–present
Chromogenic print,
39 ⅛ × 27 ½ in. (100 × 70 cm)
Courtesy of the artist

Jean-Ulrick Désert
(b. Haiti; works in Germany and
United States)
*Englischergarten (Paradise)*, from
*Negerhosen 2000*, 2000–present
Chromogenic print,
39 3/8 × 27 1/2 in. (100 × 70 cm)
Courtesy of the artist

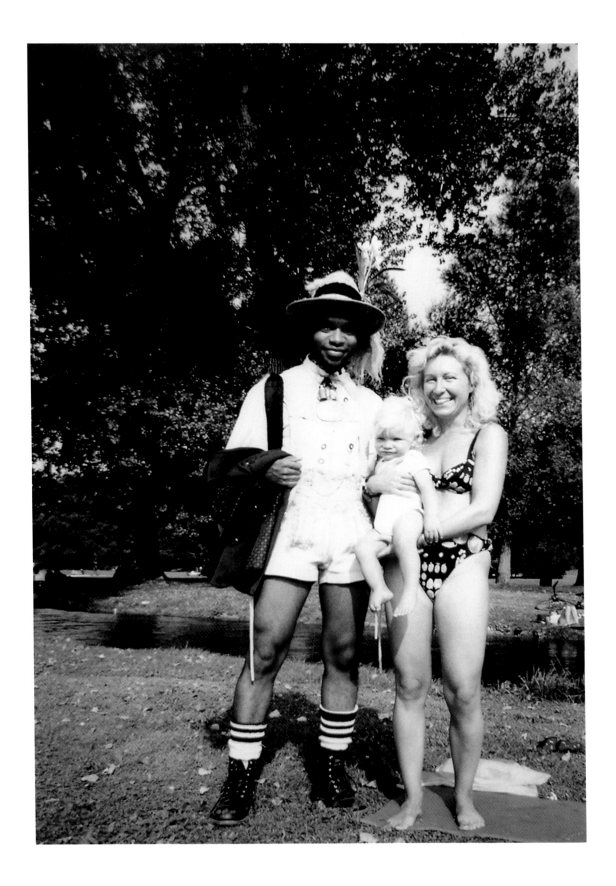

# Roberto Diago

Roberto Diago uses a conglomeration of media and "simple" or "naïve" techniques in a sophisticated treatment of his subject, which is the marginalized black population of Cuba. As a minority living under the worst of conditions, blacks have become even more invisible in postrevolutionary Cuban society, where the issue of persistent racial inequality is underplayed. Although the revolution has improved the lives of blacks by ending official discrimination, society is stratified according to race and economic means, with Afro-Cubans relegated to the lowest-paying jobs and suffering the highest rate of unemployment.

Using found materials, graffiti, and scratched, drawn, painted, and collaged imagery, Diago brings the viewer's attention to the poverty and marginal status of Cuban blacks. His installation *El poder de la presencia (The Power of Presence)*, 2006, depicts the confined tenements of the poor with a mass of found material collected from neglected neighborhoods. Poverty, as well as the fragility of life, is expressed in *Hoy no es mi día de morir (Today Is Not My Day to Die)*, 2004, through symbolic images such as a bird, a tree, and a doll's head framed in raised metal; pieced and stitched metal plates; text; and a palette of rusted browns, reds, and grays.

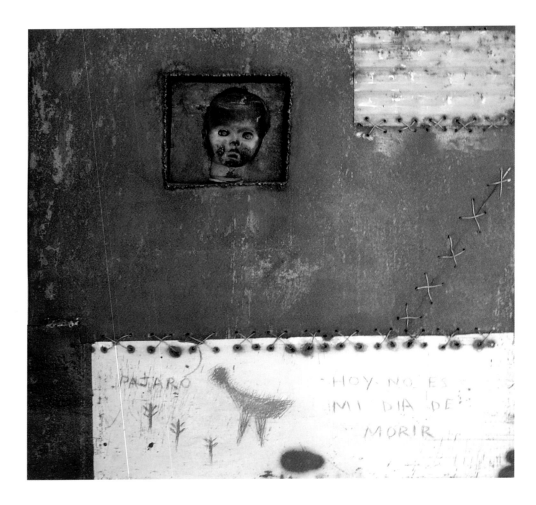

Roberto Diago
(b. Cuba 1971)
***Hoy no es mi día de morir (Today Is Not My Day to Die)***, 2004
Mixed media on metal,
40 × 40 in. (101.6 × 101.6 cm)
Courtesy of the artist and Pan American Art Projects, Miami, Florida

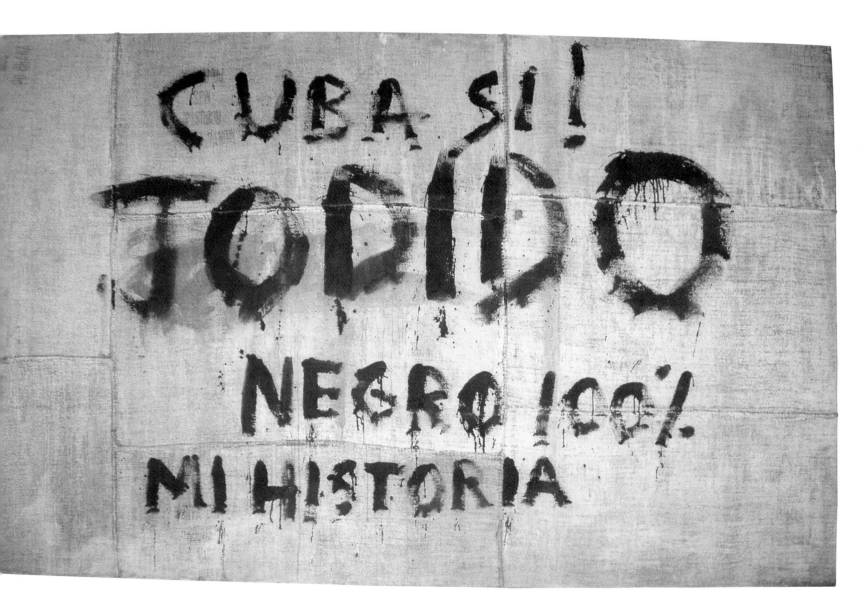

Roberto Diago
(b. Cuba 1971)
*Cuba sí (Cuba Yes)*, 2000
Mixed media on jute,
78 ¾ × 118 ⅛ in. (200 × 300 cm)
Courtesy of the artist and Pan
American Art Projects, Miami,
Florida

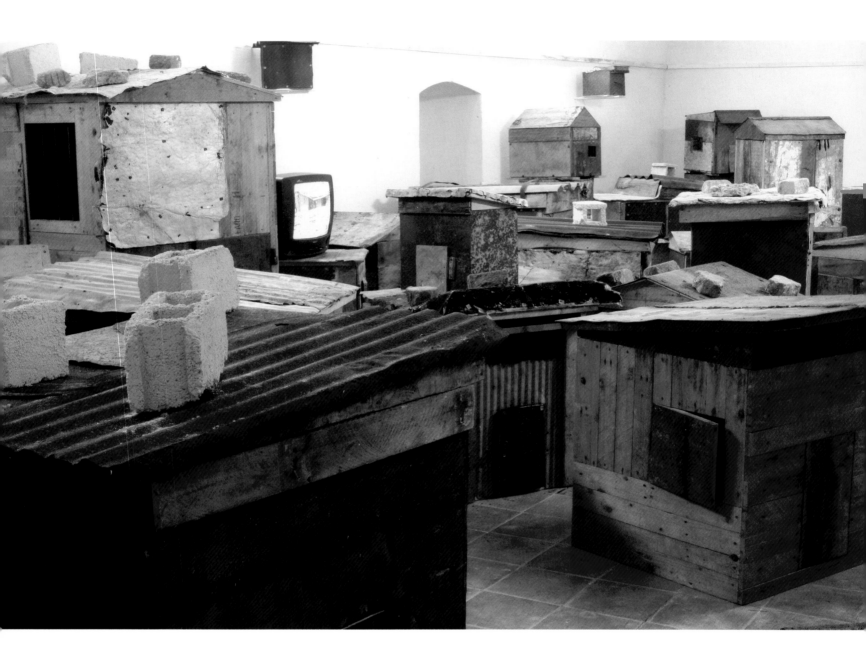

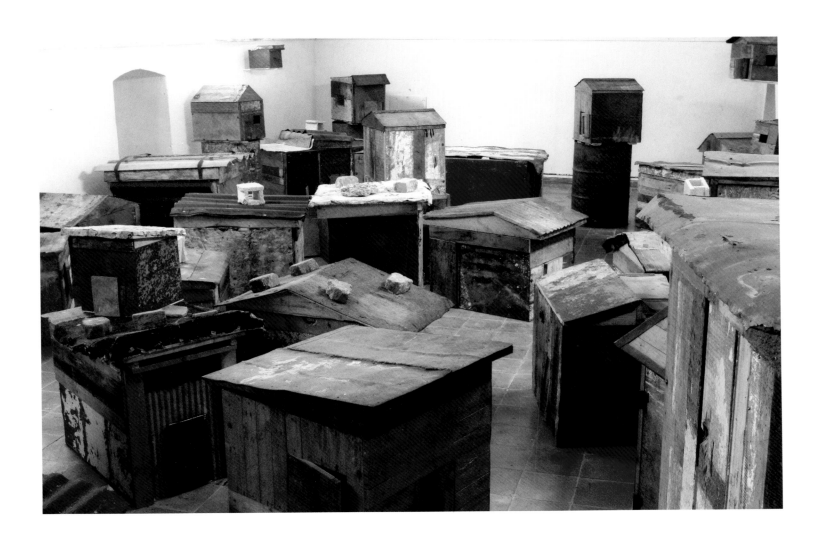

OPPOSITE AND ABOVE
Roberto Diago
(b. Cuba 1971)
☆ *El poder de la presencia*
*(The Power of Presence)*, 2006
Mixed-media installation,
dimensions variable
Courtesy of the artist and Pan
American Art Projects, Miami,
Florida

# Polibio Díaz

Polibio Díaz represents the black subject in his photography so that his fellow Dominicans can, in his words, "see ourselves as we really are: the wonderful complex mixture of several civilizations in their shades of color and reflected in the complexity of our skin and culture." Making "blackness and mulatto-ness" the subject of his work, he says he challenges the "Greco-Latin codes on which we pretend to base the concept of Dominican beauty."

The photographs of Díaz's 2001–2 *Interiors* series tell stories about the intimate and everyday lives of people with very little means. In *Después de la siesta (After the Siesta)*, 2001, vibrant colors and shapes transform and personalize the domestic spaces into balanced compositions. *Rodríguez*, 2002, centers on the social hub of a barbershop's bright green interior. In *Pasiones interiores (Interior Passions)*, 2001, a deep red-curtained wall contrasts in each scene with various images, and the transition from one section to the next takes the viewer into an intense red dream that is a composite image of a confined domestic environment. In a comic detail that relates to Díaz's vision of beauty in diversity, the buff black man "looks closely" at the blonde in the pinup poster. Another poster of a martial-arts film star in an adjacent scene suggests a role model whose fame and iconic status are far removed from the everyday reality portrayed here.

Polibio Díaz
(b. Dominican Republic 1952)
**Pasiones interiores
(Interior Passions)**, 2001
from the *Interiors* series
Chromogenic print,
39 ³/₈ × 177 ¹/₈ in. (100 × 450 cm)
Courtesy of the artist

Polibio Díaz
(b. Dominican Republic 1952)
☆ *Después de la siesta (After the Siesta)*,
2001, from the *Interiors* series
Chromogenic print,
59 × 118⅛ in. (150 × 300 cm)
Courtesy of the artist

Polibio Díaz
(b. Dominican Republic 1952)
*Rodríguez*, 2002, from the *Interiors*
series
Chromogenic print,
39⅜ × 177⅛ in. (100 × 450 cm)
Courtesy of the artist

# Dzine (a.k.a. Carlos Rolón)

The work of the installation artist Dzine (a.k.a. Carlos Rolón), whose parents came to the United States from Puerto Rico, has been linked to popular culture, including funk, hip-hop, and electronic music. His father was a salsa musician in Chicago, and Dzine started his artistic life by tagging (writing graffiti) on the streets. This street credibility and his music background have influenced his practice, both stylistically and methodologically. *Classic Dub Classics*, 2006, shows the clear correlation between music, art, and street culture in Dzine's work. The gold turntable with glass beads is a symbol of deejay and hip-hop culture, of which graffiti artists are a part.

The artist's concern with optics and graffiti art is evident in *Beautiful Otherness*, 2004, which wraps around three walls. Dzine has said he is interested in optics and how the eye perceives a work's color and light depending on the angle from which it is viewed. Recently he extended his interest in optics by using Beadazzled, a flexible glass-bead wall covering created by the textile designer Maya Romanoff. The thousands of glass beads laid onto the painted surface of *Beautiful Otherness* add a jewel-like quality and create another optical effect. This work demonstrates a number of Dzine's influences, including not only street art, music, and optics but also design, fashion, Pop Art, and abstract art. These influences are apparent in *Punk Funk—The Lost Kingdom*, 2005, a work covered with a layer of Envirotex (a reactive polymer compound), which makes the painting surface glossy and reflective.

The artist will create a new work for *Infinite Island: Contemporary Caribbean Art*.

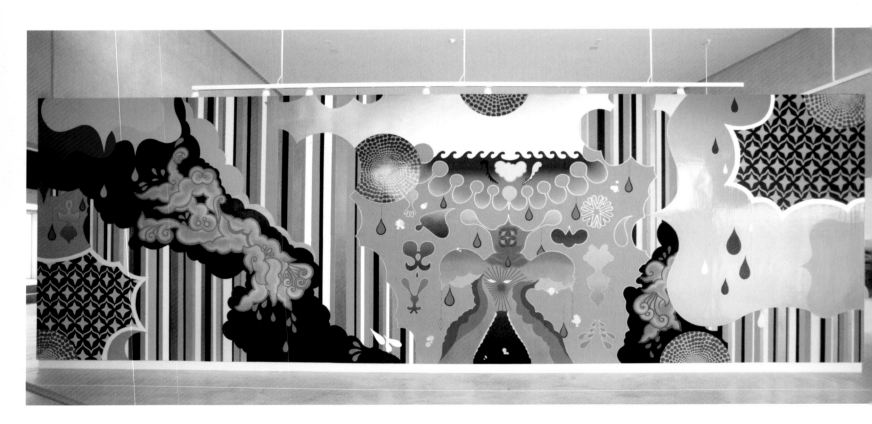

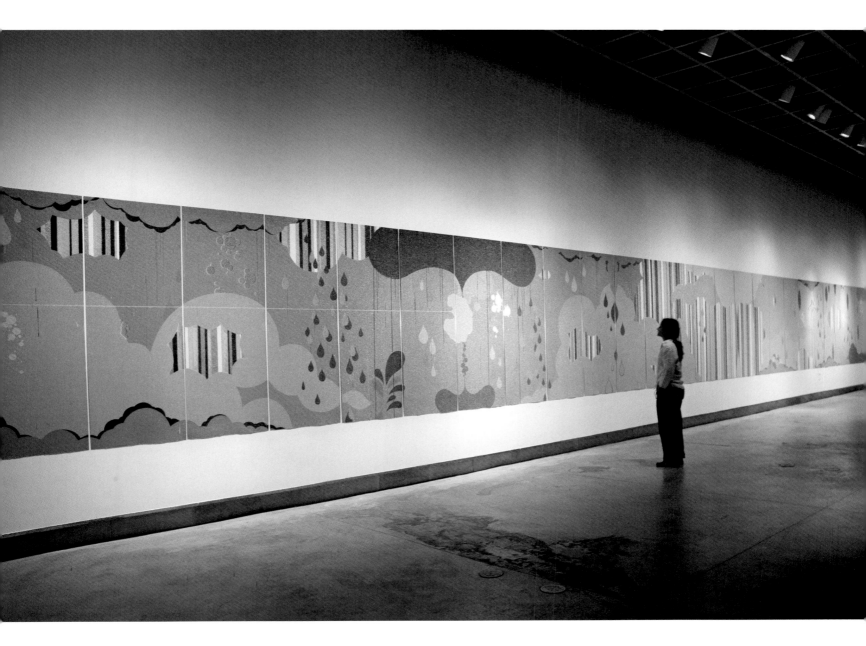

OPPOSITE
Dzine (a.k.a. Carlos Rolón)
(b. United States 1970)
**Punk Funk—*The Lost Kingdom***, 2005
Acrylic, Envirotex, varnish on wood,
audio installation produced by Dj Cam,
14 × 45 ft. (4.3 × 13.7 m)
Installation at Contemporary Art
Museum, St. Louis
Courtesy of the artist and
Contemporary Art Museum, St. Louis
(Photo: Jay Fram)

Dzine (a.k.a. Carlos Rolón)
(b. United States 1970)
**Beautiful Otherness**, 2004
Acrylic and glass beads on canvas,
6 × 52 ft. (1.8 × 15.8 m)
Installation at the Museo de Arte de
Puerto Rico, San Juan
Museo de Arte de Puerto Rico,
San Juan
(Photo: John Betancourt)

115

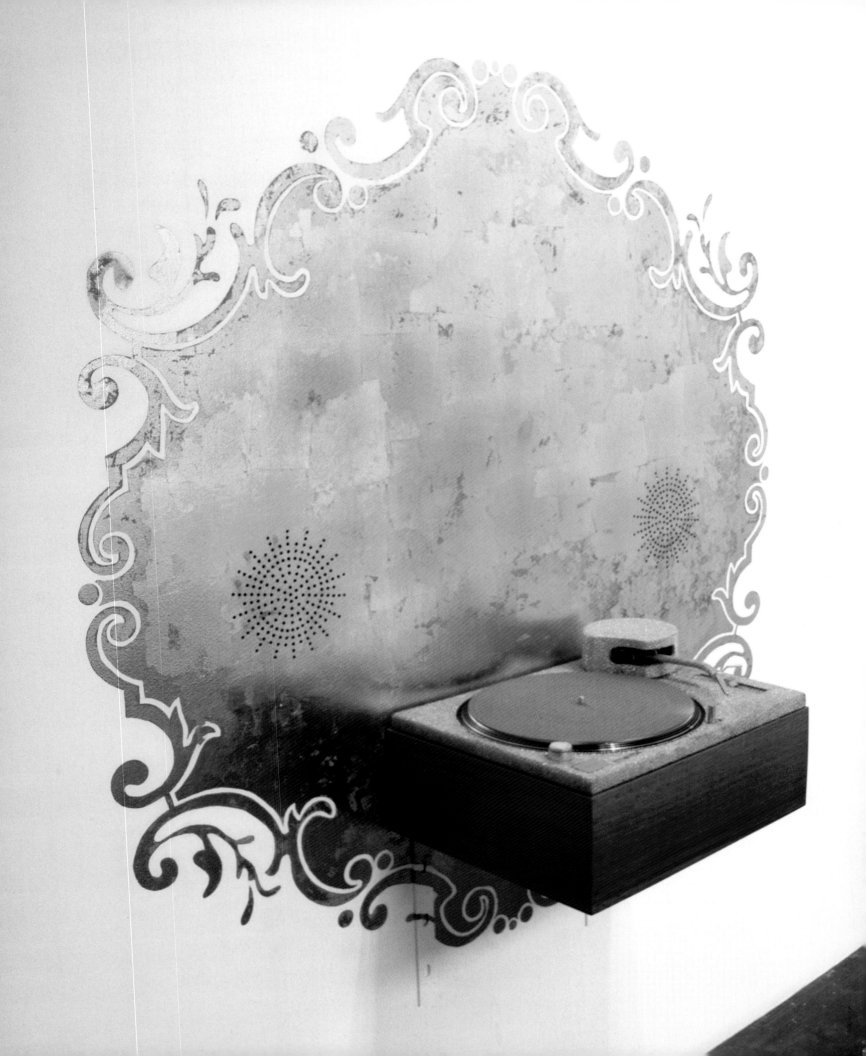

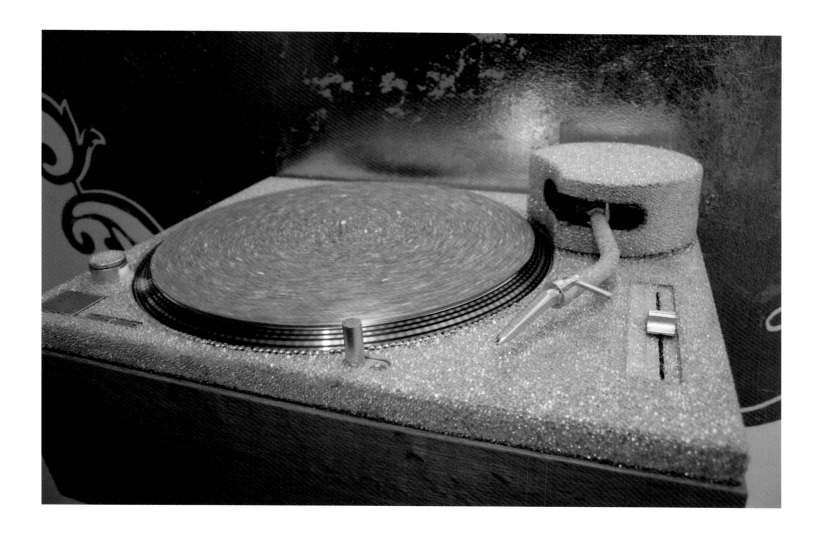

OPPOSITE AND ABOVE
Dzine (a.k.a. Carlos Rolón)
(b. United States 1970)
☆ **_Classic Dub Classics_**, 2006
Gold leaf, glass beads, Technic turntable,
custom pedestal, speakers with audio
installation produced by Hiroshi Fujiwara,
dimensions variable
Installation at SCAI/The Bathhouse/
Shiraishi Contemporary Art Inc., Tokyo
Courtesy of the artist and SCAI
(Photo: SCAI)

# Joscelyn Gardner

The work of Joscelyn Gardner, encompassing multimedia installation and printmaking, tackles issues of gender and race in contemporary Caribbean society. Her *Creole Portraits*, 2002–3, is a series of lithographs that reference the Caribbean history of slavery and explore black female hair-braiding as a form of self-empowerment. As a white Creole artist, Gardner is sensitive to the way that slavery still influences relationships in the Caribbean and the world at large, affecting the descendants of the oppressors as well as those of the oppressed. Each work in her series presents as a focal point the back of a braided head of hair, combined with a slavery-era implement of torture, leaving the viewer to wonder about the identity of the subject. What the imagination fills in is a product of personal experience and knowledge regarding race and history. The portraits could be historical, or, since the braided hairstyles are manifestations of a particularly African ongoing tradition, they could equally be contemporary. The absence of the faces also reminds the viewer that black women have historically been neglected or ignored in Western art, included primarily as stereotypes of the exotic. In pointed contrast to such romanticization of the black woman, Gardner portrays her subjects in *Creole Portraits* with their backs turned, emphasizing the complex details of their braided hairdos.

These elaborate styles are difficult, if not impossible, to execute without assistance, so the braiding speaks of a community of women. This suggested community contrasts with the separateness of the portraits, which may be seen as a metaphor for the forced separation of friends and relatives during slavery.

The dialogue between the past and present in Gardner's work is enhanced by her use of frosted Mylar as the support for the hand-drawn lithographs. The images subtly and intricately include tools of control and torture that were commonly used during slavery, but these details almost slip through unnoticed during a cursory view of the shimmering surface.

The artist will create a new work for *Infinite Island: Contemporary Caribbean Art*.

Joscelyn Gardner
(b. Barbados 1961; works in Canada)
**White Skin, Black Kin: A Creole Conversation Piece** (video still), 2003
Multimedia installation,
dimensions variable
National Art Gallery, St. Michael,
Barbados
(Photo: John Tamblyn)

Joscelyn Gardner
(b. Barbados 1961; works in Canada)
*Creole Portraits*, 2002–3
Ten lithographs on frosted Mylar,
each 36 × 24 in. (91.4 × 61 cm)
United States Embassy, Barbados
Courtesy of the artist
(Photos: John Tamblyn)

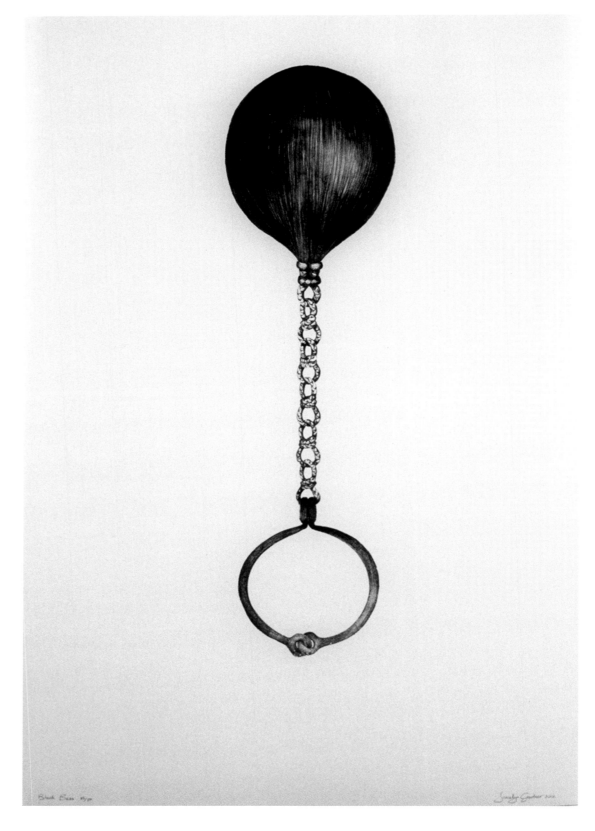

Joscelyn Gardner

*Creole Portraits* (detail): *Black Bess*

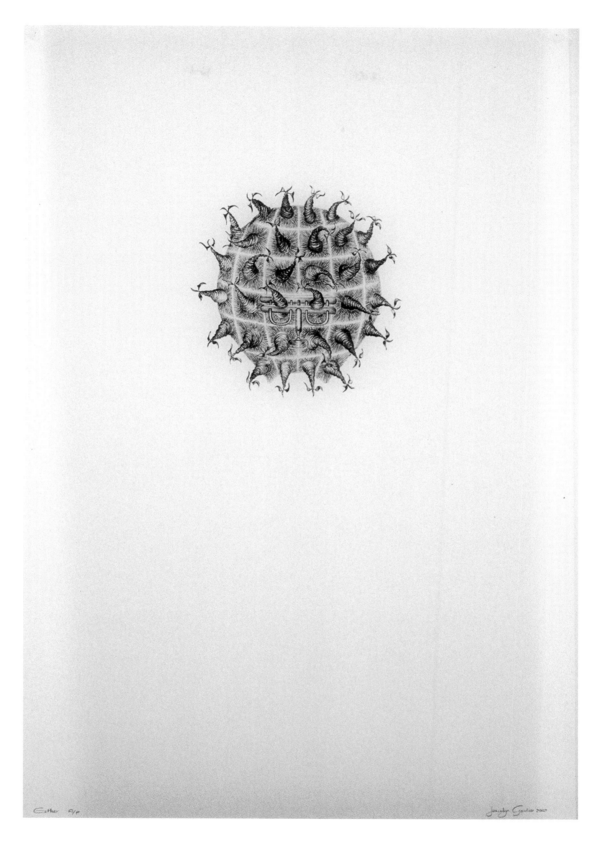

Joscelyn Gardner

**Creole Portraits** (detail): **Esther**

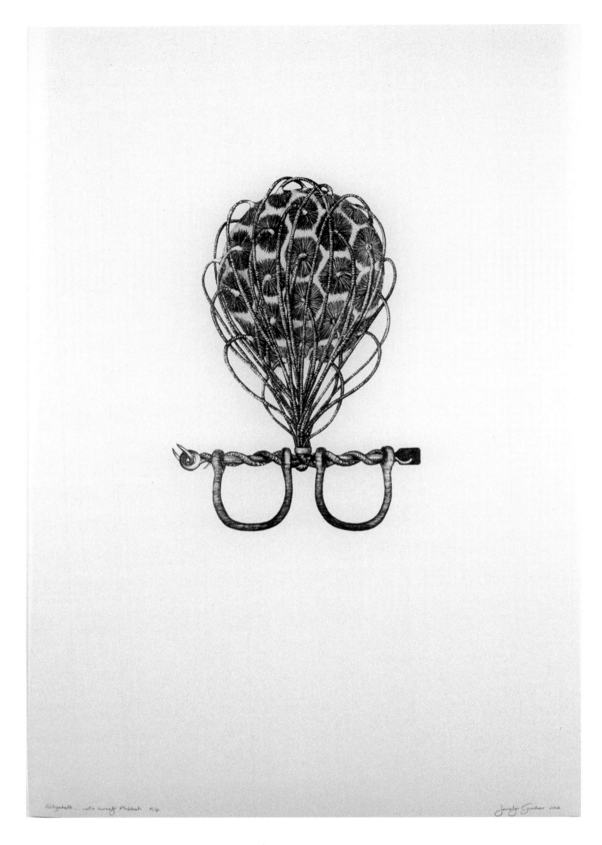

Joscelyn Gardner

*Creole Portraits* (detail): *Elizabeth*

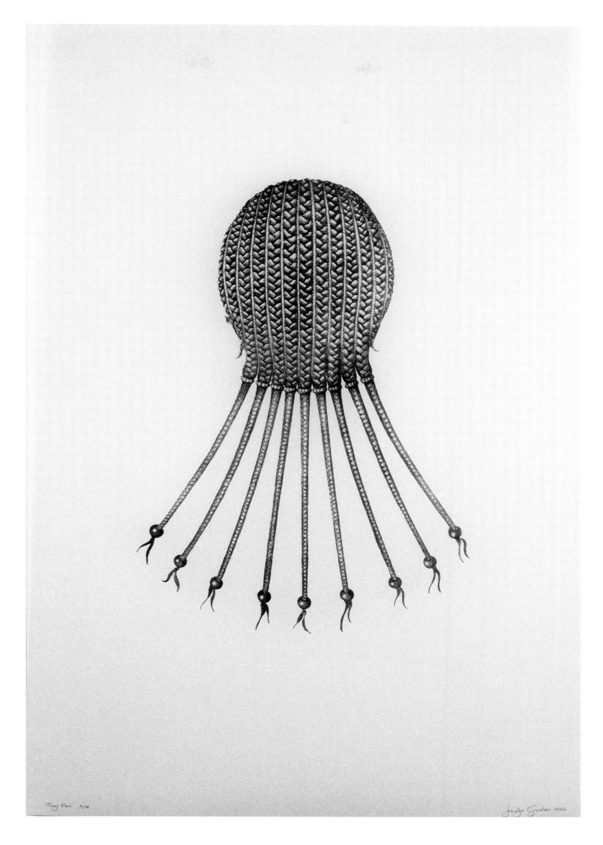

Joscelyn Gardner

**Creole Portraits** (detail): **MaryAnn**

# Quisqueya Henríquez

Quisqueya Henríquez, a Cuban artist who lives in the Dominican Republic, shifts between photography, installation, video, and sculpture to express her highly conceptual visions that explore cultural stereotypes and reality in Caribbean developing countries. Her series *Paraíso de la verdura (Paradise of Greenness)*, 2002–present, is composed of diptychs of digital photographic prints, with each image showing an urban scene reflected in one lens of a pair of eyeglasses. The artist's use of the diptych provokes the viewer to reflect on the relationships between the two images in each pair, as well as those among all the images in the series.

One diptych shows a sleeping dog on the side of the road in one lens and a homeless man sleeping on a piece of cardboard on the street in the other. In another work the same picture of the dog in the left lens contrasts with a picture of the sea and sky with a boat on the horizon. Another scene of a rocky coastline appears in a third diptych with a strange narrow building and a sliver of plastic chairs beside it. These plastic chairs are the focus of the scene in the right lens of the eyeglasses in the second half of the diptych.

The images are "framed" in a foreign vision that colors them with an aquamarine green-blue suggestive of the Caribbean Sea, giving them an underwater, dreamlike feel that alludes to the "paradise of greenness" of tourist brochures. This stereotype is belied in the lenses of these eyeglasses, which reflect the reality of globalization and Third World economies that lies beneath the glossy surface of "paradise."

OPPOSITE, BELOW, AND FOLLOWING PAGES
Quisqueya Henríquez
(b. Cuba 1966; works in Dominican
Republic)
☆ *Paraíso de la verdura*
*(Paradise of Greenness)*, 2002–present
Diptychs of digital prints,
each 27 × 69 in. (68.6 × 175.3 cm)
Courtesy of the artist and David
Castillo Gallery, Miami, Florida

# Alex Hernández Dueñas

Centered on the daily lives of ordinary citizens in Havana, the work of Alex Hernández Dueñas explores the economic disparities and lack of essential services in Cuban socialist society. Focusing on one issue, the unavailability of running water in parts of Havana, *Zona afectada (Affected Zone)*, 2006, shows the daily struggle of one man to survive and persevere. Whereas fresh water, the source of life, is abundant for the higher classes, it is a scarce and precious commodity for some in poor neighborhoods like the film's protagonist, who must labor over red and blue pails and a mysterious basin that requires multiple buckets of water to fill. The stairs the protagonist climbs, the line in which he must wait, and the crumbling buildings that surround him illustrate the difficult conditions marginal communities face and comment on the failure to achieve the socialist ideal of equality. Water functions as a metaphor of transformation and change in the film, adding complexity and allegorical resonance to the work.

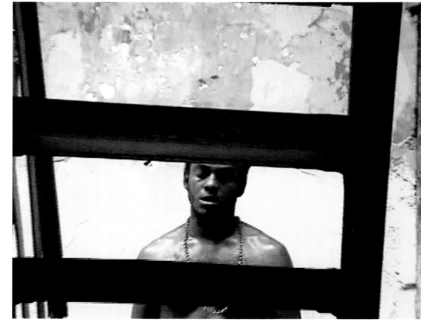

Alex Hernández Dueñas
(b. Cuba 1982)
☆ *Zona afectada (Affected Zone)*, 2006
Single-channel DVD, color, sound,
8 min. 47 sec.
Courtesy of the artist

# Satch Hoyt

In addition to creating visual art that encompasses sound, sculpture, installation, drawing, and painting, Satch Hoyt is an accomplished musician. His Jamaican ancestry and his musical background inform most of his recent work, which addresses issues of race and identity related to sports.

*Dub Ramp*, 2005, is a commentary on the West Indian appropriation and control of the colonial legacy of cricket, and the sport's intersection with Jamaican dub music, now often heard at the cricket grounds. Hoyt's assemblage, incorporating references to cricket (balls, grass, and wicket) and dub (the speaker pumping out music), displays the Rastafarian colors of red, green, and gold. Both cricket and dub music, a genre that remixes elements from existing recordings, represent triumph in the face of political, economic, and social challenges: in each case, Caribbean people transformed existing forms into something of their own, building national and regional pride.

In *Inside Out*, 2003, three hundred fifty mouthpieces and forty-four hand wraps are mounted inside a Plexiglas case and accompanied by the sound of a boxer's heavy breathing. The role that race plays in sports, particularly boxing, is highlighted here to show the racial disparity that leads a sector of the population to seek fame, recognition, and acceptance inside the ring.

*Say It Loud!*, 2004, delves into issues of the black diaspora and its cultural and political impact. Five hundred books on related subjects are piled up to create a literal platform for individual expression. Viewers are invited to participate by climbing the white staircase and singing the chorus of James Brown's *Say It Loud! I'm Black and I'm Proud!* into the microphone. Hoyt has omitted the word "black" in the song's lyrics so that participants get a chance to substitute a word of their choice.

Satch Hoyt
(b. United Kingdom 1957;
works in United States)
☆ **Dub Ramp**, 2005
Mixed media with sound,
45 × 93 × 26 in.
(114.3 × 236.2 × 66 cm)
Courtesy of the artist

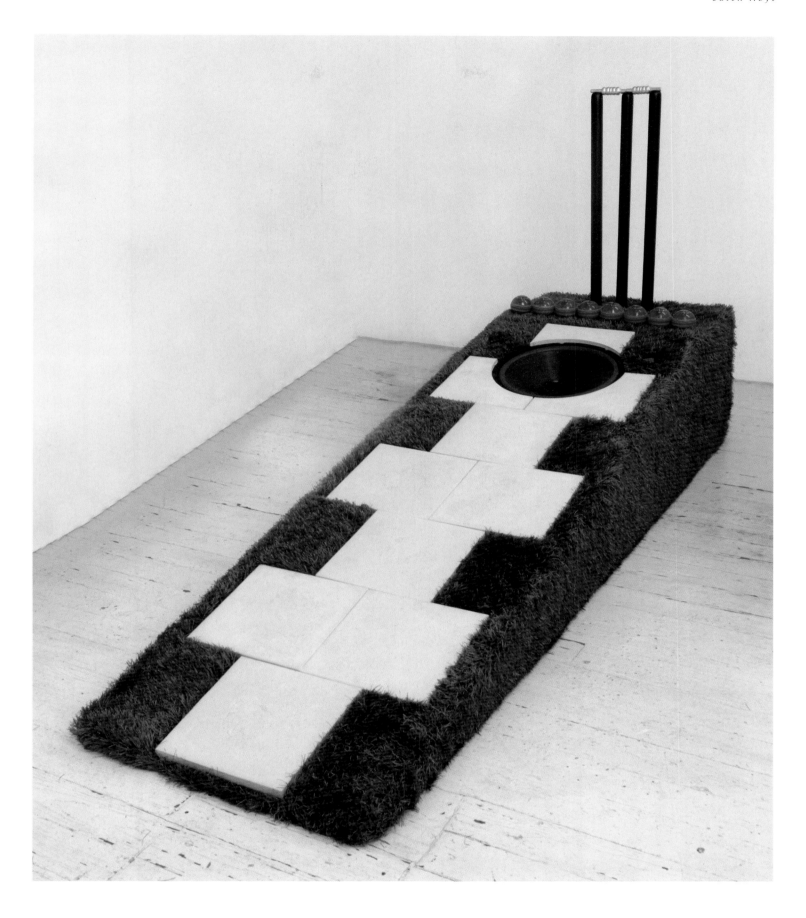

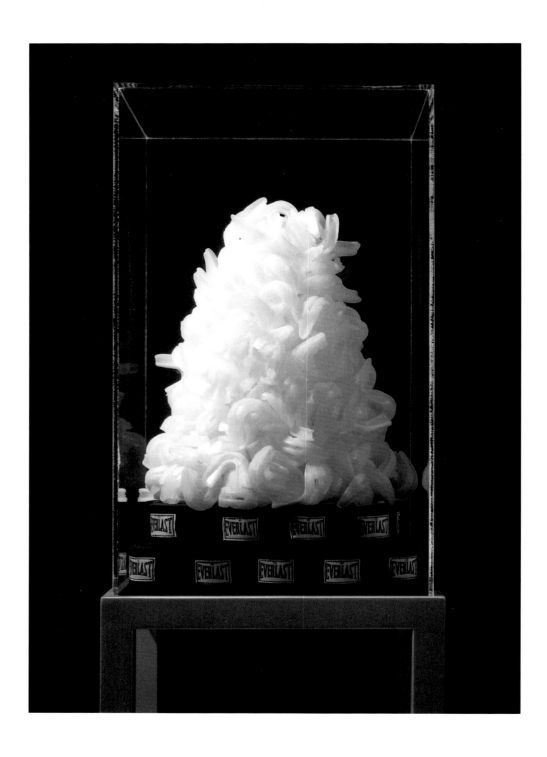

Satch Hoyt
(b. United Kingdom 1957;
works in United States)
***Inside Out***, 2003
350 transparent double
mouthpieces, 44 hand wraps,
Plexiglas and metal stand, sound,
19 ¾ × 14 × 14 in.
(50.2 × 35.6 × 35.6 cm)
Courtesy of the artist

OPPOSITE
Satch Hoyt
(b. United Kingdom 1957;
works in United States)
☆ ***Say It Loud!***, 2004
500 books, white metal staircase,
and microphone with 4 speakers,
wall text,
dimensions variable
Courtesy of the artist

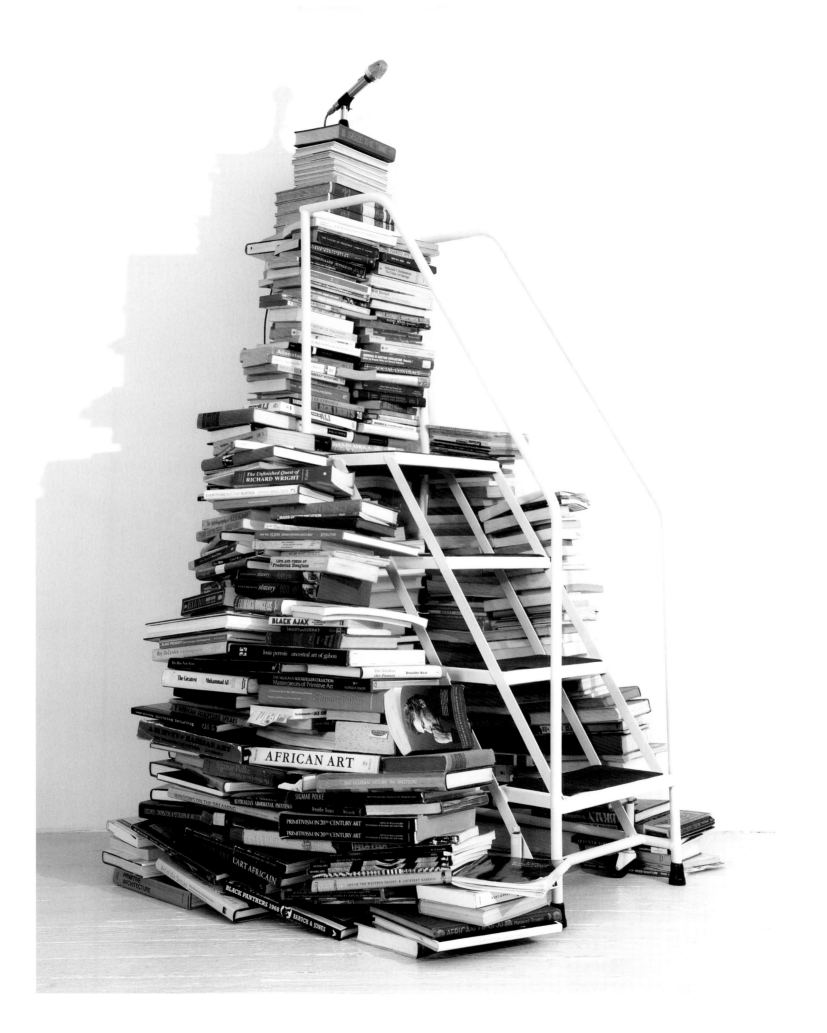

# Deborah Jack

Through multiple means of expression—painting, video and sound installation, photography, and text—Deborah Jack explores transcultural existence, memory, colonialism, and mythology. Her *Bounty* series of 2006 takes the viewer to the site of St. Maarten's Great Salt Pond, where salt was harvested for export, commerce that was central to the island's colonial economy and based in slave labor. The artist states: "[Salt] was literally the cultural currency of my country's colonial past. The salt . . . functions as a corrosive or preservative. . . . The piles of salt are a metaphor for the stockpile of memories stored in nature. . . . Like multiple permutations of memories, some are coarse and some more refined."

In other work Jack, who travels between the United States and St. Maarten, where she grew up, tackles her personal concept of home, not only as a concrete place but also as a space of shifting memory as evidenced by her blurry photographic images of places where she has lived. Movement between the Caribbean and America has been fodder for the artist in terms of developing a visual language to describe shifts between spaces that she says are "at once familiar and foreign" and a concept of a "home space somewhere in between." In her landscapes from the *Imagined Spaces* series of 2005, the artist has cut, blurred, and shifted the sepia brown image of a vegetated hill with a spindly, leafless tree in the foreground, echoing the imagery of dreams and memory. This same dreamlike fragmentation of time and imagery is seen in the *T/here* series of 2003–6, in which a reflective, dust-covered floor, shot from a low perspective, in an obviously northern locale is juxtaposed with the blurry image of a sink's drain hole and a verdant Caribbean road scene with a green mountain in the distance against the backdrop of a blue sky.

Deborah Jack
(b. Netherlands 1970;
works in United States)
☆ *T/here*, 2003–6
Digital prints, 21 × 84 in.
(53.3 × 213.3 cm) overall
Courtesy of the artist and Diaspora
Vibe Gallery, Miami, Florida
(Photo: Courtesy of the artist)

Deborah Jack
(b. Netherlands 1970;
works in United States)
☆ **Bounty**, 2006
Slides in light boxes, each light box
10 × 10 in. (25.4 × 25.4 cm)
Courtesy of the artist and Diaspora
Vibe Gallery, Miami, Florida

OPPOSITE, TOP
Deborah Jack
(b. Netherlands 1970;
works in United States)
**Landscape #1**, from the *Imagined
Spaces* series, 2005
Digital print, 18¹/₂ × 40 in.
(47 × 101.6 cm)
Courtesy of the artist

OPPOSITE, BOTTOM
Deborah Jack
(b. Netherlands 1970;
works in United States)
**Landscape #2**, from the *Imagined
Spaces* series, 2005
Digital print, 18¹/₂ × 40 in.
(47 × 101.6 cm)
Courtesy of the artist

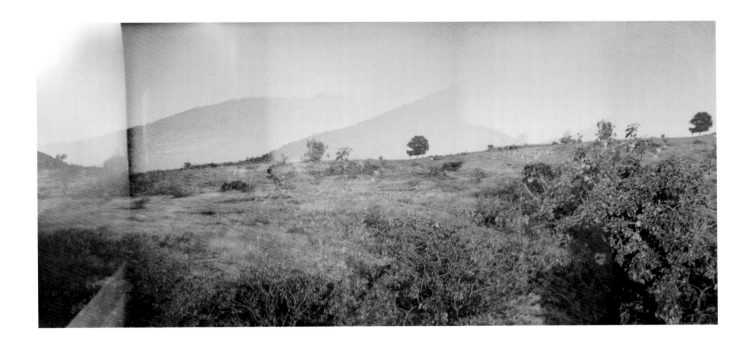

# Remy Jungerman

Coming from the multicultural society of Suriname and now living in the Netherlands, Remy Jungerman is fascinated by the way meaning changes as objects migrate into new cultural contexts. In his work, which includes sculpture, installation, video, painting, and performance, he employs a personal mythology of motifs, which are not without humor, to create layers of meaning.

In the installation *Sometimes Travelers Don't Come Back, They Become Villages Instead, Making Themselves a Place in the Elsewhere*, 1999–present, the artist has used wood, empty wine bottles, paper roses, an ironing board, and a table with monitor and video to describe this movement between places and people and the shifting of the meanings of objects between one place and another. The artist reuses his materials and incorporates new objects each time he creates his installation in a new venue. The pointed wooden rafters allude to

the dwellings of Suriname, but how the viewer interprets them and the work as a whole depends on place, time, and cultural conditioning.

One of the motifs in Jungerman's mythology is the flattened toad, a common sight on Caribbean roads, which becomes a metaphor for the risks Caribbean people face when they travel to live in First World countries and leave everything familiar behind. *Office B-Station Flattened Toad Force Dept. A'DAM*, 2004, creates a mythic office space full of jumbled wires for an army of flattened toads. The toad, which figures in Surinamese stories and myth, is an amphibian capable of adapting to different environments, but here the flattened toads are defeated by confused communication and useless bureaucracy and technology. The themes of communication, control, and power emerge again in the artist's series *Absolute Truth*, 2004.

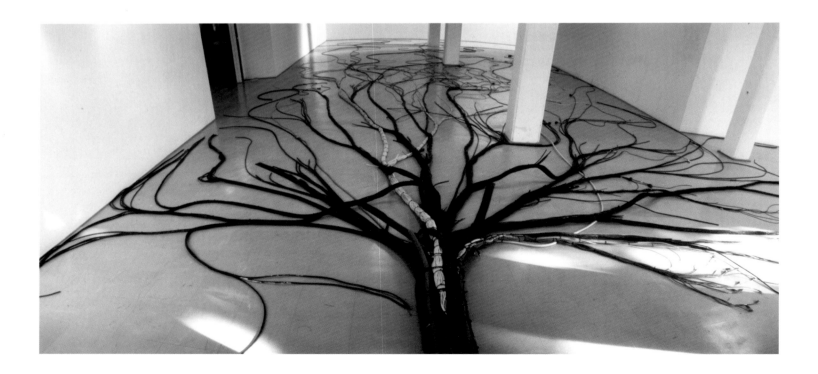

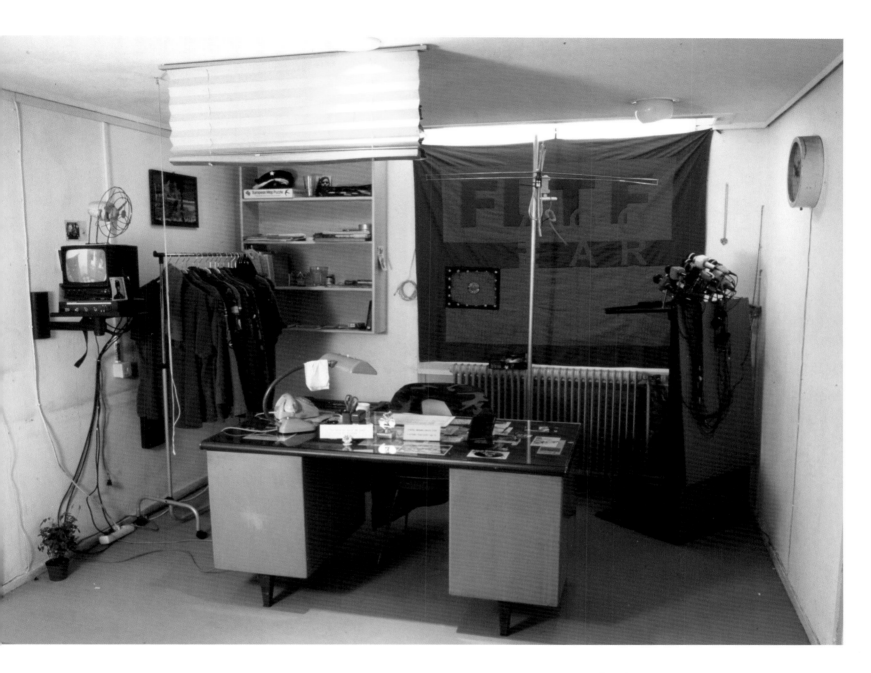

Remy Jungerman
(b. Suriname 1959; works in Netherlands)
*Absolute Truth 1*, 2004
Communication cables, cable ties,
dimensions variable
Installation at WBK Vrije Academie,
The Hague, Netherlands
Courtesy of the artist
(Photo: Ernst Moritz)

Remy Jungerman
(b. Suriname 1959; works in Netherlands)
*Office B-Station Flattened Toad Force
Dept. A'DAM*, 2004
Mixed media, dimensions variable
Installation at Arti et Amicitiae,
Amsterdam
Courtesy of the artist
(Photo: Ni Haifeng)

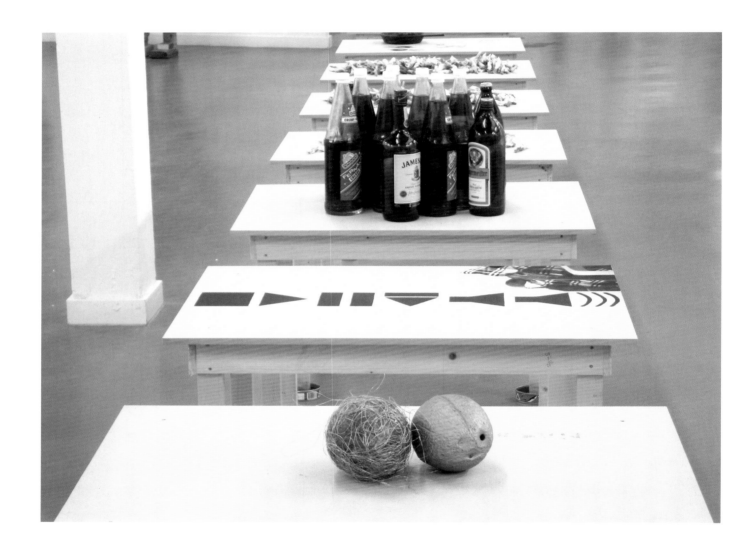

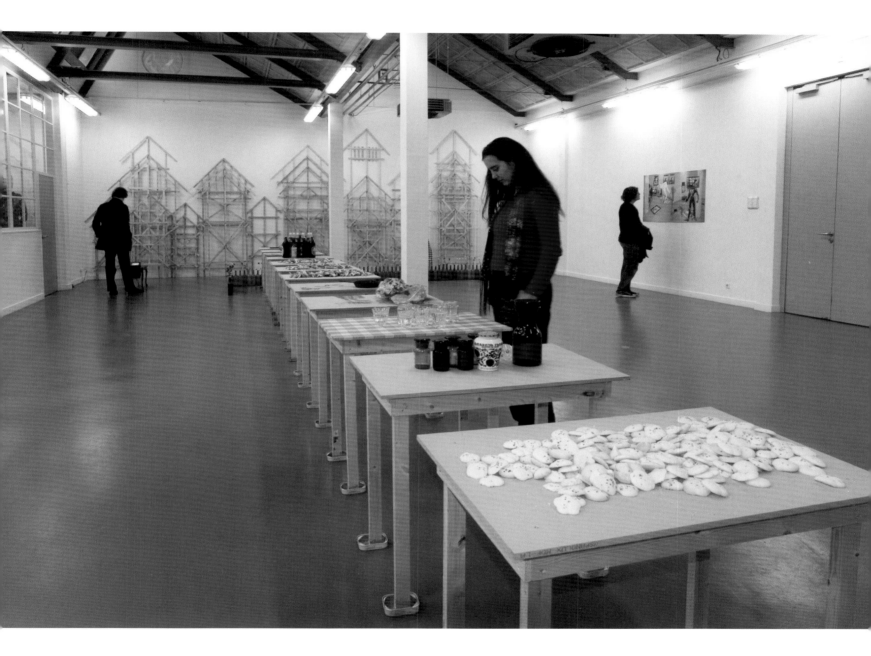

OPPOSITE AND ABOVE
Remy Jungerman
(b. Suriname 1959; works in Netherlands)
☆ ***Sometimes Travelers Don't Come Back,***
***They Become Villages Instead, Making***
***Themselves a Place in the Elsewhere****,*
1999–present
Mixed media, dimensions variable
Installation at Centrum Beeldende Kunst,
Rotterdam, 2005
Gallery Lumen Travo, Amsterdam
(Photo: Bob Goedewagen)

# Glenda León

The simplicity of the imagery and execution of Glenda León's work is based in Minimalist and Conceptual art. In her sculpture, photography, drawing, and video work, León creates a world within a world by elevating mundane scenes and materials into surreal works of art.

*Prolongación del deseo (Extension of Desire)*, 2005, is a meditation on the queue, which the artist calls a symptom of revolutionary Cuba. It is common to have to line up for everything one wants in Cuba, and this queue creates a great expectation or desire for the much-needed service or supplies. Perhaps León's line is a metaphor for failure on the part of socialist governments, or for a strategy of community building.

Here she photographed the line at the famous state-run ice-cream shop called Coppelia, where people socialize as they wait patiently for hours. Through digital technology, León combined and altered approximately one hundred shots taken over twelve hours to create a magical reality of an everyday scene.

The artist's transformation of the simple and mundane can be seen in two earlier works as well. *Linea mastica (Chewed Line)*, 2003, shows a piece of gum that has been chewed and stretched out to form a pink "brushstroke." In her video *Destino (Destiny)*, 2003, she edits footage of traffic taken over twelve hours to simulate unlikely encounters and convergences.

BELOW AND FOLLOWING PAGES
Glenda León
(b. Cuba 1976;
works in Cuba and Germany)
☆ *Prolongación del deseo*
*(Extension of Desire)*, 2005
Lambda print,
2 ³/₈ × 128 in. (5.8 × 325 cm)
Courtesy of the artist

Glenda León
(b. Cuba 1976;
works in Cuba and Germany)
*Línea mastica (Chewed Line)*
(detail), 2003
Chewing gum on plastic,
2³⁄₈ × 47¹⁄₄ in. (6 × 120 cm) overall
Courtesy of the artist

Glenda León
☆ *Prolongación del deseo (Extension of Desire)* (detail)

Glenda León
(b. Cuba 1976;
works in Cuba and Germany)
☆ **Destino** *(Destiny)*, 2003
Single-channel DVD,
color, sound, 55 sec.
Courtesy of the artist

Glenda León
(b. Cuba 1976;
works in Cuba and Germany)
*Tu ropa es mi ropa*
*(Your Clothes Are My Clothes)*, 2006
Digital print on fabric,
197 × 70⁷/₈ in. (500 × 180 cm)
Courtesy of the artist

# Hew Locke

The London-based artist Hew Locke counts Kurt Schwitters (the early modernist who incorporated recycled everyday objects in his assemblages) as one of several artistic influences on his work. Other visual influences include the Renaissance painter Piero della Francesca; the eighteenth- and nineteenth-century English caricaturists George Cruikshank and Thomas Rowlandson; the life, landscape, and dress of Guyana, where Locke was raised; symbols of British royalty including the coat of arms and the queen's head from stamps and coins; images of the royal family in the mainstream press; and imagery of Catholic icons. These varied elements drawn from high and low culture coalesce in a body of humorous and grotesque sculpture, installation, painting, and drawing that uses signs and symbols associated with nationalism to address the drama, memory, and history of colonialism throughout the African diaspora.

Locke's works, which incorporate popular items that he finds in flea markets and variety stores, transform symbols of colonial power and prestige into obscure fantastical icons. *El Dorado*, 2005, a portrait of the Queen of England created with silver plastic swords, blue and gray lizards, green and pink flowers and feathers, gold guns, and a range of other plastic objects, offers a commentary on the violence inherent in conquering lands and obtaining wealth. *Cardboard Palace*, 2002, and *Hemmed in Two*, 1999–2004—huge works that represent icons of colonialism, the palace and the ship—may refer to the fragile, "cardboard" nature of monarchical power.

The artist will create a new work for *Infinite Island: Contemporary Caribbean Art*.

Hew Locke
(b. United Kingdom 1959)
☆ *El Dorado*, 2005
Mixed media,
114 1/4 × 68 7/8 × 23 5/8 in.
(290 × 175 × 60 cm)
West Collection, Philadelphia
(Photo: FXP Photography)

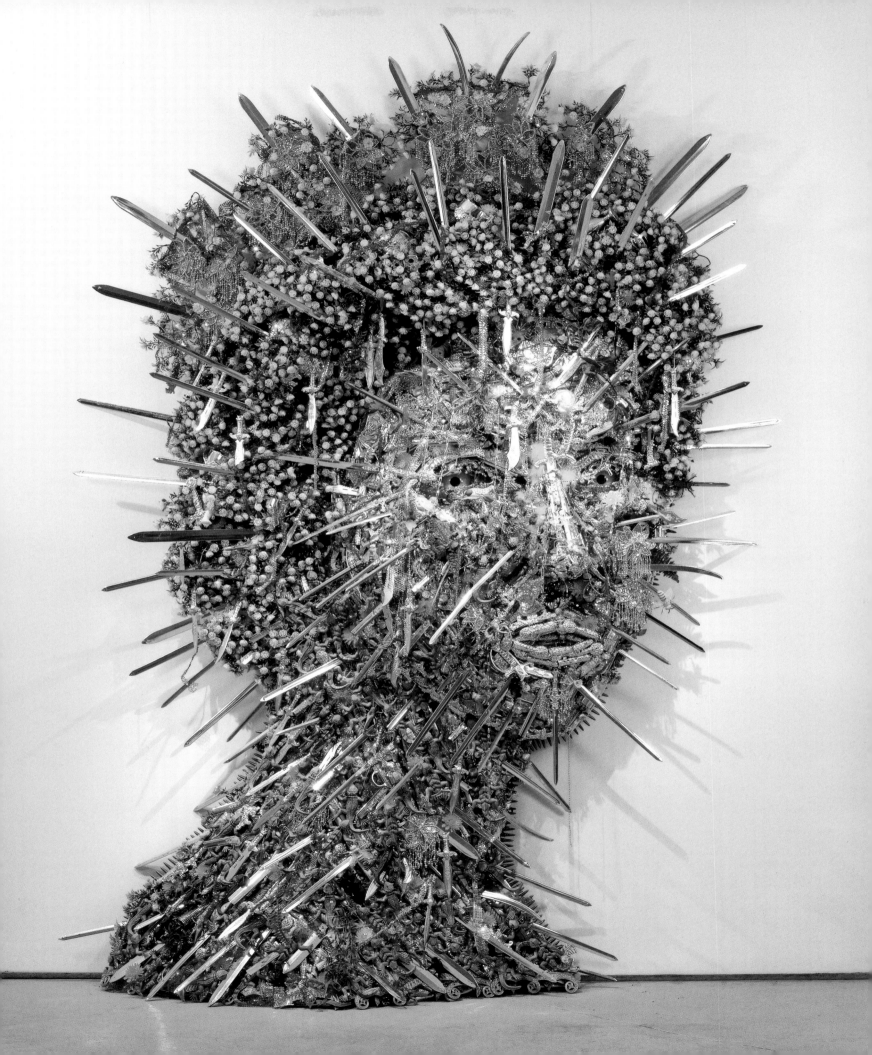

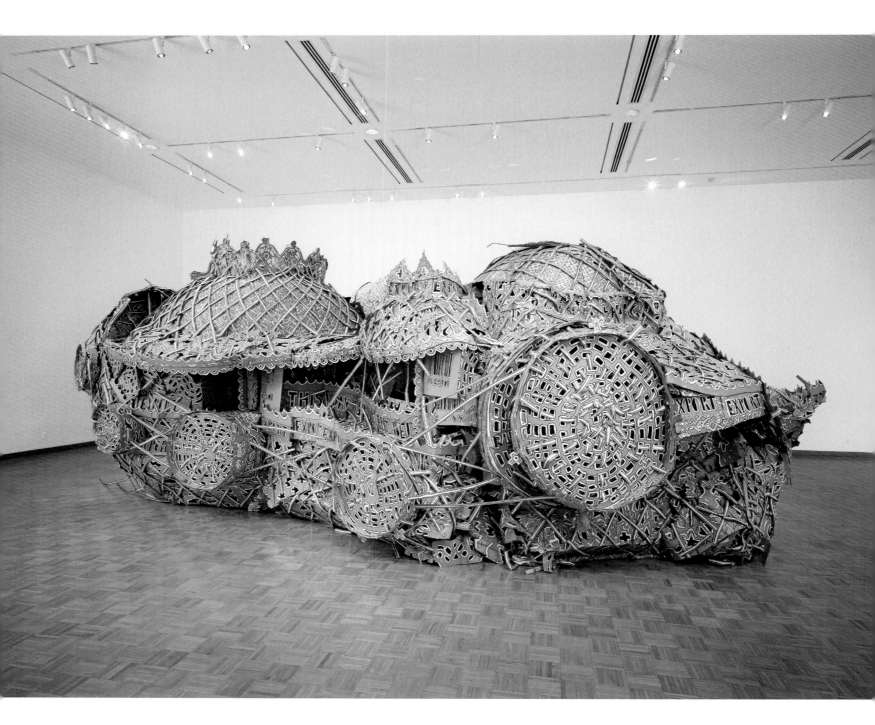

Hew Locke
(b. United Kingdom 1959)
**Hemmed in Two**, 1999–2004
Cardboard, acrylic, marker pen, wood, mixed media,
39 ft. 7$\frac{1}{2}$ in. × 26 ft. 3 in. × 13 ft. 1$\frac{1}{2}$ in. (4 × 8 × 12 m)
Installation at Luckman Gallery, California State
University, Los Angeles
Collection of Eileen Harris Norton and Peter Norton,
United States
(Photo: Joshua White)

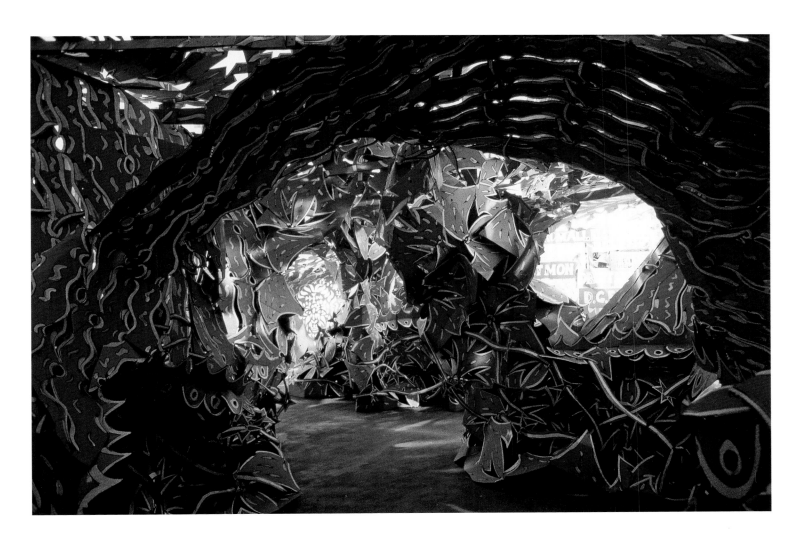

Hew Locke
(b. United Kingdom 1959)
*Cardboard Palace*, 2002
Cardboard, acrylic, marker pen, wood,
mixed media,
13 ft. 1½ in. × 36 ft. 1 in. × 65 ft. 7⅝ in.
(4 × 11 × 20 m)
Installation at Chisenhale Gallery,
London
(Photo: Steve White)

# Miguel Luciano

In recent years Miguel Luciano has focused on making art that is accessible to a broad public. He does this with a playfulness and candor that appeal to people of all ages. This playfulness belies the seriousness of his subjects, which at their core address the sometimes painful history and relationship between Puerto Rico and the United States and the continuation of colonial subjugation in the age of globalization.

Luciano associates frenzied consumerism with an "illusion of empowerment," an idea that he plays with in one of his most popular works, *Cuando las gallinas mean (When Hens Pee)*, 2003. The title comes from a Puerto Rican expression (translating literally as "Children speak when hens pee"), whose meaning is "Children should be seen and not heard." The saying here alludes to the issue of free speech and censor-

ship. In Luciano's interactive installation a hen does pee, activated by a vending machine that subsequently releases an egg. Each egg contains a prize designed by a community member who "speaks out" about a particular social or personal issue.

In a series of paintings done in 2000 based on vintage labels from early twentieth-century Louisiana produce crates, Luciano explored racist attitudes that were established in the earliest representations of Puerto Rican immigrants and still pervade corporate marketing and stereotyping. He again playfully transforms stereotypes in *Pure Plantainum*, 2006, a platinum-plated plantain that is part of a series of jewelry and other sculptural objects. The artist converts the plantain into a precious icon that seems to buy into materialistic values.

LEFT AND OPPOSITE
Miguel Luciano
(b. Puerto Rico 1972; works in United States)
***Cuando gallinas mean (When Hens Pee)***, 2003
Coin-activated vending machine,
60 × 30 × 30 in. (152.4 × 76.2 × 76.2 cm)
Installed at El Pueblo Meat Supermarket,
Newark, New Jersey, 2003
Courtesy of the artist

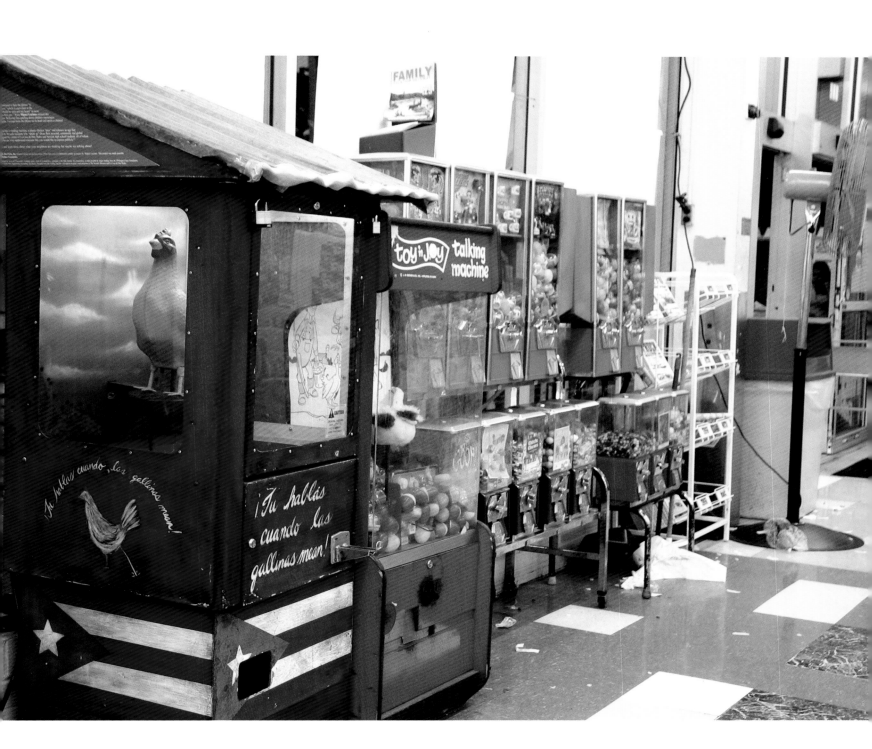

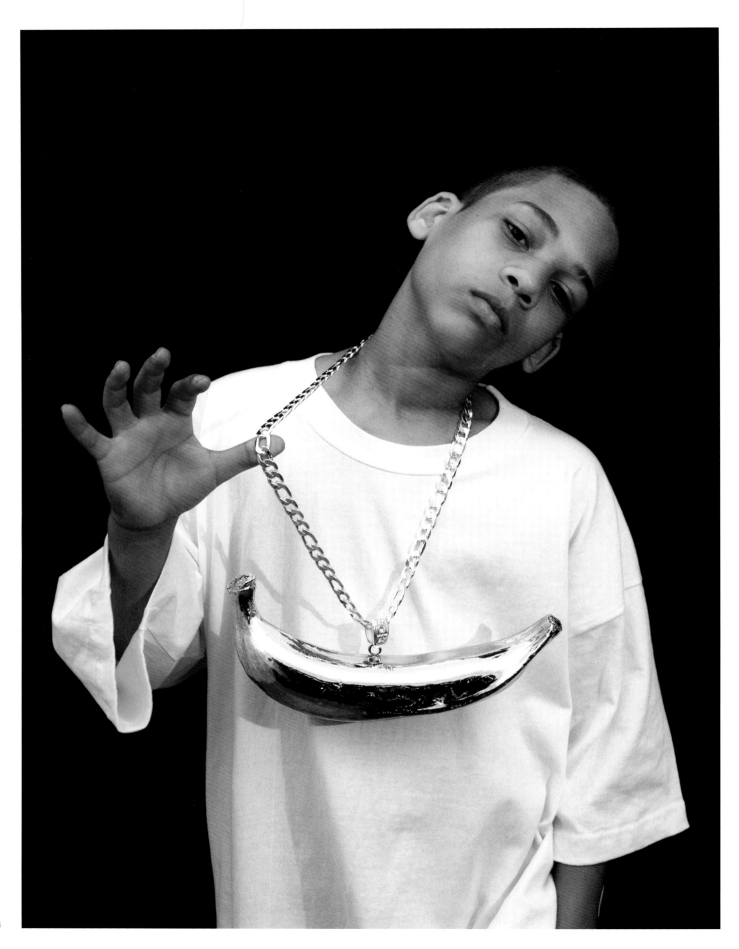

RIGHT, TOP
Miguel Luciano
(b. Puerto Rico 1972;
works in United States)
***Plantainum Pendant at King
of Platinum, 125th Street***
(detail), 2006
Chromogenic print,
24 × 36 in. (61 × 91.4 cm)
Courtesy of the artist

RIGHT, BOTTOM
Miguel Luciano
(b. Puerto Rico 1972;
works in United States)
☆ ***Pure Plantainum***, 2006
Platinum-plated plantain in
glass vitrine, 8 × 16 × 7 in.
(20.3 × 40.6 × 17.8 cm)
Courtesy of the artist

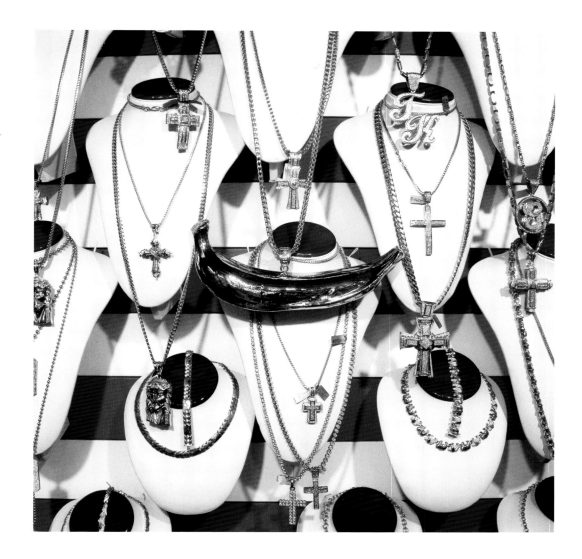

OPPOSITE
Miguel Luciano
(b. Puerto Rico 1972;
works in United States)
☆ ***Plantano Pride***, 2006
Chromogenic print,
40 × 30 in. (101.6 × 76.2 cm)
Courtesy of the artist

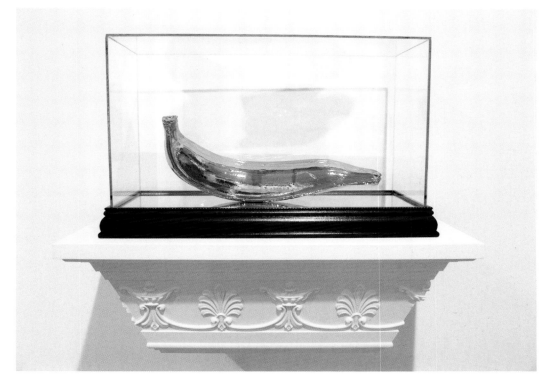

# Tirzo Martha

The installations and assemblages of the Curaçaoan artist Tirzo Martha present what he calls "an existential analysis" of contemporary Caribbean societies, which he finds haunted by a spirit of doubt and uncertainty about their heritage. Martha eschews traditional paintings of palm trees and beaches to challenge existing stereotypes about what constitutes Caribbean art, creating assemblages that sometimes resemble altars. *Spirit of the Caribbean*, 2005, is a diptych of two altars. One, with a sign that translates "Your destiny is in your hands," holds items related to work and material satisfaction such as bottles of champagne and mouthwash and a tube of toothpaste, and the other, with a sign saying "It's God's will," bears religious items including a rosary, a cross, a saint's prayer card, and religious statuettes. The altars, referring to the small altars and the displays of trophies and diplomas in Caribbean homes, also reflect a psychological schism between the two extremes of faith and personal achievement. Supporting the altar shelves are construction hats and a wooden log painted white and pierced with iron pins, inspired by African Nkondi figures used for spiritual divination.

*Reality of a Poor Man*, 2004, features domestic objects that include not only floral and everyday elements such as a man's white briefs and a television set but items that evoke darker themes: a glass jar containing used ammunition, a teddy bear tied up with duct tape, a chair whose balusters hang over the television like prison bars. In these elements we can read the reality of a life that is influenced by financial hardship and a commentary on the violence of war and the media propaganda that have subjugated Caribbean populations.

Martha's installation *Land of Blood*, 2001, a memorial shrine on a Curaçao plantation that was a major site of slave revolt, commemorates the rebellion of slaves and celebrates the spiritual connection between the living and the dead.

Tirzo Martha
(b. Curaçao 1965)
☆ **Spirit of the Caribbean**, 2005
Mixed-media installation,
157¹/₂ × 74⁷/₈ × 37 in.
(400 × 190 × 94 cm)
Courtesy of the artist

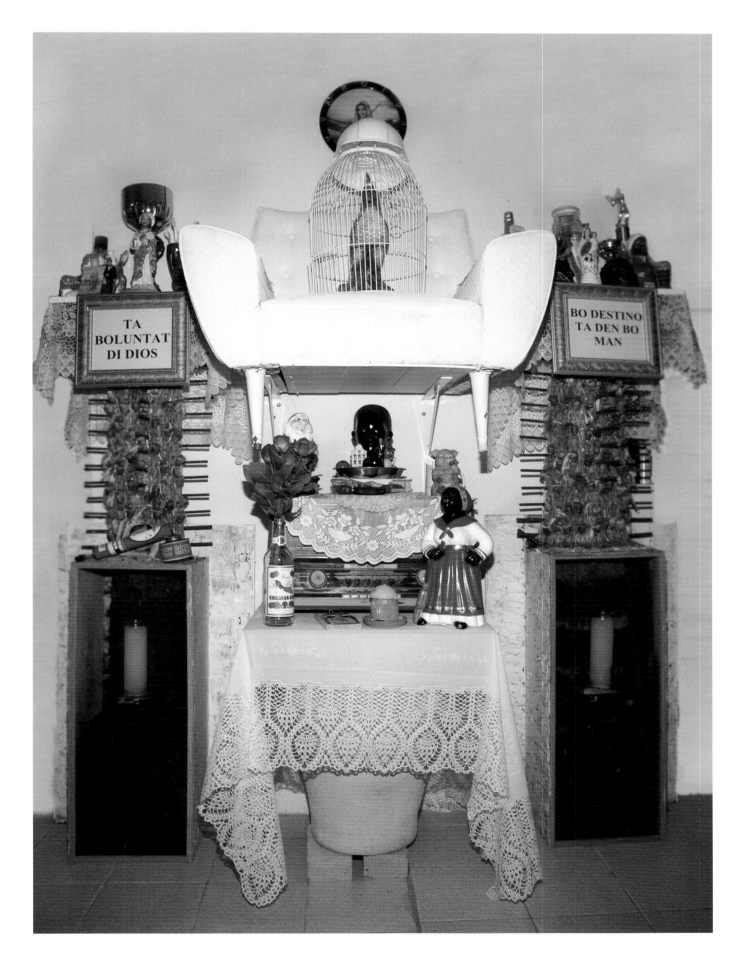

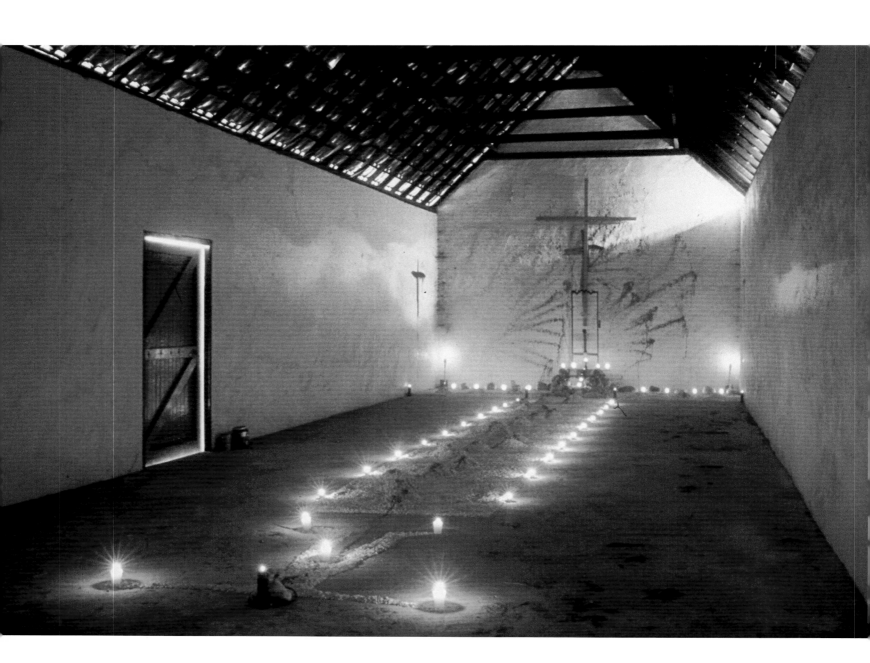

Tirzo Martha
(b. Curaçao 1965)
*Land of Blood*, 2001
Mixed-media installation,
19 ft. 7½ in. × 55 ft. 9 in. × 13 ft. 1½ in.
(6 × 17 × 4 m)
Memorial installation at Kenepa
Plantation, Curaçao
(Photo: Courtesy of the artist)

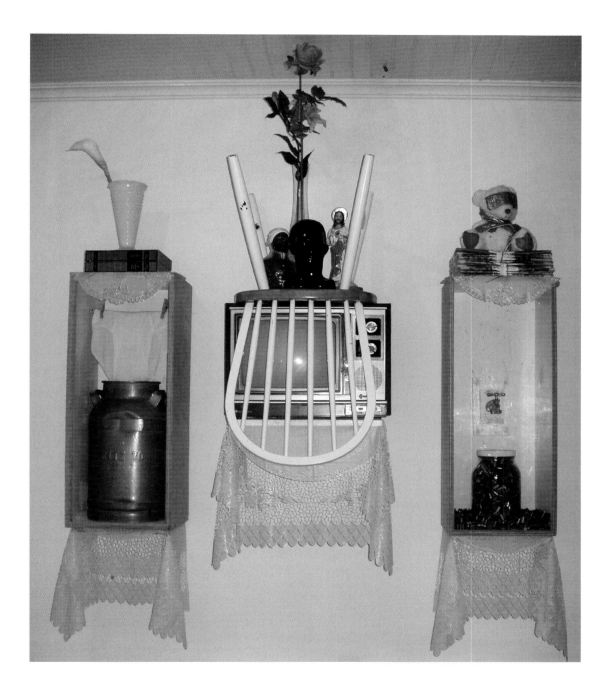

Tirzo Martha
(b. Curaçao 1965)
*Reality of a Poor Man*, 2004
Mixed-media installation,
47$^1$/$_4$ × 70$^7$/$_8$ × 23$^5$/$_8$ in.
(120 × 180 × 60 cm)
Courtesy of the artist

# Ibrahim Miranda

Although Ibrahim Miranda takes cartography, and in
particular the map of Cuba, as the foundation for his
paintings, drawings, collages, woodcuts, and screenprints, his
work transforms the scientific precision of mapmaking into
a poetic evocation of the island's continual metamorphosis.
"I try to create an unrecognizable microscopic animal
that constantly mutates, a metaphor for sociopolitical and
economic changes that Cuba as a country has constantly
undergone in its most recent history," he explains. His
approach was inspired by the poem "Noche insular, jardines
invisibles" (Island Night, Invisible Gardens), by the Cuban
writer José Lezama Lima.

In his mixed-media series *Noche insular: Metamorfosis
(Island Night: Metamorphosis)*, 2004–6, images are layered as
if in a dream. Parts of maps of the island of Cuba and its cities
float on the surface, while others disappear under multiple
forms of flora and fauna taken from natural-history books.
Miranda transforms the outline of the island into a recurrent
amoeba-like shape that he says is "a small archaic invertebrate
animal that takes us back to our infinitely far-off genesis."

Ibrahim Miranda
(b. Cuba 1969)
☆ *Noche insular: Metamorfosis (Island
Night: Metamorphosis)*, 2004–6
Vermilion, xylograph, serigraph,
varnish, mercury chromium on maps,
67 × 78¾ in. (170 × 200 cm)
Courtesy of the artist

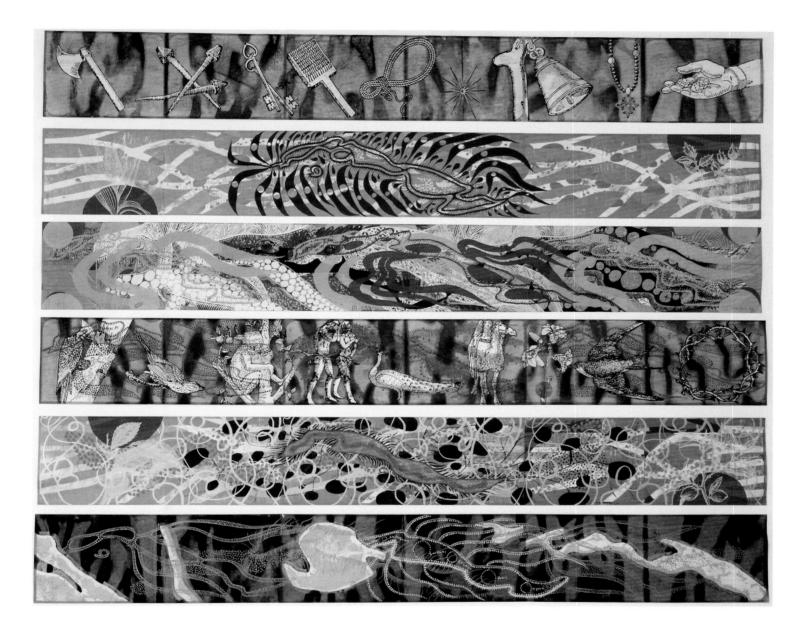

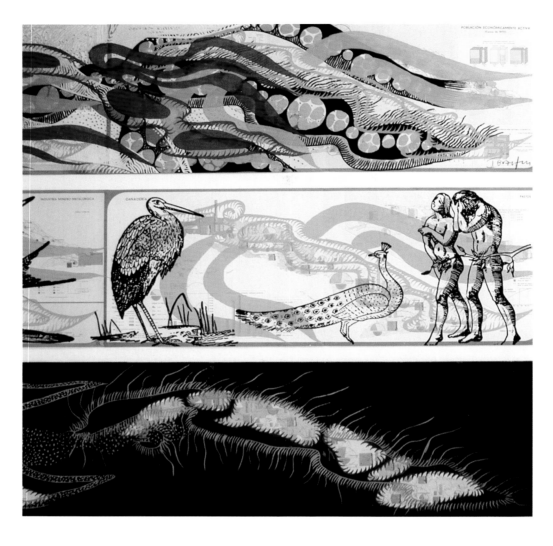

Ibrahim Miranda
(b. Cuba 1969)
☆ *Noche insular: Metamorfosis (Island
Night: Metamorphosis)*, 2004–6
Vermilion, xylograph, serigraph,
varnish, mercury chromium on maps,
dimensions variable
Installation at Galeria Rubén Martínez
Villena, Havana, Cuba, 2004
Courtesy of the artist

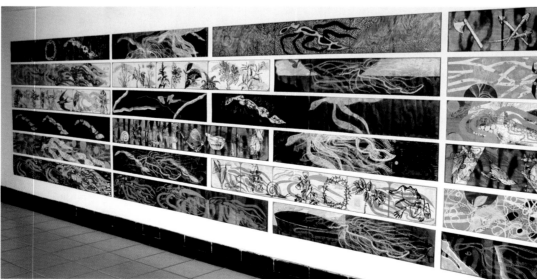

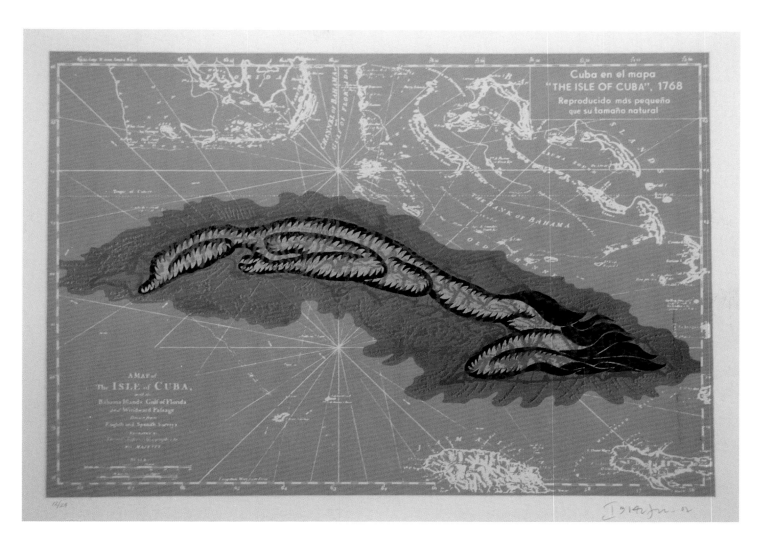

Ibrahim Miranda
(b. Cuba 1969)
*Atzolotl*, 2002
Serigraph, 15$\frac{1}{2}$ × 22$\frac{1}{2}$ in.
(39.5 × 57 cm)
Courtesy of the artist

# Melvin Moti

Born in the Netherlands to Surinamese parents, the filmmaker Melvin Moti has been interested in the layers of history that have shaped his cultural background. *Stories from Surinam*, 2002, presents the stories of indentured laborers who came from India to work on the plantations in Suriname, then a Dutch colony, between 1873 and 1916, after slavery was abolished. Interweaving interviews with elderly survivors and archival material, Moti attempts to reclaim the oral histories of their everyday lives on the plantation. The passage of time and the function of language and memory are themes that find expression in Moti's film, whose witnesses offer a subjective representation of history.

In making *Top Legs*, 2005, Moti found one of the most famous Jamaican ska dancers, Miss Daisy, and persuaded her to dance for the camera in front of her home. Miss Daisy's facial expressions, laughter, and dress convey her character as much as her dance and narration. At the age of seventy-two, she improvises a dance, shown without sound, whose music, and particular place and time, we sense through her movements.

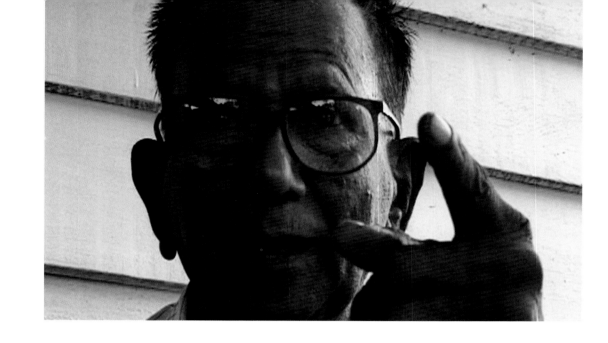

Melvin Moti
(b. Netherlands 1977)
☆ **Stories from Surinam**, 2002
Single-channel DVD, color,
sound, 35 min.
Courtesy of the artist

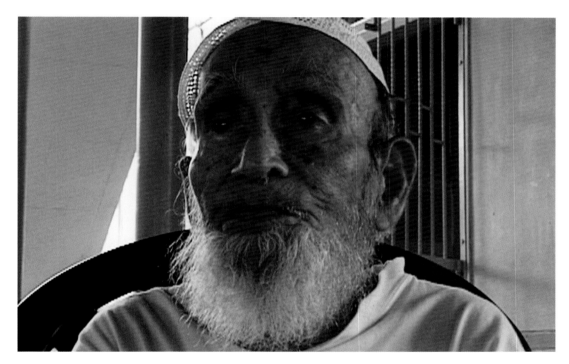

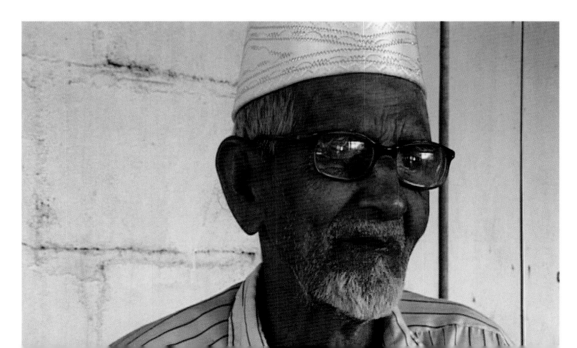

OPPOSITE
Melvin Moti
(b. Netherlands 1977)
☆ **Top Legs**, 2005
Single-channel DVD, color,
sound, 14 min.
Courtesy of the artist

# Fausto Ortiz

The anonymous status of undocumented immigrants—in particular, the Haitians who are victims of prejudice and negative stereotyping in the Dominican Republic—is a major concern of the Dominican photographer Fausto Ortiz. Outside the census, these immigrants live like shadows in the city, participating in the fabric of society only when needed to perform the jobs no one else will do.

The photographic medium is ideally suited to Ortiz's interest in documenting those who are undocumented. His triptych *Compartiendo la libertad (Sharing Freedom)*, 2004, shows two men leaning against a wall as they wait, in vain perhaps, for something to occur. The shadow of the wire fence is a subtle yet poignant reminder of the barriers and borders that separate countries and people. The invisibility and alienation of illegal migrants are suggested by the ghost of a shadow in the last part of the triptych. *Ciudad de las sombras (City of Shadows)*, 2003, again employs the image of a shadow. Here it is all we see, a specter of the undocumented people, not only in the Dominican Republic but around the world.

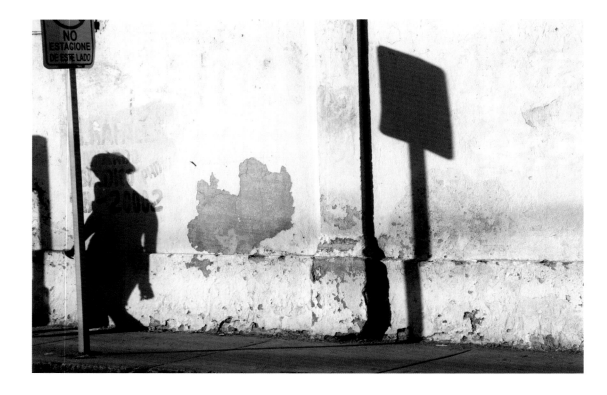

Fausto Ortiz
(b. Dominican Republic 1970)
***Caminante (Pedestrian)***, 2005
Digital print, 20 × 70 in.
(50.8 × 177.8 cm)
Courtesy of the artist

Fausto Ortiz
(b. Dominican Republic 1970)
**Sombras de acero**
**(Steel Shadows)**, 2003
Triptych of digital prints,
20 × 70 in. (50.8 × 177.8 cm)
Courtesy of the artist

Fausto Ortiz
(b. Dominican Republic 1970)
☆ *Ciudad de las sombras*
*(City of Shadows)*, 2003
Diptych of digital prints,
25¹⁄₄ × 57¹⁄₈ in. (64 × 145 cm)
Centro León, Santiago, Dominican
Republic

Fausto Ortiz
(b. Dominican Republic 1970)
☆ *Compartiendo la libertad*
*(Sharing Freedom)*, 2004
Triptych of digital prints,
25¹⁄₄ × 73⁵⁄₈ in. (64 × 187 cm)
Courtesy of the artist

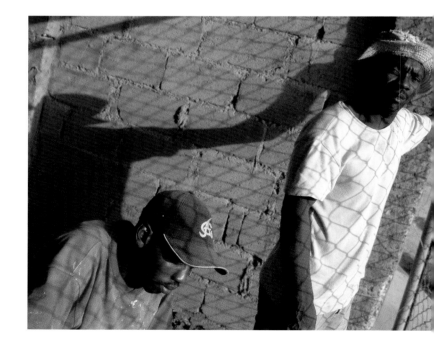

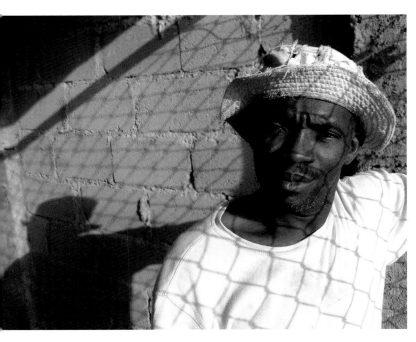

# Steve Ouditt

In his art and writings, the Trinidadian artist Steve Ouditt reflects on the legacy of colonialism as present in the global economy. *Plantation Economy and Trademark Capital*, 2006, is an installation of pictograms that were custom-designed for the exhibition *Rethinking Nordic Colonialism* in Reykjavik, Iceland. The interactive installation is part of a long-term educational project designed to stimulate an inquiry into colonialism. The flashcard-like pictograms not only function as a storyboard in the gallery but are intended for distribution beyond the exhibition among people of different social strata. The colorful, graphic images, which the artist says "reflect and speculate on social, cultural, political, and business exchanges and the colonial imagination from the past, through the present and to the future," represent the industries and functions that define social roles and therefore define identity, such as "policing," "entertainment," "tourism," "field labour," "communications," and "mental health care."

Ouditt's *Creole Processing Zone*, 2000, is an installation fashioned after a warehouse in a Free Trade Zone, or Export Processing Zone, where migrant laborers working in nineteenth-century conditions are often exploited by multi-national corporations benefiting from incentives in developing countries. The artist says that the installation interprets these areas as "processing zones that trade in Creole equity."

The artist will create a new work for *Infinite Island: Contemporary Caribbean Art.*

LEFT AND OPPOSITE
Steve Ouditt
(b. Trinidad 1960)
***Plantation Economy and Trademark Capital***, 2006
Digital graphic images silk-screened with inks on
card stock, dimensions variable
Installation at the Living Art Museum, Reykjavik,
Iceland
Courtesy of the artist

Steve Ouditt
*Plantation Economy and Trademark Capital* (selected pictogram cards): (clockwise from top left) *Animal Farming*, *Entertainment?*, *Tourism*, *Policing*, *Natural Science*, *Surveillance*

Steve Ouditt
*Plantation Economy and Trademark Capital* (selected pictogram cards): (clockwise from top left)
*Military, Industrial, Government, Field Labour, Free Trade Zones, Agriculture*

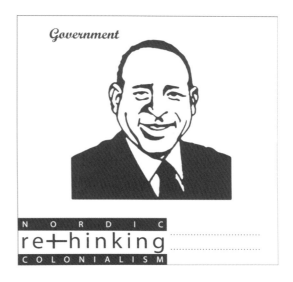

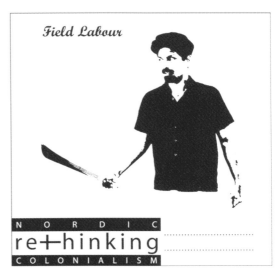

# Raquel Paiewonsky

As manifested by the prosthesis-like appendages in her art, Raquel Paeiwonsky's oeuvre centers on the transformation and mutation of the body. Her paintings, sculptures, installations, and photographs are explorations of the postmodern world that resonate with social and psychic symbolism.

In Paiewonsky's *Ima diptico (Ima Diptych)*, 2005, and *Sembrada*, 2005, stockings that bind or cover the woman's face, in conjunction with the fertility symbol of multiple breasts or a pregnant belly, evoke the oppression of women as well as the power and strength of the female body. The female figure also appears in the *Sin titulo* series of 2004, which reflects the artist's preoccupation with the female form and women's precarious place in society, with the female body and face appearing fractured and tortured. The installation *Levitando: A un solo pie (Levitating: On One Foot)*, 2003, also sounds the theme of the insecurity of women's social position. Wax casts of feet are suspended from the ceiling by stockings. The feet seem to try, unsuccessfully, to touch the floor, but fail to reach firm ground.

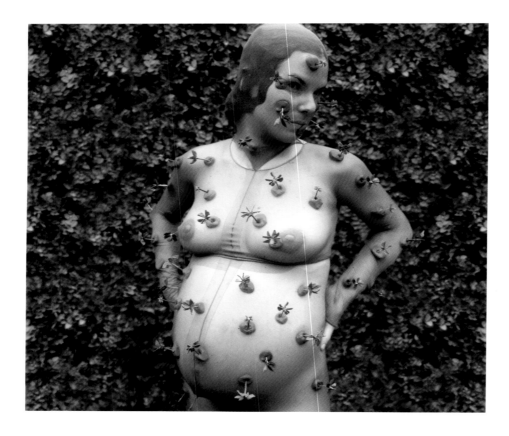

Raquel Paiewonsky
(b. Dominican Republic 1969)
**Sembrada**, 2005,
from the *Mutantes (Mutants)* series
Digital print, 16½ × 18⅞ in.
(42 × 48 cm)
Courtesy of the artist

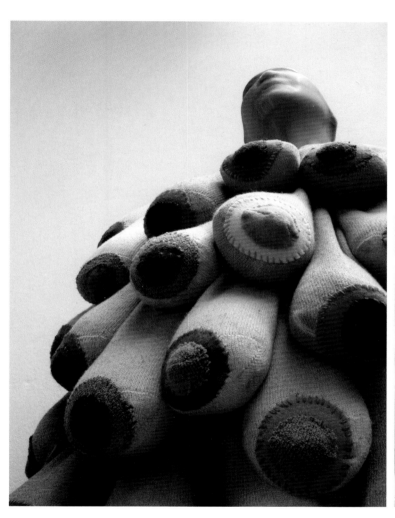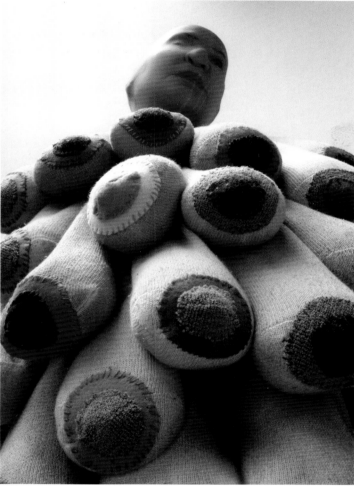

Raquel Paiewonsky
(b. Dominican Republic 1969)
*Ima diptico (Ima Diptych)*, 2005
Diptych of digital prints,
27 × 36 in. (68.6 × 91.4 cm)
Courtesy of the artist

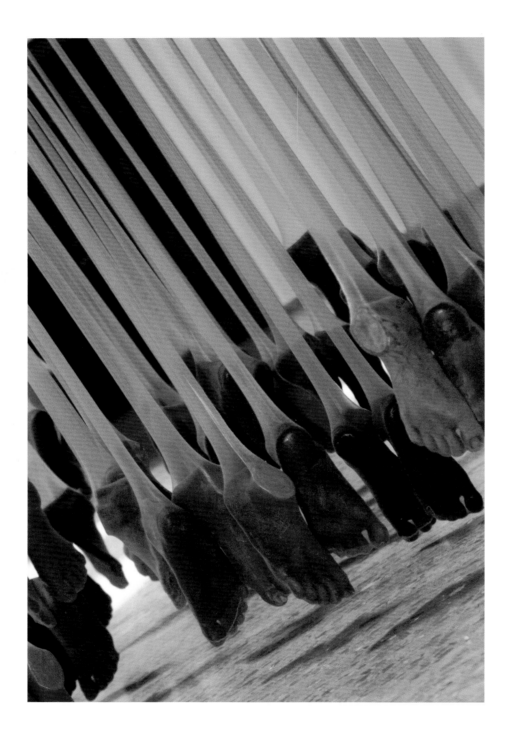

LEFT AND OPPOSITE
Raquel Paiewonsky
(b. Dominican Republic 1969)
☆ *Levitando: A un solo pie*
*(Levitating: On One Foot)*, 2003
Beeswax, panty hose, cable,
118 1/8 × 118 1/8 × 157 1/2 in. (300 × 300 × 400 cm)
Installation at Museo de Arte Moderno,
Santo Domingo, Dominican Republic
Courtesy of the artist
(Photo: Ruy Dos Santos)

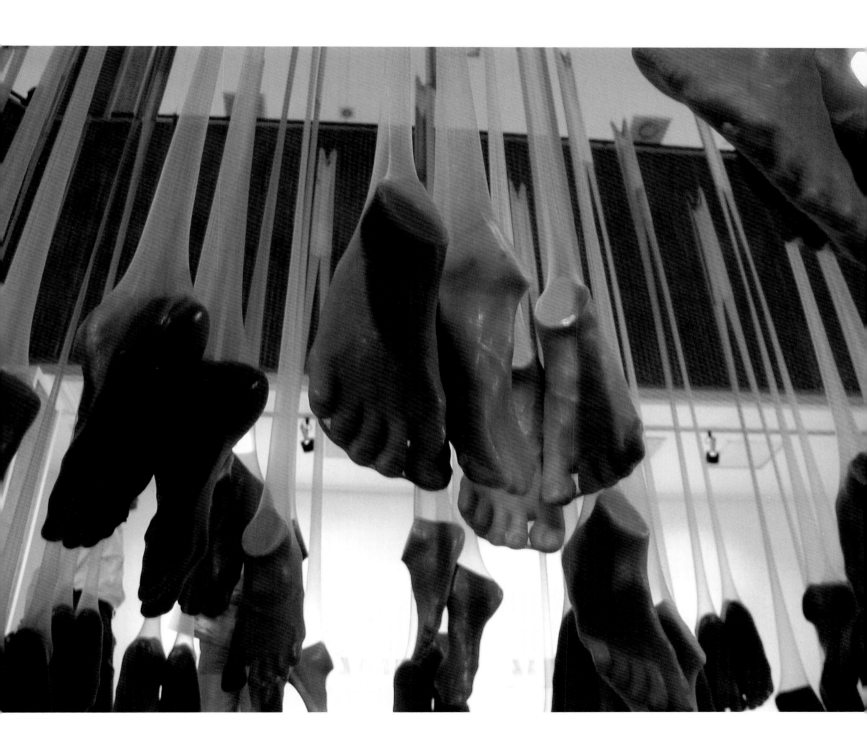

# Ebony Grace Patterson

Ebony Grace Patterson uses printmaking, drawing, painting, and sculpture to bring to life a vision of feminine beauty that is radically different from the cookie-cutter images propagated by the media. The artist states that she is fascinated by the female body—how it looks, feels, smells, and functions. Although it begins with a very personal look at her own body, Patterson's work addresses universal female issues such as menstruation and weight gain and celebrates beauty in diversity while ruminating on the body's vulnerability to disease and decay.

Maggot-filled meat, sanitary napkins, and bloody tampons are just some of the shocking elements of this young artist's work. Drawing from influences as diverse as her fellow Jamaican artist and close friend Keisha Castello, the Young British Artist Jenny Saville, and historical female iconography including the prehistoric Venus of Willendorf and Venus of Tan-Tan, and the nineteenth-century "Hottentot Venus," Patterson has been able to forge strong statements of her own about female identity and the place of black women in society.

As seen in *Untitled*, 2005, from the *Venus Inverts* series, Patterson's female forms are far from model-thin— Rubenesque with rolling stomach, ripe-to-bursting breasts, and thick thighs—and are without head, arms, and legs. This truncation of the female body, together with the artist's use of repeated patterns, transforms the black Venuses into a vision of beauty outside the norm. The headless state of the black Venuses may be suggestive of the invisibility in society of the black woman, who has been denied a voice and an identity because she has not fit the conventional media-derived definition of beauty. The bodies in *Untitled* confront the viewer with a strong, proud declaration of self in defiance of societal dictates that try to pigeonhole women in strict behavioral and aesthetic categories.

Ebony Grace Patterson
(b. Jamaica 1981)
☆ *Untitled*, from the *Venus Inverts* series, 2005
Collagraphs, 96 × 192 in. (243.8 × 487.7 cm) overall
Courtesy of the artist

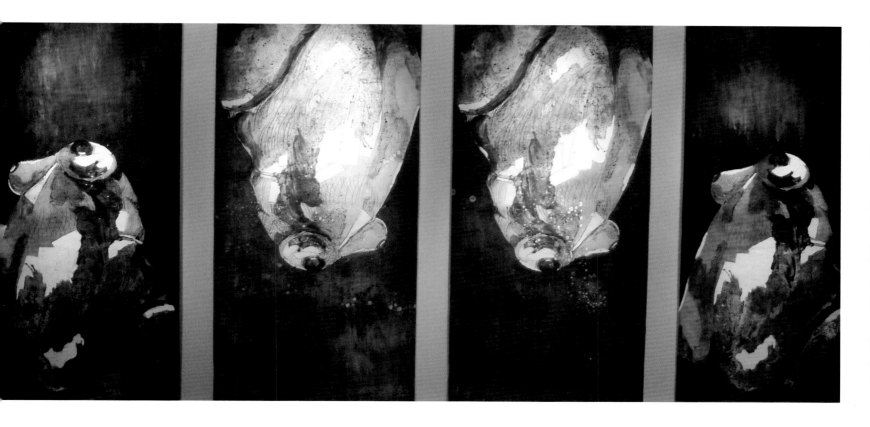

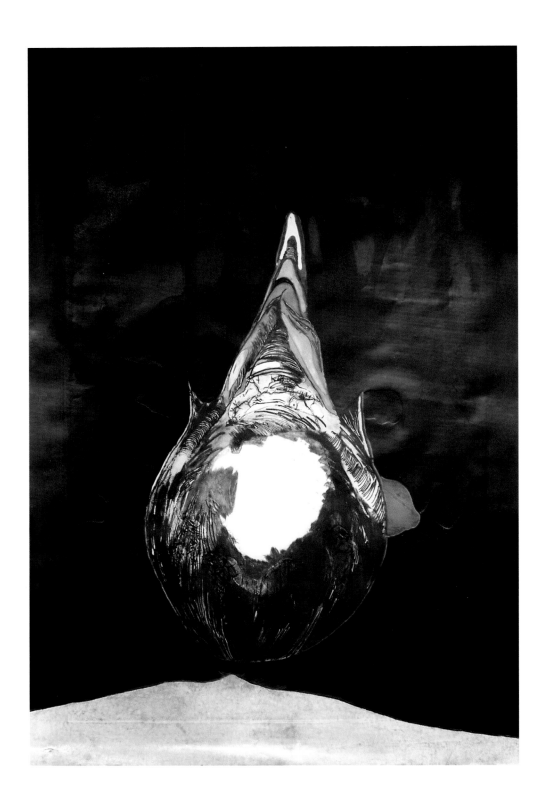

Ebony Grace Patterson
(b. Jamaica 1981)
*Vulva II*, 2006
Monoprint, 108 × 60 in.
(274.3 × 152.4 cm)
Courtesy of the artist

Ebony Grace Patterson
(b. Jamaica 1981)
*Hybrid Thing*, 2006
Monoprint, 132 × 60 in.
(335.3 × 152.4 cm)
Courtesy of the artist

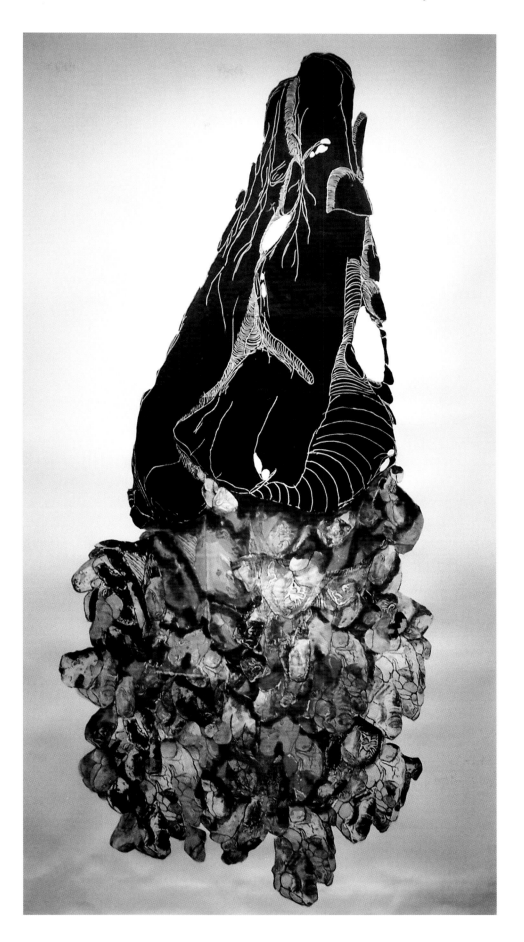

# Marta Maria Pérez Bravo

Marta Maria Pérez Bravo creates photographs that are deeply immersed in the Afro-Cuban religions of Santeria and Palo Monte. Using the body to search for meaning and identity, she evokes a range of rituals such as initiations, sacrifices, libations, sacraments, and communions. Pérez Bravo often presents her body as an altar or vessel to emphasize the personal connection to the spiritual world that is characteristic of many Afro-Caribbean religions. Her autobiographical work of the 1990s deals with her own maternity, and her more recent photographs allude to the importance of spirituality in her life, drawing from a long history of personal exploration in these highly symbolic religions whose deities, Pérez Bravo says, endorse female presence. Prominent among them is the West African Yoruba mother goddess Yemoja, a compassionate healer associated with the moon, the ocean, and womanhood who became Agwe in Vodun, Yemaya in Santeria, and Yemanja in Brazil's Candomble. This sense of a nurturing female deity is conveyed in the imagery of Pérez Bravo's work.

The artist creates tableaux in which her body—adorned with headdress or cross or shown amid everyday items such as bowls, crosses, candles, and thread—becomes imbued with aspects of the divine and morphs into a symbol of ritual. Her scenes, she says, "cross borders between sacred and profane." In the *Nunca me abandona (It Never Leaves Me)* series of 2001, the artist has drawn a black outline around her body and negated parts of her facial features. It is almost as if Pérez Bravo is elevating her own body to the level of the spirit world.

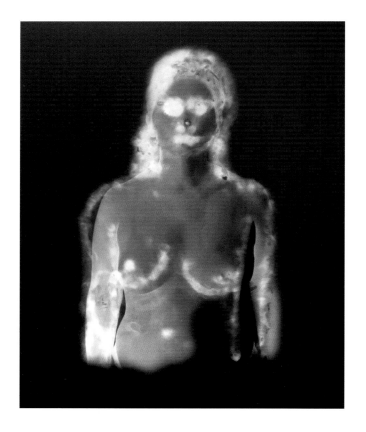

Marta Maria Pérez Bravo
(b. Cuba 1959)
**Nunca me abandona
(It Never Leaves Me)**, 2001
Photographic negative,
59 × 48 in. (150 × 122 cm)
Courtesy of the artist and Galeria
Fernando Pradilla, Madrid

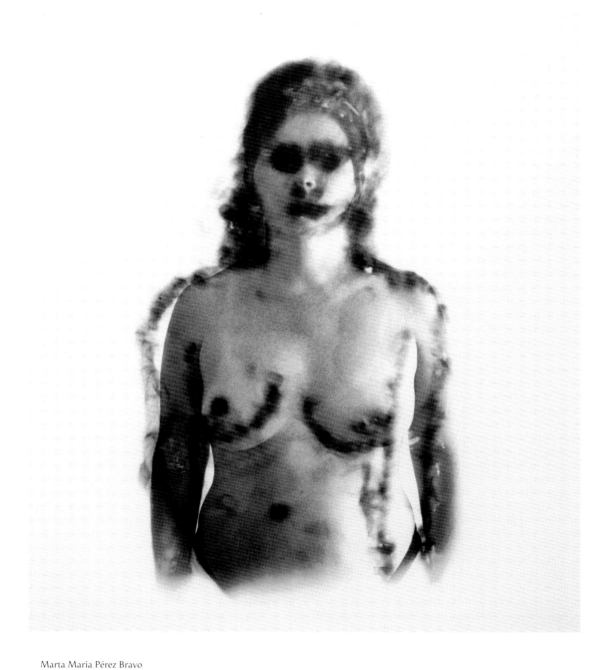

Marta Maria Pérez Bravo
(b. Cuba 1959)
☆ *Nunca me abandona I*
*(It Never Leaves Me I)*, 2001
Digital print, 59 × 48 in.
(150 × 122 cm)
Courtesy of the artist and Galeria
Fernando Pradilla, Madrid

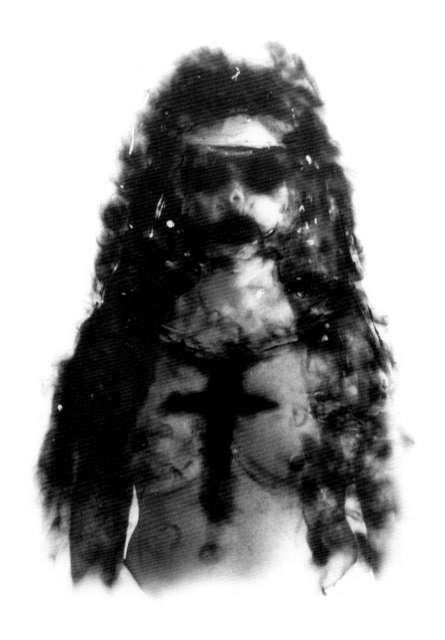

Marta Maria Pérez Bravo
(b. Cuba 1959)
☆ *Nunca me abandona II*
*(It Never Leaves Me II)*, 2001
Digital print, 59 × 48 in.
(150 × 122 cm)
Courtesy of the artist and Galeria
Fernando Pradilla, Madrid

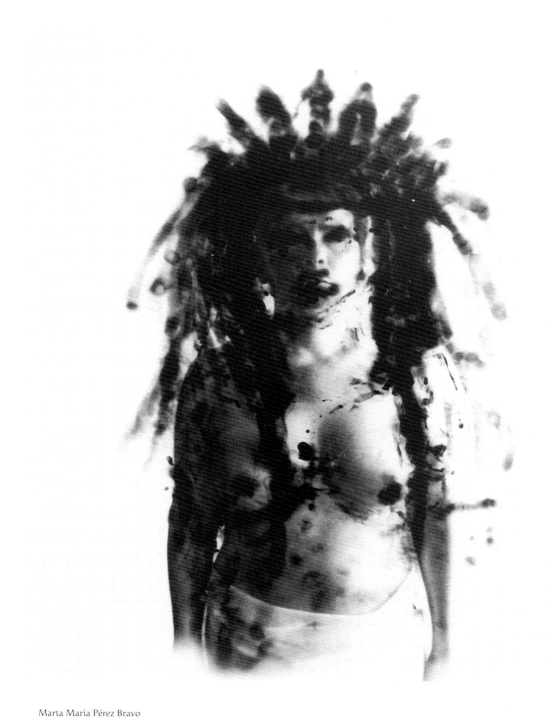

Marta Maria Pérez Bravo
(b. Cuba 1959)
☆ *Nunca me abandona III*
*(It Never Leaves Me III)*, 2001
Digital print, 59 × 48 in.
(150 × 122 cm)
Courtesy of the artist and Galeria
Fernando Pradilla, Madrid

# Marcel Pinas

Marcel Pinas comes from the Ndjuka tribe of Suriname's Maroon community, descendants of fugitive African slaves. His assemblage *Afaka kibi supun (Afaka Protect the Spoon)* and his installation *Kuku (Kitchen)*, both 2005, have several things in common: spoons, Ndjuka carving motifs, and a title derived from Afaka, the script created in the early twentieth century that is used by the Maroon community of Suriname. It is customary in Ndjuka culture to decorate domestic tools such as spoons with imagery as a means of beautifying objects, communicating with loved ones, or recording a message about some occurrence in everyday life.

Pinas's work reflects his interest in preserving the Maroon culture, threatened by globalization, for future generations of Surinamese. In his words, *Kuku* "is a traditional kitchen that I have transformed into an art object. This is the way the plates [and] spoons are displayed in the Maroon hut." Of the allegorical *Afaka kibi supun* he says: "Preservation of the culture does not have to be always in the museum but by using it in daily life. The Afaka sign has been used to protect the spoons that symbolize the Maroon community." The education of the young in the Maroon community is particularly important to Pinas in connection with keeping his culture alive. His installation *School te Pilgrim Kondre (School at Pilgrim Village)*, 2005, shows classroom desks and a blackboard decorated and protected with icons to draw attention to imparting knowledge of this living culture to a future generation.

In addition to his sculptures and installations of everyday objects decorated with symbols of his Maroon culture, Pinas does paintings and collages on canvas, paper, and wood, incorporating fabric, wicker, and other traditional Maroon objects as well as painted Ndjuka symbols and Afaka script. By drawing his subjects and themes from this native culture and using a combination of traditional media with local materials that are readily available, Pinas makes art that is a form of preservation.

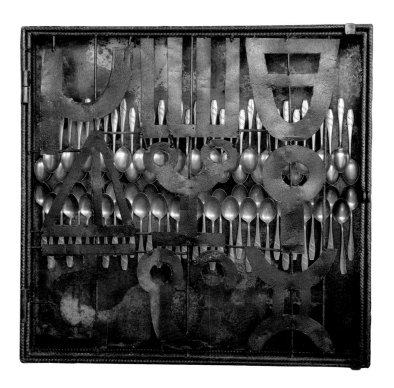

Marcel Pinas
(b. Suriname 1971)
☆ *Afaka kibi supun
(Afaka Protect the Spoon)*, 2005
Iron and aluminum spoons on
board, 23⅝ × 31½ × 3⅞ in.
(60 × 80 × 10 cm)
Collection of Ricardo Wijndal,
Amsterdam
(Photo: Courtesy of the artist)

OPPOSITE
Marcel Pinas
(b. Suriname 1971)
☆ *Kuku (Kitchen)*, 2005
Wood, acrylic, plastic, aluminum,
59 × 59 × 8⅝ in. (150 × 150 × 22 cm)
Courtesy of the artist

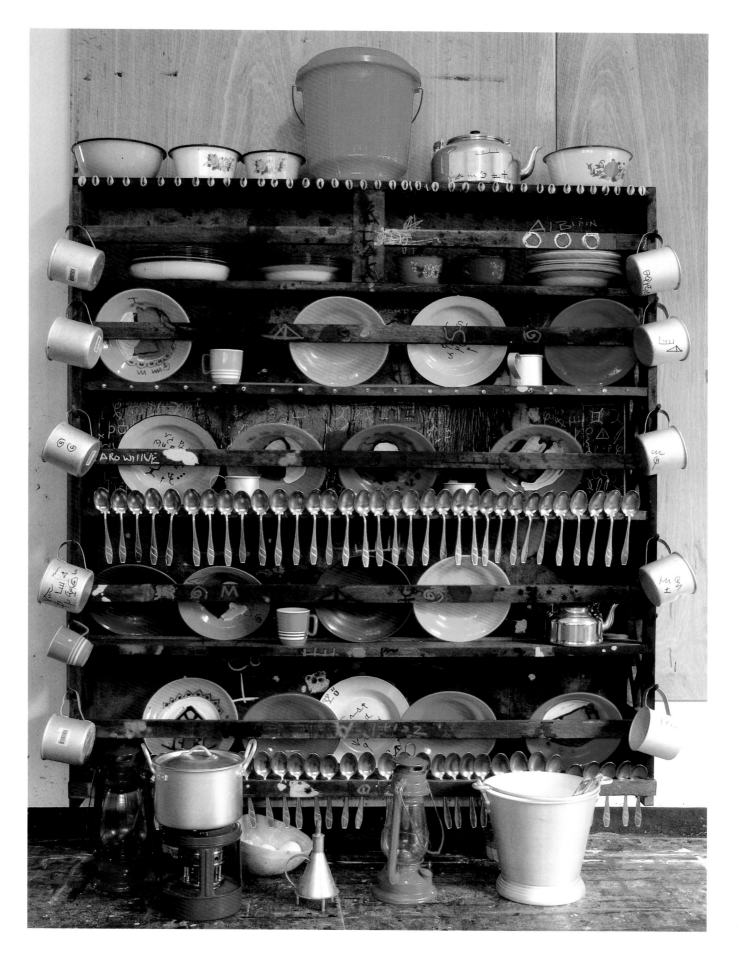

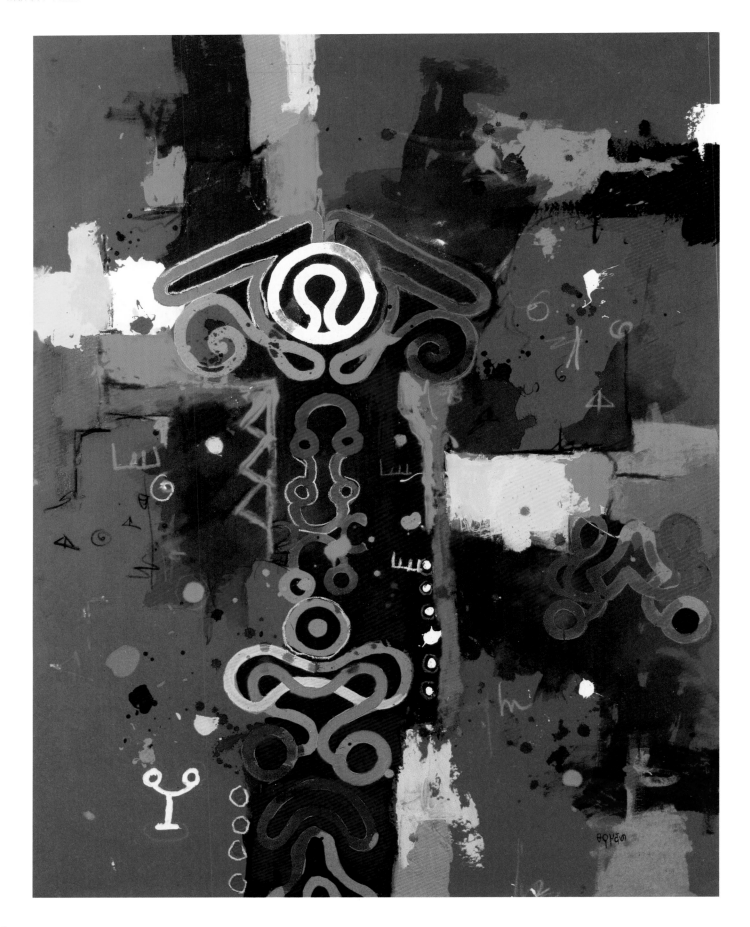

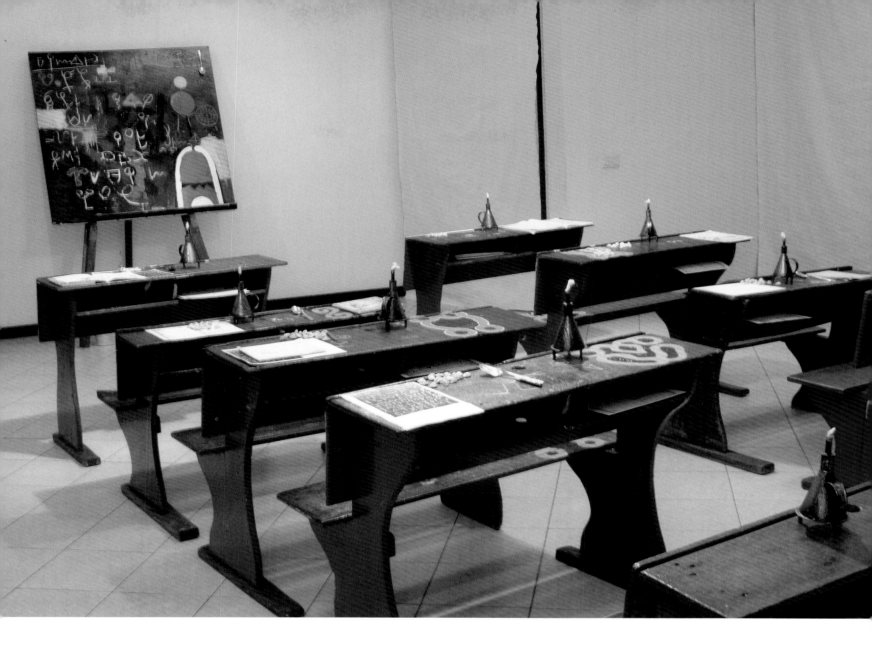

ABOVE AND RIGHT
Marcel Pinas
(b. Suriname 1971)
**School te Pilgrim Kondre**
**(School at Pilgrim Village)**, 2005
Mixed media with
wooden school desks,
26 ft. 3 in. × 19 ft. 7½ in. (8 × 6 m)
Courtesy of the artist

OPPOSITE
Marcel Pinas
(b. Suriname 1971)
**Tembe Wood Carving**, 2004
Acrylic and oil stick on canvas,
78¾ × 61 in. (200 × 155 cm)
Collection of Readytexart Gallery,
Paramaribo, Suriname
(Photo: Courtesy of the artist)

189

# Jorge Pineda

Jorge Pineda's work, including drawing, sculpture, and installation, addresses the violence and fear inflicted on innocent citizens of the world—particularly society's most marginalized social groups such as the homeless, street children, and poverty-stricken families—by those greedy for wealth and power. *Mambrú*, 2006, takes its title from a children's song popular in Latin America that begins "Mambrú se fue a la guerra" (Mambrú went to war). The sculpture consists of nine little soldiers, about six to nine years old, holding weapons practically as large as they are. The children's forms are wood covered in lead, suggesting their hardened psyches and lost innocence. Though the sculpture reminds the viewer of the ubiquitous toy soldiers of childhood, it refers most powerfully to the young children recruited for guerrilla fighting throughout the world. The children's colorful masks, sometimes associated with childhood play, hold more sinister meaning here.

Each of the drawings in the *Niñas locas (Mad Little Girls)* series of 2005–6 juxtaposes the innocence of the young girl's body with a threatening black form that suggests her dark side. The mask she wears may be the one we learn to wear as we grow older but may also suggest, as in *Mambrú*, that children, still not fully socialized, can be hardened and cruel when war, poverty, and injustice take a toll on their lives.

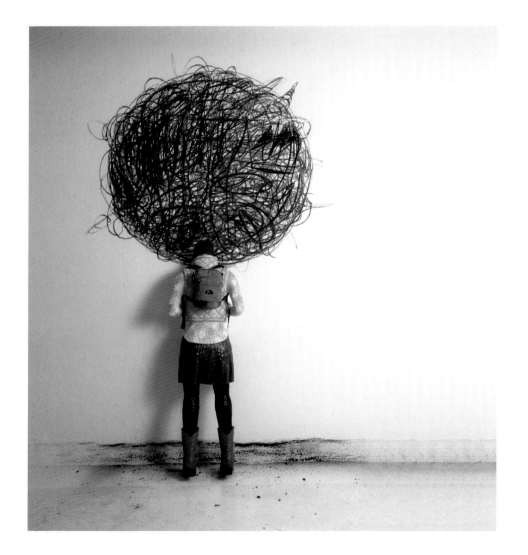

Jorge Pineda
(b. Dominican Republic 1961)
**Afro: Issue I**, 2006
Painted cedar wood, charcoal and textiles, dimensions variable
Courtesy of the artist

OPPOSITE
Jorge Pineda
(b. Dominican Republic 1961)
☆ **Mambrú** (detail), 2006
Three figures, cedar wood, lead, textiles, each 60 × 4 × 8 in.
(152.4 × 10.2 × 20.3 cm)
Courtesy of the artist

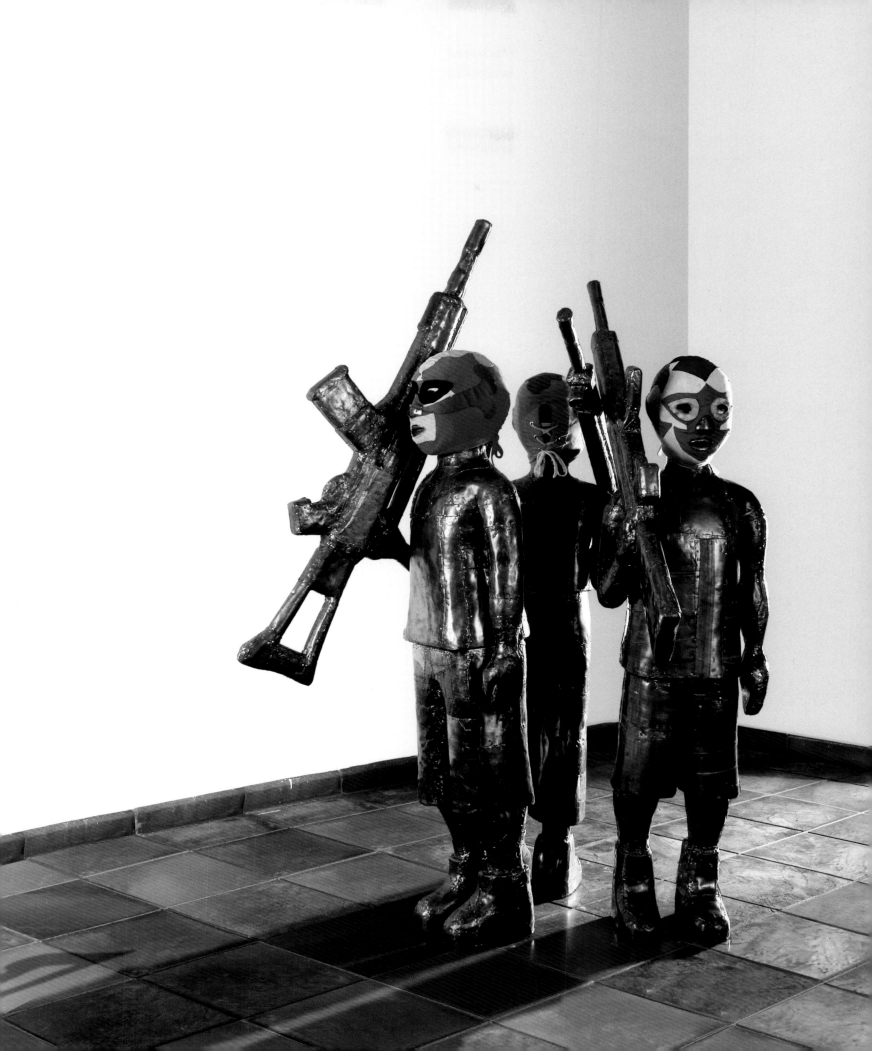

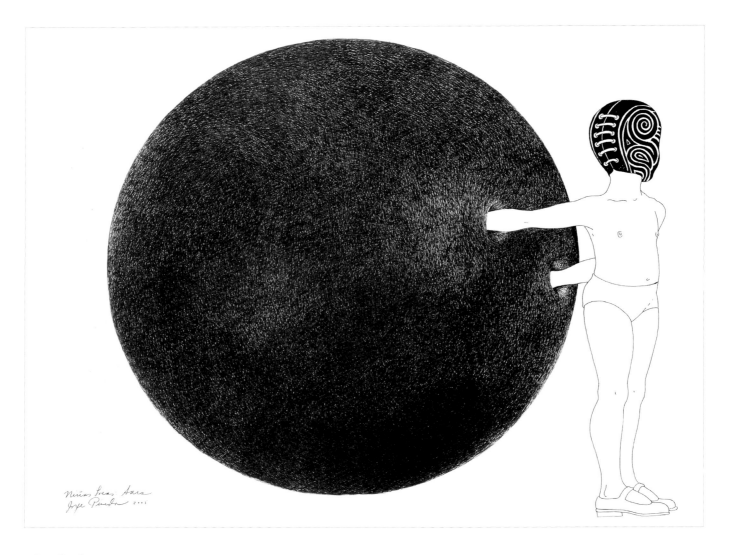

Jorge Pineda
☆ *Niñas locas (Mad Little Girls)* (detail): *Sara*

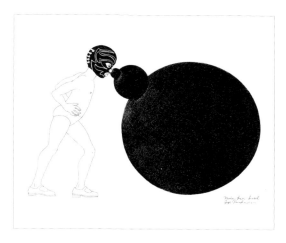

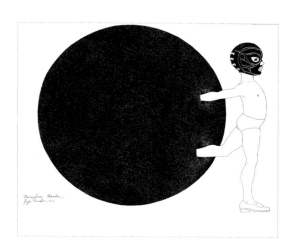

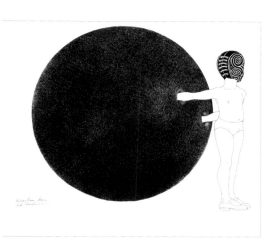

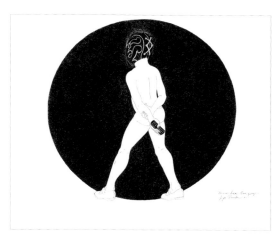

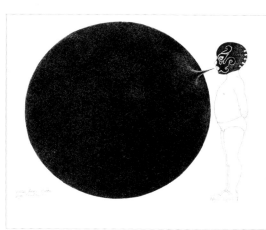

Jorge Pineda
(b. Dominican Republic 1961)
☆ *Niñas locas (Mad Little Girls)*, 2005–6
Six drawings, ballpoint pen on paper,
each 20 × 26 in. (50.8 × 66 cm)
Top, left to right: *Mónica*, *Isabel II*, *Claudia*;
Bottom, left to right: *Sara*, *Quisqueya*, *Belkis*
Courtesy of the artist

# K. Khalfani Ra

In his often politically charged, narrative, and elaborately titled works, K. Khalfani Ra eschews traditional artistic materials and often treats his surfaces harshly, cutting holes in fabric and piercing it with nails, knives, animal horns, and other objects. In so doing, he projects a powerful visual and literal message through his work.

The layers of meaning in *Script(ure)—The (Re)constitution of Arcahaie*, 2003, are evident in the title. Ra is attempting to examine the script(ure), or the established historical account, that has dictated the lives of millions following the events of 1803 in Arcahaie, Haiti. At that time, during the last months of the slave rebellion, the revolutionary army destroyed the French flag and introduced the red-and-blue Haitian flag. In this work evoking the image of a flag, Ra seems to be saying that Caribbean people have to throw off the flag of the oppressors and build one on their own strength. Perhaps part of the strength needed to create their own flag and their own destiny involves bloodshed, as suggested by the reddened surface around the knives in the center of this piece.

In addition to political messages and philosophy, Caribbean and world history are major themes in Ra's work, as evidenced in *The Zumbi Imperative: Palmares the First Republic, Cucau/New Orleans/Jamaica, The Cursed Lowlands*, 2005. Zumbi was a revolutionary freedom fighter and national hero who fought against the Portuguese colonial powers in Brazil to defend Quilombo dos Palmares, a republic of runaway slaves, or Maroons. By piercing the fabric of his work with nails, Ra creates a chilling image of the violence necessary to emancipate the slaves not only of Brazil but of New Orleans and Jamaica. The nails pull the fabric in certain places to create an almost topographic map of hills, valleys, and "cursed lowlands," where the viewer can imagine the slaves were forced to work. The varying density and direction of the nails suggest a scarred landscape, which evokes disfigurement of a place and a people, afflicted by violence and unrest.

The simultaneously constructive and destructive nature of nails, horns, and knives suggests the conflict and pain that must precede catharsis in the Jamaican community and the rest of the black diaspora in order to heal the wounds of colonialism. Similarly, Ra's works create a sense of discomfort and confrontation that is intended to balance the dialogue in politics, history, and culture.

BELOW (DETAIL) AND OPPOSITE
K. Khalfani Ra
(b. Jamaica 1958)
☆ *The Zumbi Imperative: Palmares the First Republic, Cucau/New Orleans/Jamaica, The Cursed Lowlands*, 2005
Nails on fabric, 116½ × 73¾ in. (297.1 × 187.3 cm)
Courtesy of the artist
(Photo: Donnette Zacca)

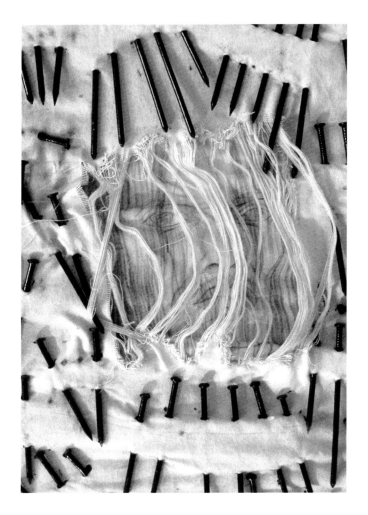

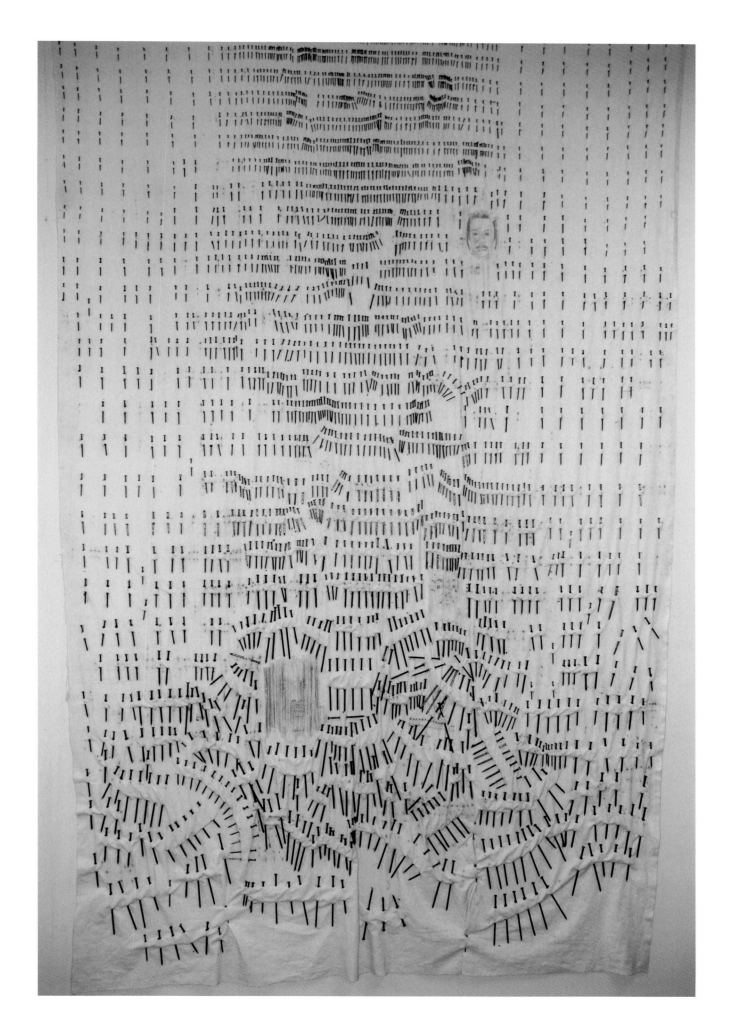

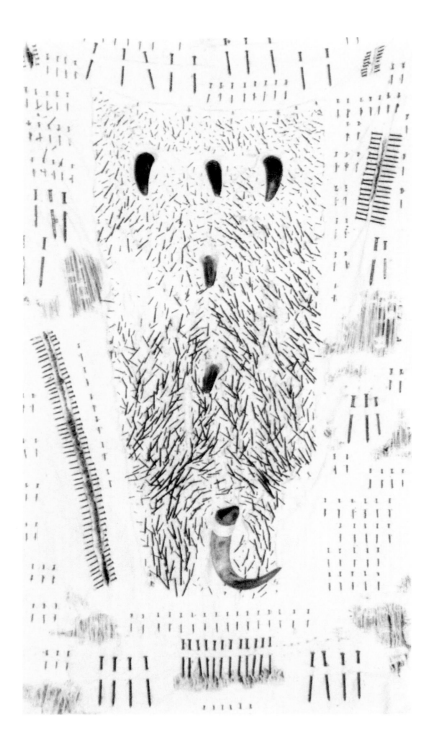

K. Khalfani Ra
(b. Jamaica 1958)
*The Vicissitudes of Memory:*
*Long Live the Maroon Killers,*
*Death to the Maroon Traitors.*
*For De Sierras the Unsung*, 2004
Nails and horns on fabric,
57⅞ × 33½ in. (147 × 85 cm)
Courtesy of the artist

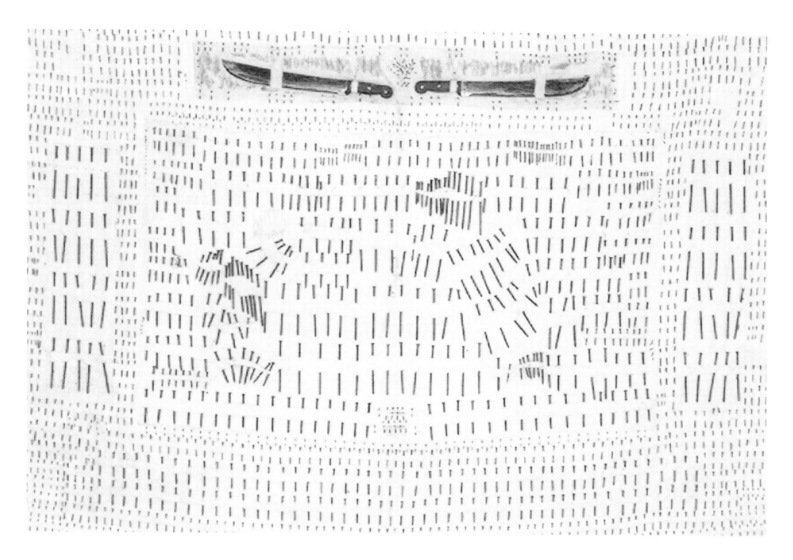

K. Khalfani Ra
(b. Jamaica 1958)
☆ *Script(ure)—The (Re)constitution*
*of Arcahaie*, 2003
Nails and machetes on fabric,
64 × 84½ in. (162.6 × 214.6 cm)
Courtesy of the artist

# Santiago Rodríguez Olazábal

The work of Santiago Rodríguez Olazábal reflects his personal religious practice as a priest in the Afro-Cuban cult of Ifa, which emphasizes the balance between nature and humankind. Rodríguez Olazábal's installations, drawings, paintings, and prints express the need to venerate the earth, which sustains life, and to respect one's elders and religious rituals. He says that his work is "a form of praise to the memory of my ancestors."

The five serigraphs (prints made by a screenprinting process) in the series titled *La huella (The Wound)*, 2004, seem to map the interface between natural forces in the universe and the human heart, body, mind, and spirit. By combining the material with the immaterial, the artist evokes a reality based in religious consciousness. He employs figuration, abstraction, and various sign systems such as spirals, crosses, and written words that allude to secret meanings of Ifa belief systems as well as cycles of nature and everyday life. He approaches his work as a form of ritual in which the spirit strives toward achieving harmony with nature and the universe.

Santiago Rodríguez Olazábal
(b. Cuba 1955)
☆ *La huella I (The Wound I)*, 2004
Serigraph, 19⅝ × 13¾ in.
(50 × 35 cm)
Taller Amoerro SL, Madrid

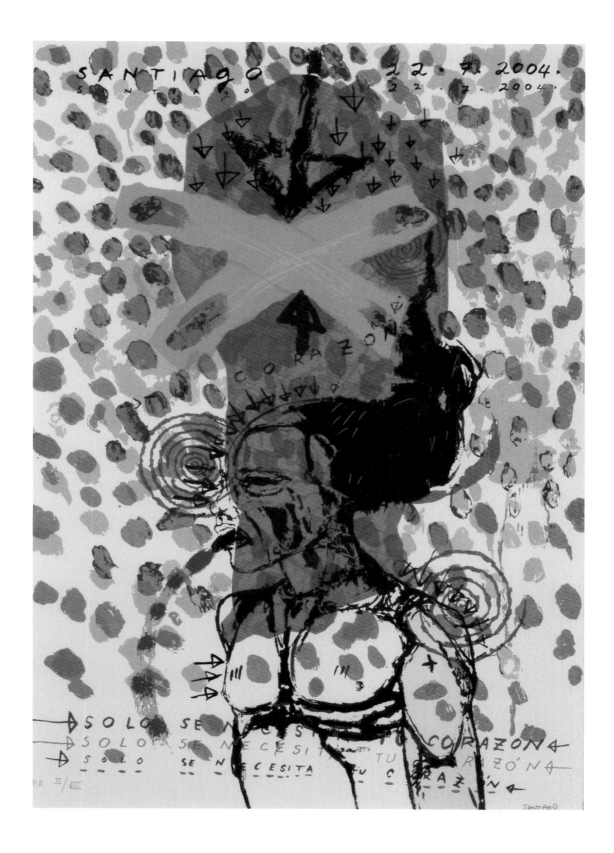

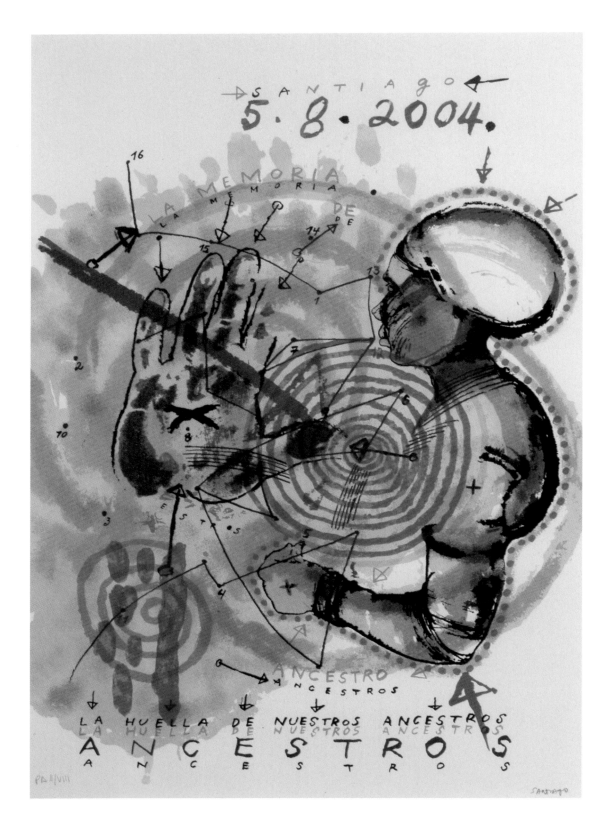

Santiago Rodríguez Olazábal
(b. Cuba 1955)
☆ *La huella II (**The Wound II**)*, 2004
Serigraph, 19⅝ × 13¾ in.
(50 × 35 cm)
Taller Amoerro SL, Madrid

Santiago Rodríguez Olazábal
(b. Cuba 1955)
☆ *La huella III (The Wound III)*, 2004
Serigraph, 19⅝ × 13¼ in.
(50 × 35 cm)
Taller Amoerro SL, Madrid

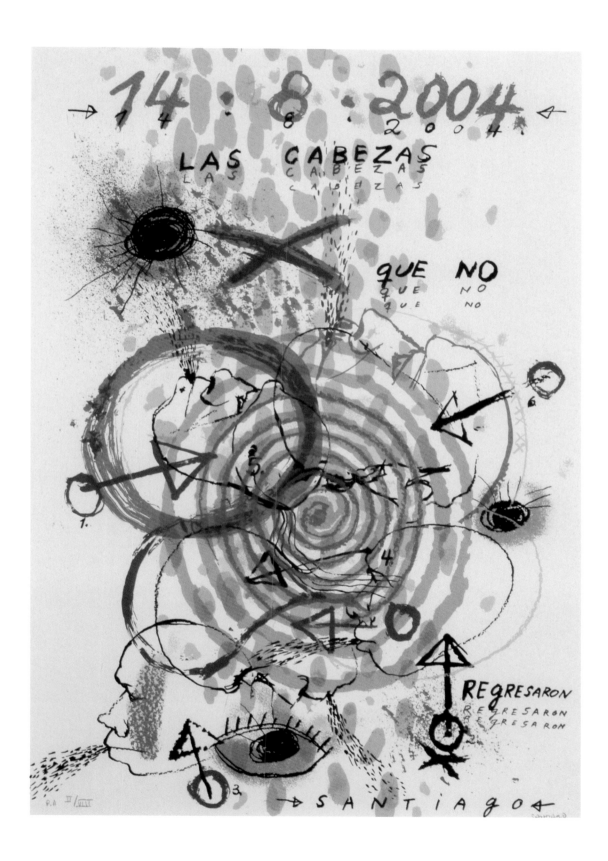

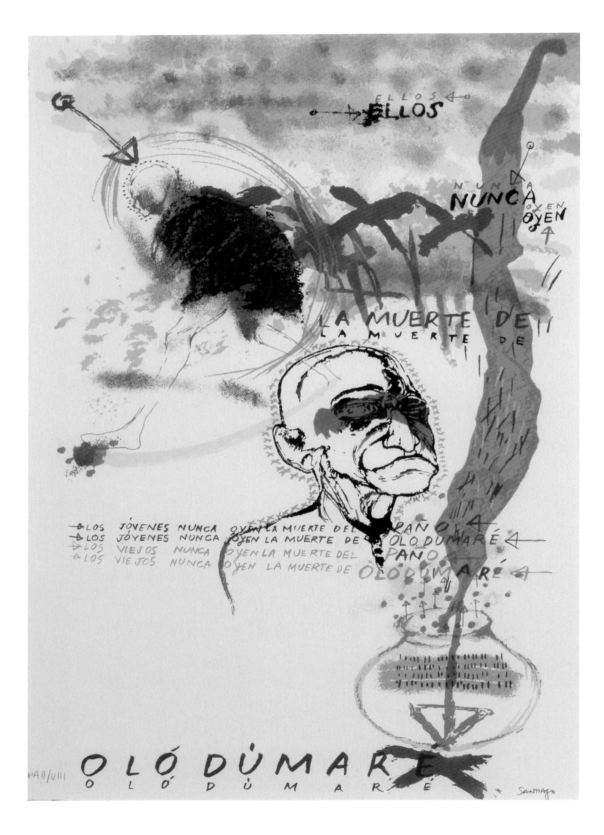

Santiago Rodríguez Olazábal
(b. Cuba 1955)
☆ *La huella IV* (*The Wound IV*), 2004
Serigraph, 19⅝ × 13¼ in.
(50 × 35 cm)
Taller Amoerro SL, Madrid

Santiago Rodríguez Olazábal
(b. Cuba 1955)
☆ **La huella V (*The Wound V*)**, 2004
Serigraph, 19⅝ × 13¾ in.
(50 × 35 cm)
Taller Amoerro SL, Madrid

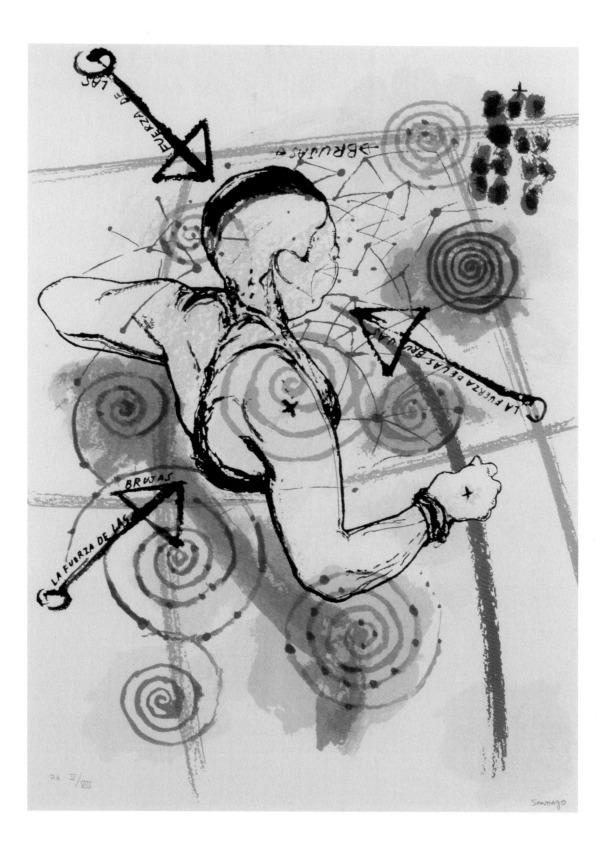

# Veronica Ryan

In her long career as an artist working with sculpture and installation, Ryan has utilized materials that range from natural products reminiscent of her Caribbean roots (seeds, shells, fruit, and pods) to domestic objects (sieves, plastic toys, lightbulbs), from conventional media to industrial elements such as Styrofoam, milk crates, boxes, and plaster. How these forms are placed (clearly in view or hidden in an enclosure) is suggestive of the way that the artist brings to light what is hidden and places what is obvious in a more discreet and unfamiliar light.

*Between Spaces*, 2003–present, is an ongoing installation that investigates architectural forms in urban environments. Stacked cardboard boxes and cages in columns of various heights create a stable yet precariously fragile cityscape. The recesses and niches in the boxes create inner cell-like spaces, some containing partially revealed objects such as lightbulbs in a bag or a wire-mesh strainer—highlighting ambiguous dichotomies of private and public, accessible and inaccessible, and physical and metaphysical space. The compartmentalized, seemingly fragmented spaces and the close and closed nature of the work relate to the urban experience in general but also invoke the challenging, uprooted condition of those who migrate to metropolitan centers.

ABOVE AND FOLLOWING PAGES
Veronica Ryan
(b. Montserrat 1956; works in United States)
☆ *Between Spaces*, 2003–present
Mixed-media installation, dimensions variable
Courtesy of the artist
(Photos: Orcutt & Van Der Putten)

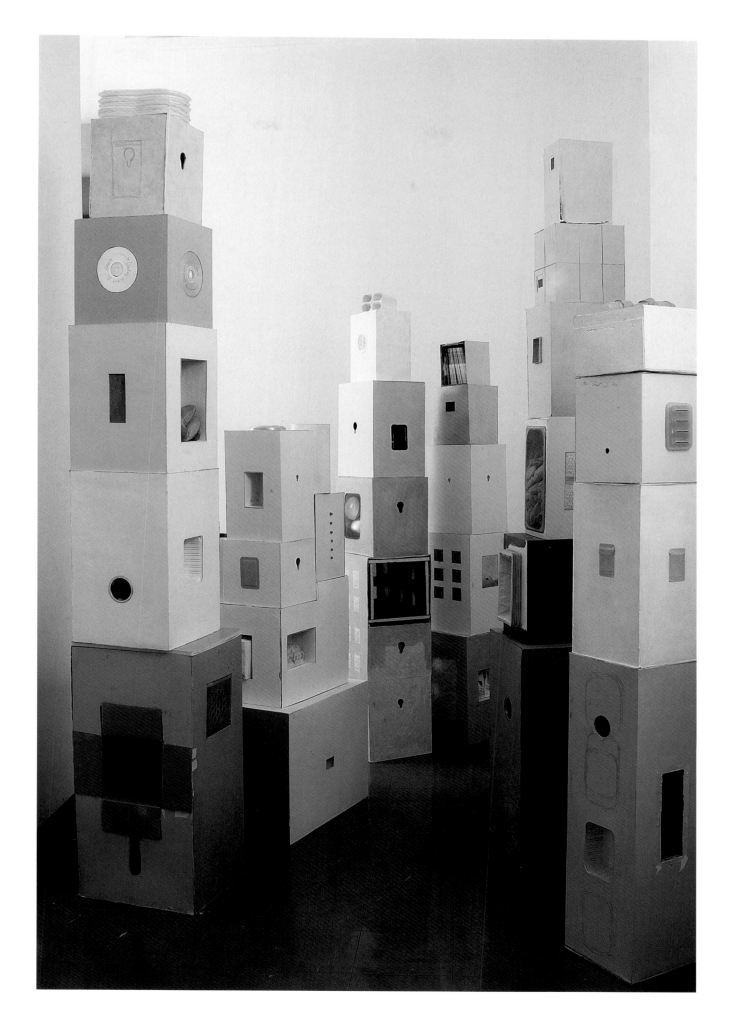

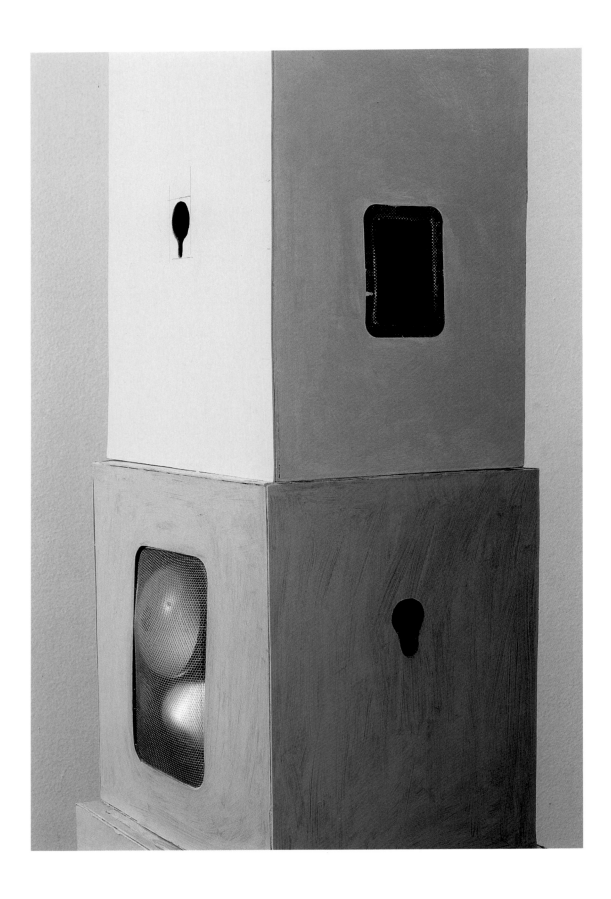

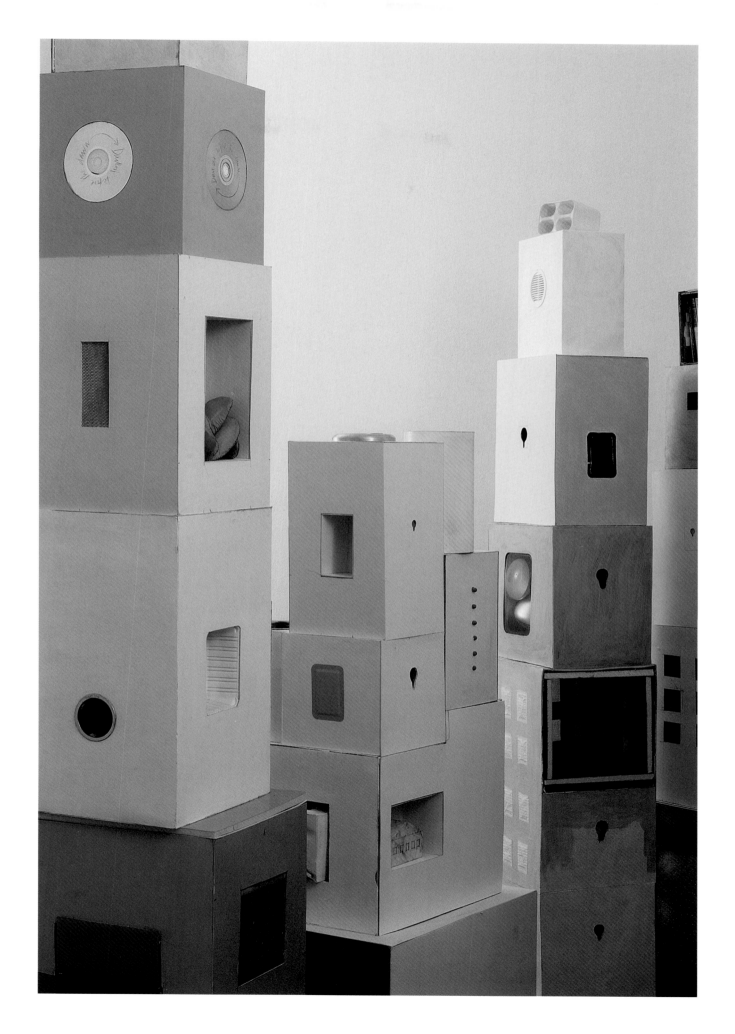

# Beatriz Santiago Muñoz

In her sometimes surreal and always engaging video work, Beatriz Santiago Muñoz scripts dramatic re-creations of historical and present-day events and has them acted out by ordinary people who are not professional actors. The participants are encouraged to role-play with a sense of spontaneity and fun. Eschewing concerns of perfection, routine, and proper conduct, the "actors" push the boundaries of what is expected, thus creating a surreal form of entertainment that provides a different framework for understanding social issues and stimulates new modes of thinking about the subjects.

*Película de desastre (Disaster Film)*, 2003, shows a series of stories of people packing up their belongings, bidding each other tearful goodbyes, and preparing to flee an imminent disaster. Whether these disasters are real or imagined neither the characters nor the viewers seem to know. The dramatic situations range from the catastrophic (an impending natural disaster) to the more mundane (the threatened approach of the police). The fact that the actors are actually street vendors gathering up their wares at the end of the day adds a sense of haste and urgency to their actions.

Disaster and the loss and transformation of the environment and the effect of such crises on culture are some of the issues that Santiago Muñoz explores in her videos. These topics find expression in the artist's unique creative technique, which straddles a fine line between what is real and what is imaginary, what exists and what is created, what is said and what is only understood in gesture. In giving her actors the freedom to improvise, the artist opens her work to a new level of meaning and understanding.

Santiago Muñoz is inspired by what she describes as the "ecstatic ethnographies, documents of collective imagining" of Jean Rouch (1917–2004), the pioneer of cinema verité whose experimental ethnographic films required the intellectual participation of his (mainly African) subjects. In collaborating with her subjects, Santiago Muñoz is able to create a work of art that is her own yet much bigger than herself as well as accessible to all.

Beatriz Santiago Muñoz
(b. Puerto Rico 1972)
☆ **Película de desastre (*Disaster Film*)**, 2003
Single-channel DVD, color, sound, 7 min.
Courtesy of the artist

# Storm Saulter

The vitality of Storm Saulter's native environment of Negril, Jamaica, and his previous collaborations in music video have been important influences on his work, which explores individual expression within popular culture. After attending film school and working in Los Angeles, he returned to Jamaica to participate in the island's budding film industry, completing his first high-definition film in 2005.

His video *Waterboot*, 2003, accompanied by Bedouin Soundclash's reggae song "Money Worries," features a freewheeling young man on a moving motorbike that seems to ride itself through busy city streets and green-bordered country lanes. The changing city- and landscapes through which the rider passes are accentuated by the changing colors in the composition of the frames, which fade from black-and-white to vibrant greens and blues, as if to suggest that in life, things change from good to bad and bad to good and we all pass through hard times but can still come out laughing.

*Inna di dance (In the Dance)*, 2003, presents another part of Jamaican social life, the dancehall, or dance club, where groups of people gather to dance to deejay-led "dancehall beats," which have become popular among youth in Jamaica since the eighties. At times Saulter slows down the movements of the dancers, speeds up the film, or repeats the sequences in a loop, thus emphasizing the rhythmic nature of the dance and the raw sexuality of dancehall culture.

Storm Saulter
(b. Jamaica 1983)
☆ *Inna di dance (In the Dance)*, 2003
Single-channel DVD,
color, sound, 4 min. 29 sec.
Courtesy of the artist

OPPOSITE
Storm Saulter
(b. Jamaica 1983)
☆ *Waterboot*, 2003
Single-channel DVD,
color, sound, 2 min. 25 sec.
Courtesy of the artist

# Arthur Simms

Arthur Simms creates large and small sculptural assemblages composed of everyday objects such as embroidery, bicycle wheels, bottles, stones, chairs, and wire. The recurring use of wire in his body of work (as seen in *Roman Chair* and *Yellow Mini*, both 2003) is a symbolic thread that connects disparate elements of the diasporic experience. Reflecting his personal history as a Jamaican living in the United States, the technique of assemblage evokes the convergence of cultures and the compromises and negotiations that are necessary to hold together the fragmented experience of being born in one place, living in another, and moving back and forth between the two.

Simms's use of recycled elements references the improvisational skills Caribbean people must employ when they live in regions of scarcity. The histories of these recycled objects are at once highly personal for the artist and yet universal and symbolic. The bicycle and bicycle wheels of *Dreamcatcher*, 2000, are symbols for journeying, evoking the diaspora. In this piece a chair becomes a place of rest, and rope and wire become the political, emotional, and psychological ties that bind people to places and to each other. The work's title alludes to the small Native American talismans that are supposed to "catch" bad dreams in their web and allow children to have a peaceful night's rest. This melding of Caribbean and Native American culture suggests the struggle for harmony and unity among the various cultures coexisting on the planet, a theme that is also reflected in *Globe: The Veld*, 2004. In that work, the bottom half of the sphere, consisting of sticks, stones, rusting tools, and plastic spools and held precariously together by a web of thin wire, appears to weigh the globe down.

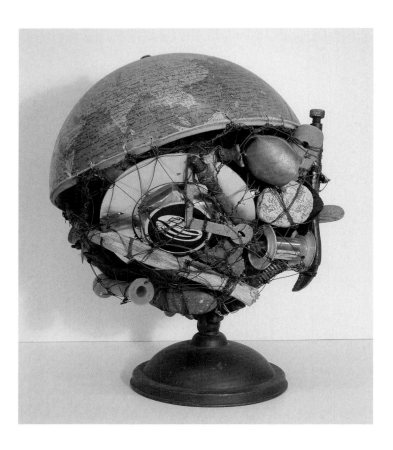

Arthur Simms
(b. Jamaica 1961;
works in United States)
☆ ***Globe: The Veld***, 2004
Globe, artists' nails, metal, wood, plastic, wire, tools, and other found objects, 17 × 14 × 14 in.
(43.2 × 35.6 × 35.6 cm)
Courtesy of the artist

OPPOSITE
Arthur Simms
(b. Jamaica 1961;
works in United States)
☆ ***Dreamcatcher***, 2000
Wire, stones, wood, metal, bicycles, tin foil, feathers, rocks,
61 × 180 × 45 in.
(154.9 × 457.2 × 114.3 cm)
Courtesy of the artist

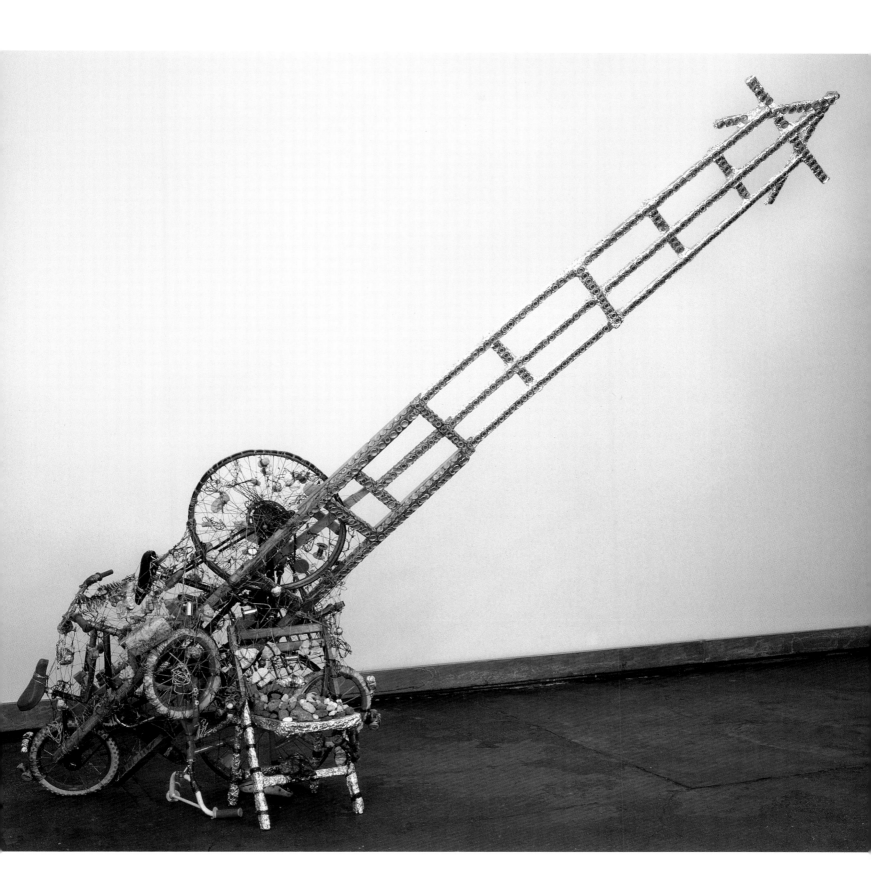

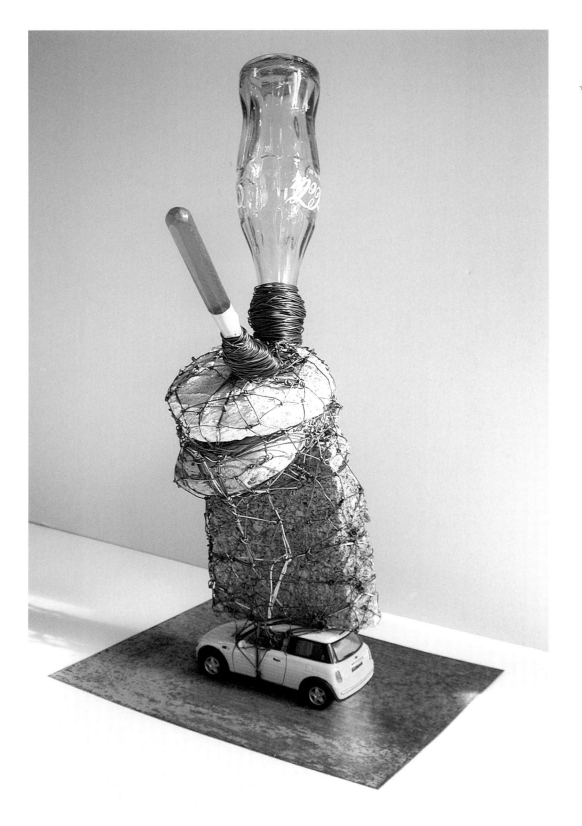

Arthur Simms
(b. Jamaica 1961;
works in United States)
☆ **Yellow Mini**, 2003
Bottle, toy car, wire, stones,
plastic, metal,
18 × 10½ × 11 in.
(45.7 × 26.7 × 27.9 cm)
Courtesy of the artist

OPPOSITE
Arthur Simms
(b. Jamaica 1961;
works in United States)
**Roman Chair**, 2003
Chair, stones, wire, bottles,
metal, wood,
25 × 28 × 25 in.
(63.5 × 71.1 × 63.5 cm)
Courtesy of the artist

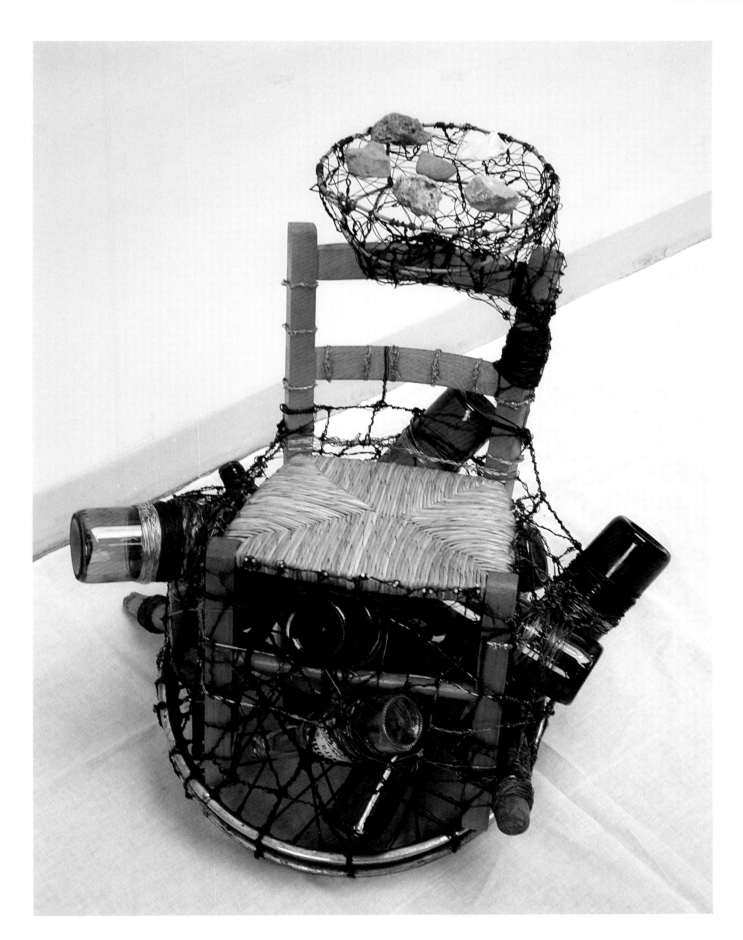

# Artists' Biographies

JENNIFER ALLORA (b. United States 1974) received an M.S. from the Massachusetts Institute of Technology, Cambridge, and GUILLERMO CALZADILLA (b. Cuba 1971) received an M.F.A. from Bard College, Annandale-on-Hudson, New York. They have exhibited at the Whitney Museum of American Art, New York; Institute of Contemporary Art (ICA), Boston; Walker Art Center, Minneapolis; and Museo de Arte de Puerto Rico, San Juan, among many other institutions. They participated in the 51st Venice Biennale and the 2005 Biennale d'Art Contemporain de Lyon, France. Allora and Calzadilla continue to work together and live and work in San Juan.

ALEXANDRE ARRECHEA (b. Cuba 1970) graduated from the Instituto Superior de Arte, Havana, Cuba. He has exhibited at such venues as the San Diego Museum of Art, California; American University Museum, Washington, D.C.; and Galeria Habana, Havana. While still a member of the art collective Los Carpinteros, he exhibited at P.S.1 Contemporary Art Center, New York; San Francisco Art Institute, California; and Espacio Aglutinador, Havana. He participated in the 2006 Taipei Biennial and the 51st Venice Biennale. Arrechea lives and works in Havana and Madrid.

EWAN ATKINSON (b. Barbados 1975) earned a B.F.A. from the Atlanta College of Art, Georgia. He has exhibited at the Zemicon Gallery, Bridgetown, Barbados; Diaspora Vibe Gallery, Miami, Florida; and CCA7, Port-of-Spain, Trinidad. He was awarded Barbados's NIFCA Governor General's Award of Excellence in Fine Art in 1999 and the Atlanta College of Art's Presidential Scholarship in 1996, 1997, and 1998 and its Gene Alcott Scholarship in 1997. Atkinson lives and works in St. Michael, Barbados.

NICOLE AWAI (b. Trinidad 1966) received an M.F.A. from the University of South Florida, Tampa. Her work has been exhibited at the Jersey City Museum, New Jersey, and in New York at the Jamaica Center for Arts and Learning, P.S.1 Contemporary Art Center, and Studio Museum in Harlem. She also participated in the *Open House: Working in Brooklyn* exhibition at the Brooklyn Museum, New York, in 2004. Awai lives and works in Brooklyn.

MARIO BENJAMIN (b. Haiti 1964) is a self-taught artist. He has had numerous solo exhibitions, most recently at the Institut Français d'Haïti, Port-au-Prince; Museum of Contemporary Art, Miami, Florida; and Carmen Rita Pérez/ Arte Actual Gallery in Santo Domingo, Dominican Republic. He also participated in the 2nd Johannesburg Biennale; the IV Bienal del Caribe, Santo Domingo; and the 49th Venice Biennale. Benjamin lives and works in Port-au-Prince.

TERRY BODDIE (b. Nevis 1965) received an M.F.A. from Hunter College and a B.F.A. from Tisch School of the Arts, New York University. He has participated in exhibitions at the Studio Museum in Harlem, New York; Philadelphia African American Museum; and Jersey City Museum, New Jersey. He has also exhibited at Gallery 138 and Triple Candie, both in New York, and participated in the IV Bienal del Caribe, Santo Domingo, Dominican Republic. Boddie lives and works in West Orange, New Jersey.

ALEX BURKE (b. Martinique 1944) has participated in selected group exhibitions at the Musée des Arts Derniers, Paris; Centre Martiniquais d'Action Culturelle (CMAC), Fort-de-France, Martinique; and Malba Colección Costantini, Buenos Aires. He also exhibited work at the VII Bienal de La Habana, Havana, Cuba. His work has been presented in solo exhibitions at the Nantes Métropole, Nantes, France, and Instituts Universitaires de la Formation des Maîtres (IUFM), Fort-de-France. Burke lives and works in Paris.

JAVIER CAMBRE (b. Puerto Rico 1966) received a diploma of architecture from the Universidad Pontificia Bolivariana, Medellín, Colombia, and an M.F.A. from the School of the Art Institute of Chicago. He has exhibited at the Museo de Arte de Puerto Rico, San Juan, and at El Museo del Barrio and P.S.1 Contemporary Art Center, both in New York. Cambre's work is in several collections including those of the Whitney Museum of American Art, New York, and Museo de Arte de Puerto Rico. Cambre lives and works in Newark, New Jersey, and San Juan.

CHARLES CAMPBELL (b. Jamaica 1970) completed an M.F.A. at Goldsmiths College at the University of London, United Kingdom. He has held solo exhibitions in Jamaica and Canada, and participated in group exhibitions at the National Gallery of the Cayman Islands, George Town, Grand Cayman; National Gallery of Jamaica, Kingston; and Museo de Arte Moderno, Santo Domingo, Dominican Republic. Campbell currently resides and works in Victoria, Canada.

KEISHA CASTELLO (b. Jamaica 1978) received her undergraduate degree from the Edna Manley College of Visual and Performance Arts, Kingston, Jamaica. As a recent graduate, she has exhibited at the National Gallery of Jamaica and the Mutual Gallery, both in Kingston. Castello lives and works in Kingston.

LISET CASTILLO (b. Cuba 1974) attended art school in Camaguey, Cuba, and later graduated from the Instituto Superior de Arte, Havana. Castillo has exhibited in The Hague, Netherlands, and at the Black & White Gallery, Brooklyn, New York, and other institutions. She participated in the VIII Bienal de La Habana, Havana, and has received many awards, including a Cintas Fellowship in 2003–4 and a Guggenheim Fellowship in 2004–5. Castillo lives and works in Brooklyn, New York.

COLECTIVO SHAMPOO, whose core members include Jose Dolores Alfonseca, Angel Rosario, and Maurice Sánchez (all from the Dominican Republic), unites writers, graphic designers, illustrators, musicians, sociologists,

and architects to examine social issues. The collective has participated in numerous projects that include the V Bienal del Caribe, Santo Domingo, Dominican Republic; Trienal Poli/Gráfica de San Juan, Puerto Rico; and XXIII Bienal de Artes Visuales, Santo Domingo. The members of Colectivo Shampoo live and work in Santo Domingo.

CHRISTOPHER COZIER (b. Trinidad 1959) received an M.F.A. from the Mason Gross School of the Arts at Rutgers University, New Brunswick, New Jersey, and a B.F.A. in painting from the Maryland Institute College of Art, Baltimore. Cozier has participated in exhibitions within and outside the Caribbean at such venues as CCA7, Port-of-Spain, Trinidad; Bag Factory, Johannesburg; and Museo Extremeño e Iberoamericano de Arte Contemporáneo, Badajoz, Spain. Cozier lives and works in Port-of-Spain.

JOSÉ (TONY) CRUZ (b. Puerto Rico 1977) completed his doctorate at the Universidad de Castilla–La Mancha, Cuenca, Spain. He has held several solo exhibitions in Puerto Rico and participated in the VIII Bienal Internacional de Cuenca, Ecuador; the V Bienal del Caribe, Santo Domingo, Dominican Republic; and the VII Bienal de La Habana, Havana, Cuba. Cruz currently lives and works in San Juan, Puerto Rico.

ANNALEE DAVIS (b. Barbados 1963) received an M.F.A. from the Mason Gross School of the Arts at Rutgers University, New Brunswick, New Jersey. She has held solo exhibitions at the Barbados Museum & Historical Society, Bridgetown; National Gallery of Jamaica, Kingston; and Art Museum of the Americas, Washington, D.C., among others. She participated in the XXII Bienal Internacional de São Paulo; IV Bienal Internacional de Cuenca, Ecuador; and the I, II, and III Bienal del Caribe, Santo Domingo, Dominican Republic; as well as in the KHOJ International Artists' Workshop in Mumbai, India, the Centro Cultural Recoleta, Buenos Aires, and the 30ème Festival International de la Peinture, Cagnes-sur-Mer, France. Davis has worked throughout the Caribbean as an artist, teacher, curator, and writer. She currently lives and works in Bridgetown.

MAXENCE DENIS (b. Haiti 1968) was trained at the École Supérieure de Réalisation Audiovisuelle, Paris. He has participated in exhibitions predominantly in Port-au-Prince, Haiti, and Paris. In Port-au-Prince he has exhibited at the Institut Français d'Haïti and Musée d'Art Haïtien, Collège Saint-Pierre. In Paris he has exhibited at the Hôtel de Ville, Galerie Labo TeknoPlus, and Frigo Gallery. His work was selected for the 51st Venice Biennale and the 37th Congress of the International Association of Art Critics in Barbados and Martinique. Denis resides and works in Port-au-Prince.

JEAN-ULRICK DÉSERT (b. Haiti) graduated from the Cooper Union School for the Advancement of Science and Art and Columbia University Graduate School of Architecture, both in New York City. He has participated in numerous exhibitions, recently in the Kunstverein Wolfsburg, Germany; Studio Museum in Harlem, New York; Schwules Museum, Berlin; and SEB Foundation, Amsterdam. Désert divides his time between Berlin and New York.

ROBERTO DIAGO (b. Cuba 1971) received his degree from the Academia Nacional de Bellas Artes San Alejandro, Havana, Cuba. He has exhibited in the Museo National de Bellas Artes and Centro de Arte Contemporáneo Wifredo Lam, both in Havana. He has also participated in ARCO, Feria Internacional de Arte Contemporáneo, Madrid, in 2003, 2004, and 2005, and Art Basel, Miami, Florida, in 2002, 2003, 2004, 2006, and 2007. Diago lives and works in Havana.

POLIBIO DÍAZ (b. Dominican Republic 1952) earned a degree in civil engineering from Texas A&M University, College Station, where he was introduced to photography. He has since become actively involved in the arts and has exhibited extensively in Spain and the Dominican Republic. He has shown his work at the IILA (Istituto Italo-Latino Americano), Rome, and has participated in the IV Bienal del Caribe, Santo Domingo, Dominican Republic. Díaz lives and works in Santo Domingo.

DZINE (a.k.a. Carlos Rolón; b. United States 1970), the son of Puerto Rican parents, studied at Columbia College, Chicago. He has held solo exhibitions at the St. Louis Contemporary Art Museum; Museum of Contemporary Art, Chicago; SCAI The Bathhouse/Shiraishi Contemporary Art Inc., Tokyo; and Museo de Arte de Puerto Rico, San Juan. His work is included in the collections of El Museo del Barrio, New York, and Museo de Arte de Puerto Rico. Dzine lives and works in Chicago.

JOSCELYN GARDNER (b. Barbados 1961) received an M.F.A. from the University of Western Ontario, London, Canada. She has exhibited at CCA7, Port-of-Spain, Trinidad; Zemicon Gallery and Barbados Museum & Historical Society, both in Bridgetown, Barbados; and White Columns, New York. She has contributed to numerous international print and graphic festivals such as the International Print Triennial, Cracow, Poland, and Carifesta, Port-of-Spain, Trinidad. Gardner currently lives and works in London, Ontario.

QUISQUEYA HENRÍQUEZ (b. Cuba 1966) began her art studies at the Universidad Autonoma de Santo Domingo (UASD), Dominican Republic, and later graduated from the Instituto Superior de Arte, Havana, Cuba. She has exhibited at the New Museum of Contemporary Art, New York; Miami Art Museum, Florida; and Museum of Contemporary Art (MOCA), North Miami. She has participated in numerous group international exhibitions including the V Bienal del Caribe, Santo Domingo, and VIII Bienal Internacional de Cuenca, Ecuador. Henríquez lives and works in Santo Domingo.

ALEX HERNÁNDEZ DUEÑAS (b. Cuba 1982) studied at the Academia Nacional de Bellas Artes San Alejandro, Havana, Cuba, and is continuing his studies at the Instituto Superior de Arte, also in Havana. His work has been exhibited at the Fordes Gallery and Centro de Arte Contemporáneo Wifredo Lam, both in Havana; San Juan Art Gallery, Guadalajara, Mexico; and Konstall Rodenskolan, Norrtalje, Sweden. He participated in the VIII and IX Bienal de La Habana, Havana. Hernández Dueñas currently lives and works in Havana.

SATCH HOYT (b. United Kingdom 1957), who is of Jamaican ancestry, is an accomplished musician as well as a visual artist. His work has been exhibited in New York at the Brooklyn Museum and New Museum of Contemporary Art, at the Walker Art Center in Minneapolis, and at other institutions around the world. He participated in the 2004 Tate Liverpool Biennial, United Kingdom. Hoyt lives and works in New York.

DEBORAH JACK (b. Netherlands 1970) grew up in St. Maarten and earned a B.A. from Marist College, Poughkeepsie, New York, and an M.F.A. from the State University of New York, Buffalo. She has held solo exhibitions at the Carnegie Art Center, North Tonawanda, New York; Rochester Contemporary, Rochester, New York; and Diaspora Vibe Gallery, Miami, Florida. Her work was included in the V Salon Internacional de Arte Digital, Havana, Cuba. A poet and a visual artist, Jack currently lives and works in Jersey City, New Jersey.

REMY JUNGERMAN (b. Suriname 1959) attended the Academy for Higher Arts and Cultural Studies in Paramaribo, Suriname, and Gerrit Rietveld Academie, Amsterdam. His work has been included in group exhibitions at Dutch institutions such as the Museum voor Moderne Kunst Arnhem and the Villa de Bank, Enschede. He has also participated in exhibitions in Paris and at the Stedelijk Museum Aalst, Belgium. Jungerman currently lives and works in Amsterdam.

GLENDA LEÓN (b. Cuba 1976) received a B.A. in Art History from the Facultad de Artes y Letras of the Universidad de La Habana, Havana, Cuba. She has had solo exhibitions at M:A Contemporary, Berlin, and at Galeria 23 y 12 and Centro de Desarrollo de las Artes Visuales, both in Havana. She has taken part in group exhibitions at venues including the Frauenmuseum, Bonn, Germany, as well as in numerous biennials and art festivals such as the 2006 Glasgow International Festival of Contemporary Art, the VIII and IX Bienal de La Habana, Havana, the II Bienal de Jafre, Girona, Spain, 2005, and IV Bienal Internacional de Estandartes, Guadalajara, Mexico. León lives and works in Havana and Berlin.

HEW LOCKE (b. United Kingdom 1959) received a B.A. in Fine Art from the Falmouth School of Art, United Kingdom, and an M.A. from the Royal College of Art, London. He has exhibited at Tate Britain, the Chisenhale Gallery, and Victoria and Albert Museum in London and at the New Art Gallery in Walsall, United Kingdom. Outside of Britain, he has participated in exhibitions at the Luckman Gallery at California State University, Los Angeles, and the Atlanta Contemporary Art Center, Georgia, among other institutions. His work is included in the collections of the British Museum and Eileen Harris Norton and Peter Norton, United States. Locke was raised in British Guiana (later Guyana) and currently resides in London.

MIGUEL LUCIANO (b. Puerto Rico 1972) received a B.F.A. from the New World School of the Arts, Miami, Florida, and an M.F.A. from the University of Florida, Gainesville. His work has been exhibited at many institutions, including the Bronx Museum of Art, El Museo del Barrio, and Cue Art Foundation in New York and Jersey City Museum in New Jersey. Luciano participated in the 2005 Ljubljana Biennial, Slovenia, and the 2004 Trienal Poli/Gráfica de San Juan, Puerto Rico. He is a recipient of the New York Foundation for the Arts (NYFA) and Mid Atlantic Arts Foundation awards. His work is included in the collections of El Museo del Barrio, New York, and the Newark Museum, New Jersey. Luciano currently lives and works in New York.

TIRZO MARTHA (b. Curaçao 1965) completed his studies at Molenaar Fashion School, Amsterdam. He has exhibited extensively in Curaçao, Aruba, and the Netherlands, and at venues such as Art Studio Insight, Oranjestad, Aruba; Centrum Beeldende Kunst Dordrecht, Netherlands; and the Wereldmuseum, Rotterdam, Netherlands. He participated in the 2003 Biennale Internazionale dell'Arte Contemporanea, Florence. His work is included in the collection of the Curaçao Museum, Willemstad, and private collections. Martha lives and works in Willemstad.

IBRAHIM MIRANDA (b. Cuba 1969) graduated from the Instituto Superior de Arte, Havana, Cuba. He has exhibited at the Galeria Galiano, Galeria Habana, and Galeria Rubén

Martínez Villena in Havana, as well as overseas at Havana Gallery, Zurich; Alonso Art Gallery, Miami, Florida; and Couturier Gallery, Los Angeles. Miranda lives and works in Havana.

MELVIN MOTI (b. Netherlands 1977), whose parents immigrated to the Netherlands from Suriname, studied at the Academie voor Beeldende Vorming, Tilburg, Netherlands. His work has been exhibited at the Musée d'Art Moderne de la Ville de Paris; Museum Boijmans van Beuningen, Rotterdam, Netherlands; de Ateliers, Amsterdam; E-Flux, New York; Platform Garanti, Istanbul; and Museo Nacional Centro de Arte Reina Sofía, Madrid. He participated in the 2005 Baltic Triennial of International Art, Vilnius, Lithuania; 2004 International Documentary Film Festival, Amsterdam; and 2004 Argosfestival, Brussels. Moti lives and works in Amsterdam.

FAUSTO ORTIZ (b. Dominican Republic 1970) received a degree in architecture from the Universidad Technologica de Santiago, Dominican Republic. He has had solo exhibitions at the Casa Dominicana, Patterson, New Jersey, and the Centro de la Cultura de Santiago and Casa de Arte, both in Santiago, Dominican Republic. He has also participated in many group exhibitions in the Dominican Republic and Florida. Ortiz lives and works in Santiago.

STEVE OUDITT (b. Trinidad 1960) received an M.A. from Goldsmiths College at the University of London, United Kingdom. He has exhibited at the Camden Arts Centre and Institute of International Visual Arts (inIVA), both in London; Centre for Contemporary Arts (CCA), Glasgow; and Nordic Institute for Contemporary Art, Reykjavik, Iceland. Ouditt currently lives and works in Port-of-Spain, Trinidad.

RAQUEL PAIEWONSKY (b. Dominican Republic 1969) received a B.F.A. from the Parsons School of Design, New York. Her work has been exhibited at the Museo de Arte, Santo Domingo, Dominican Republic, and Lyle O. Reitzel Gallery, Miami, Florida. She participated in the VIII Bienal de La Habana, Havana, Cuba, and the V Bienal del Caribe, Santo Domingo. Paiewonsky lives and works in Santo Domingo.

EBONY GRACE PATTERSON (b. Jamaica 1981) received an M.F.A. from Washington University, St. Louis. Her work has been included in numerous group exhibitions in Jamaica and abroad, at institutions such as the Mutual Gallery and Pegasus Gallery, both in Kingston; Des Lee Gallery, Washington University School of Art, St. Louis; and Centre International d'Art Contemporain, Pont-Aven, France. She participated in the 2004 and 2006 Jamaica Biennials, Kingston. Her work is in private and public collections in Jamaica, Sweden, the United States, Britain, and France. In 2006 she received the Prime Minister's Award for Arts and Culture in Jamaica. Patterson lives and works in Kingston.

MARTA MARIA PÉREZ BRAVO (b. Cuba 1959) attended the Academia Nacional de Bellas Artes San Alejandro and later the Instituto Superior de Arte, both in Havana, Cuba. She has exhibited in New York at the Annina Nosei Gallery and Galeria Ramis Barquet and in Los Angeles at the Iturralde Gallery. She has also participated in group exhibitions at the San Francisco Museum of Modern Art, California; Los Angeles County Museum of Art; and Museo Extremeño e Iberoamericano de Arte Contemporáneo, Badajoz, Spain. Pérez Bravo lives and works in Havana.

MARCEL PINAS (b. Suriname 1971) studied art at the Edna Manley College of Visual and Performance Arts, Kingston, Jamaica. He has exhibited at the Relegation Collective, St. Laurent, French Guiana; Readytex Art Gallery, Paramaribo, Suriname; Art Creators Gallery, Port-of-Spain, Trinidad; and Wereldmuseum, Rotterdam, Netherlands. Pinas lives and works in Latour, Suriname.

JORGE PINEDA (b. Dominican Republic 1961) studied at the Universidad Autónoma, Santo Domingo, Dominican Republic, and at the Studio Franck Bordas, Paris. He has exhibited his work at the Confluences Gallery, Lyons, France; Museo de Arte Moderno, Santo Domingo, Dominican Republic; and Museo de Arte Contemporáneo de Castilla y León, León, Spain. He participated in the XXIII Bienal Nacional de Artes Visuales, Santo Domingo; VIII Bienal de La Habana, Havana, Cuba; VII Bienal Internacional de Cuenca, Ecuador; and II Bienal Ibero-americana de Lima, Peru. Pineda lives and works in Santo Domingo.

K. KHALFANI RA (b. Jamaica 1958) was educated at the Edna Manley College of Visual and Performance Arts, Kingston, Jamaica. He has exhibited regularly in the annual National and Jamaica Biennial exhibitions, Kingston, and has shown his work at the Museum of Modern Art of Latin America, Washington, D.C. He participated in the III Bienal del Caribe, Santo Domingo, Dominican Republic, and the 1995 Johannesburg Biennale. Ra lives and works in Kingston.

SANTIAGO RODRÍGUEZ OLAZÁBAL (b. Cuba 1955) studied at the Academia Nacional de Bellas Artes San Alejandro, Havana, Cuba. He has exhibited at the Musée du Louvre, Paris; Museo Nacional de Bellas Artes, Havana; Palacio de Cristal, Madrid; Galeria La Acacia and Galeria Habana, both in Havana; Afrika Museum, Berg en Dal, Netherlands; and Museum Het Valkhof, Nijmegen, Netherlands. Rodríguez Olazábal currently lives and works in Havana.

VERONICA RYAN (b. Montserrat 1956) grew up in England and graduated from the School of Oriental and African Studies, London University, United Kingdom. She has exhibited at Tate Modern, Institute of Contemporary Art (ICA), and Camden Arts Centre, all in London; Tate, St. Ives, United Kingdom; and Third Eye Centre, Glasgow. She has received numerous awards and is represented in public collections in England. Ryan lives and works in New York.

BEATRIZ SANTIAGO MUÑOZ (b. Puerto Rico 1972) received an M.F.A. from the School of the Art Institute of Chicago. She has exhibited at the Laboratorio 060, Corozal, Chiapas, Mexico; Instituto de Cultura Puertorriqueña, San Juan, Puerto Rico; Contemporary Art Museum, Los Angeles; El Museo del Barrio, New York; Museo de Arte Moderno, Santo Domingo, Dominican Republic; and Museo de Arte Contemporáneo, San Juan. Santiago Muñoz currently lives and works in San Juan.

STORM SAULTER (b. Jamaica 1983) received film training at the Los Angeles Film School, California. He has screened his films at the Museum of Contemporary Art, Miami, Florida, and Movimiento de Arte y Cultura Latino Americana (MACLA), San Jose, California. He was a participant in the V Bienal del Caribe, Santo Domingo, Dominican Republic; 2006 ARCO, Feria Internacional de Arte Contemporáneo, Madrid; and 2006 Art Basel, Miami. Saulter lives and works in Kingston.

ARTHUR SIMMS (b. Jamaica 1961) received both a B.A. and an M.F.A. from Brooklyn College, Brooklyn, New York. He has exhibited in New York at P.S.1 Contemporary Art Center, Five Myles Gallery, Studio Museum in Harlem, and Queens Museum of Art, and he participated in the 49th Venice Biennale. Simms lives and works in New York.

# Selected Bibliography

Anderson, Benedict R. O'G. *Imagined Communities: Reflections on the Origin and Spread of Nationalism*. Rev. and extended ed. New York: Verso, 1991.

Bammer, Angelika, ed. *Displacements: Cultural Identities in Question*. Bloomington: Indiana University Press, 1994.

Benitez, Marimar. "Neurotic Imperatives: Contemporary Art from Puerto Rico." *Art Journal* 57, no. 4 (Winter 1998): 75–85.

Benitez-Rojo, Antonio. *The Repeating Island: The Caribbean and Postmodern Perspective*. Translated by James Maraniss. Durham, North Carolina: Duke University Press, 1992.

Bhabha, Homi K., ed. *The Location of Culture*. New York: Routledge, 1994.

Bienal de La Habana. Catalogues of exhibitions held at the Centro de Arte Contemporáneo Wifredo Lam, Havana, 2000–present.

Block, Holly, ed. *Art Cuba: The New Generation*. Translated by Cola Franzen and Marguerite Feitlowitz. New York: Harry N. Abrams, 2001.

Bottomley, Gillian. *From Another Place: Migration and Politics of Culture*. Cambridge: Cambridge University Press, 1992.

Boxer, David, et al. *New World Imagery: Contemporary Jamaican Art*. Exh. cat. London: Hayward Gallery and South Bank Centre, 1995.

Boxer, David, and Veerle Poupeye. *Modern Jamaican Art*. Kingston, Jamaica: Ian Randle Publishers, 1998.

Bremer, Thomas, and Ulrich Fleischmann, eds. *Alternative Cultures in the Caribbean: First International Conference of the Society of Caribbean Research, Berlin 1988*. Frankfurt am Main: Vervuert Verlag, 1993.

Burton, Richard D. E. *Afro-Creole: Power, Opposition, and Play in the Caribbean*. Ithaca, New York: Cornell University Press, 1997.

Camnitzer, Luis. *New Art of Cuba*. Rev. ed. Austin: University of Texas Press, 2003.

*Caribbean Visions: Contemporary Painting and Sculpture*. Exh. cat. Alexandria, Virginia: Art Services International, 1995.

*Caribe Insular: Exclusión, Fragmentación y Paraíso*. Exh. cat. Badajoz, Spain: Museo Extremeño e Iberoamericano de Arte Contemporáneo, 1998.

Césaire, Aimé. *Discourse on Colonialism*. Translated by Joan Pinkham; introduction by Robin D. G. Kelley. New York: Monthly Review Press, 2000.

Chamberlain, Mary, ed. *Caribbean Migration: Globalised Identities*. London: Routledge, 1998.

Chambers, Iain. *Migrancy, Culture, Identity*. London: Routledge, 1994.

Clifford, James. *The Predicament of Culture: Twentieth-Century Ethnography, Literature, and Art*. Cambridge, Massachusetts: Harvard University Press, 1988.

———. "Diasporas." In *Routes: Travel and Translation in the Late Twentieth Century*. Cambridge, Massachusetts: Harvard University Press, 1997.

Cohen, Robin. *Global Diasporas: An Introduction*. Seattle: University of Washington Press, 1997.

Cooper, Carolyn. *Noises in the Blood: Orality, Gender, and the "Vulgar" Body of Jamaican Popular Culture*. London: Macmillan Caribbean, 1993.